To Daphne, with much love,
on her 70ᵗʰ birthday,
Feb. 4, 1993
from Michael

THE ROYAL COLLECTION

PAINTINGS FROM WINDSOR CASTLE

An exhibition sponsored by

WELSH WATER PLC

in association with their advisers

ALLEN & OVERY

Burson·Marsteller

COUNTY NATWEST

Kleinwort Benson

Securities

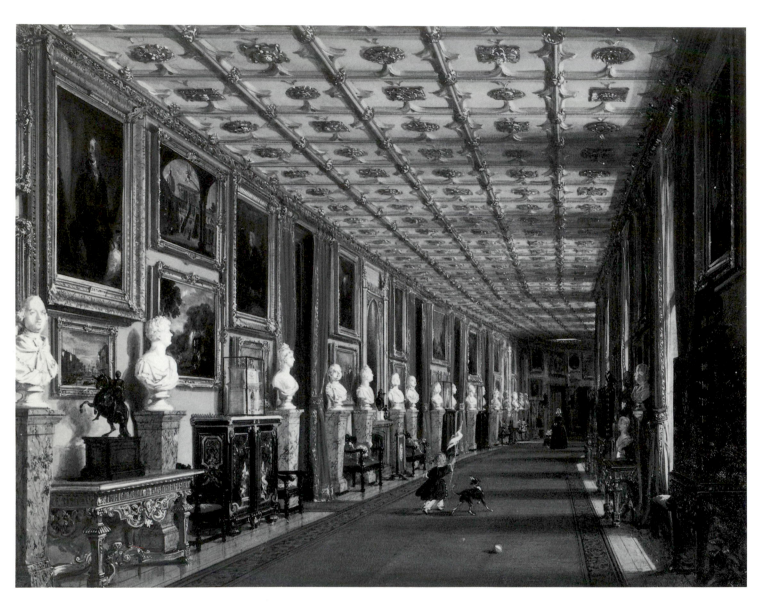

1. Joseph Nash, *Windsor Castle. The Corridor. East*
Watercolour. *c.*1840.
The Royal Library

Introduction by Christopher Lloyd
Catalogue by Mark Evans

The Royal Collection

Paintings from Windsor Castle

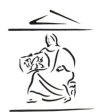

National Museum of Wales / Cardiff
in association with
Lund Humphries / London

1990

First edition 1990

Published by
National Museum of Wales
Cathays Park
Cardiff CF1 3NP
in association with
Lund Humphries Publishers Ltd
16 Pembridge Road, London W11 3HL

on the occasion of the exhibition
THE ROYAL COLLECTION
PAINTINGS FROM WINDSOR CASTLE
2 November 1990–24 February 1991

British Library Cataloguing in Publication Data

The Royal Collection: Paintings from Windsor Castle.

1. Paintings – Catalogues. Indexes
I. Evans, Mark, L.
750.74

ISBN 0 85332 589 2 casebound
ISBN 0 7200 0344 x paperback
ISBN 0 7200 0345 8 Welsh paperback

International distribution to the book-trade worldwide
by Lund Humphries Publishers Ltd

Designed by Alan Bartram
Typesetting by August Filmsetting, Haydock, St Helens
Made and printed in Great Britain
by Balding + Mansell plc, Wisbech

Contents

Preface 6
Foreword 7
Introduction 9

Catalogue 15
Pompeo Batoni 16
Sir William Beechey 18
Giovanni Antonio Canal, called Canaletto 20
Thomas Gainsborough 56
Sir Francis Grant 66
William Hogarth 68
Sir Edwin Landseer 70
Sir Thomas Lawrence 74
Jean-Baptiste Joseph Pater 84
Sir Joshua Reynolds 92
Marco Ricci and Sebastiano Ricci 98
George Stubbs 102
Antonio Visentini and Francesco Zuccarelli 116
John Wootton 120
Johann Zoffany 124

Acknowledgements 136

Preface

The opportunity for the public to view 60 of The Queen's pictures which normally hang in Windsor Castle away from the public eye is a unique one, and one which Welsh Water and their advisers are extremely pleased to be associated with.

Burson-Marsteller, Allen & Overy, County NatWest and Kleinwort Benson Securities have all worked closely with each other and Welsh Water over the last two years before and since the successful privatisation, and are all keen to continue this relationship with the Principality. Her Majesty The Queen has given permission for the National Museum of Wales to exhibit these paintings and we are honoured to be able to help realise this exhibition.

JOHN ELFED JONES
Chairman, Welsh Water PLC

W TUDOR JOHN
Partner, Allen & Overy

ROBIN BAILLIE
Chairman, Burson-Marsteller Ltd

HOWARD MACDONALD
Chairman and Chief Executive, County NatWest Ltd

DAVID PEAKE
Chairman, Kleinwort Benson Group PLC

Foreword

Her Majesty The Queen has graciously given permission for the loan of these paintings which usually hang at Windsor Castle, in apartments not open to the public. This exhibition at the National Museum of Wales brings together pictures previously on loan between six regional galleries, and additional views by Canaletto. The Council of the National Museum would like to thank Her Majesty for this loan which will give so much pleasure to our visitors.

Welsh Water PLC in association with their advisers Allen & Overy, Burson-Marsteller, County NatWest and Kleinwort Benson Securities have generously sponsored this exhibition and the Council of the Museum is greatly indebted to them for their support.

The Royal Collection reflects the tastes, interests and friendships of a family. Most of the pictures in this exhibition were acquired by George III, his son George IV or his granddaughter, Queen Victoria. Each sought artists who could portray their circle of family and friends with insight and sympathy. In Johann Zoffany, George III and Queen Charlotte found the ideal artist to record their vision of family life. Gainsborough painted elegant portraits of the whole Royal Family and many of their friends. For George IV, Thomas Lawrence displayed a brilliant technique, capturing the likenesses of the generation which led Britain in the war against Napoleon. The witty, domestic pictures of Landseer accorded with the tastes of Queen Victoria.

The exhibition also contains eighteen magnificent canvases by Canaletto which were purchased, together with the rest of the collection of Consul Smith, by George III in 1762.

I would like to thank Timothy Stevens and his colleagues at the Department of Art for organising this exhibition, and especially Mark Evans who has written the excellent catalogue, setting the pictures in their contemporary context. I am also very grateful to Christopher Lloyd, Surveyor of The Queen's Pictures, for his perceptive essay on the Grand Corridor at Windsor Castle. Throughout the preparation of the exhibition he and his colleagues have provided invaluable help on matters too numerous to list.

It is not often that we at the National Museum of Wales have the opportunity of mounting such a superb display – the depth and quality of this exhibition should attract many visitors from Wales and further afield.

Jonathan Davies

THE HONOURABLE JONATHAN DAVIES
President
National Museum of Wales

2. Joseph Nash, *Windsor Castle.*
The Corridor. Angle
Watercolour. *c.*1840.
The Royal Library

Introduction

The Grand Corridor in Windsor Castle is a focal point of the Royal Collection. It was created by George IV (1820-30) as part of the extensive programme of rebuilding at the Castle during the middle of his reign. When Prince of Wales and (from 1811) Prince Regent, George IV had concerned himself primarily with Carlton House in London and the Pavilion in Brighton. Both residences epitomise his taste for flamboyant architecture and sumptuous, richly decorated interiors offsetting his distinguished collection of paintings and works of art.

After acceding to the throne in 1820 George IV decided that Carlton House was not suitable as an official royal residence and eventually in 1826 instructions were given to pull it down and to develop Buckingham House (as it was then known) and Windsor Castle. John Nash was appointed to enlarge the former and Jeffry Wyatt (later Sir Jeffry Wyatville) won a competition for the redesigning of the latter. The regrettable decision to demolish Carlton House resulted in what is probably the greatest architectural loss of the nineteenth century in Britain. Many of its interior fittings, however, were incorporated in the newly designed areas of Buckingham Palace and Windsor Castle. So, too, were the paintings and works of art.

Windsor Castle was built during the reign of William I (1066-87) as one of several fortresses guarding the approach to London. The structure was made of earth and timber. A century later Henry II (1154-89) rebuilt it in stone. At the same time he determined the essential layout of the Castle which is divided into three sections: a Lower Ward allowing for public access, a Middle Ward dominated by the Round Tower, and an Upper Ward comprising the Private Apartments of the monarch. Substantial additions were made by Henry III (1216-72) and Edward III (1327-77), who founded the Order of the Garter which is still so closely associated with the Castle. The magnificent Chapel of St George forming part of the buildings in the Lower Ward of the Castle was begun by Edward IV (1461-83), and continued by the early Tudors – Henry VII (1485-1509) and Henry VIII (1509-47).

The Castle was transformed by Charles II (1649-85), who employed the architect Hugh May to conjure up a Baroque palace while retaining the 'Castle Air' of the medieval structure. This transformation was inspired by the activities of Louis XIV. Several of the rooms designed for Charles II survive as part of the State Apartments with allegorical frescoes by Antonio Verrio and wood-carvings by Grinling Gibbons. Unfortunately, the redesigning of the Castle by Wyatville destroyed others, such as the Chapel, which today are known only through the illustrations (fig.3) in W H Pyne, *The History of the Royal Residences* (1819). George III (1760-1820) spent a great deal of time at Windsor Castle, but during his reign only modifications rather than major alterations were made. Yet, it was George III with his architect James Wyatt who during the second half of his reign, partly for historical reasons, espoused the Neo-Gothic style. They sought to introduce the style to Windsor as more in keeping with the medieval origins of the building; a notion which Wyatville fully embraced and perfected for George IV. He doubled the height of the Round Tower to create a focal point and elsewhere in the Upper Ward added towers and battlements. The Neo-Gothic style predominated with pointed windows, machicolations and castellations sprouting in great profusion. The Castle now offered a memorable skyline when seen from a distance and as a result Wyatville's achievement was hymned by writers and illumined by artists (fig.4). It was an unashamedly romantic conception summed up perfectly by the German connoisseur, G F Waagen, the first

3. Windsor Castle. The Royal Chapel.
Print. T Sutherland after a drawing by C Wild.
From W M Pyne, *The History of the Royal Residences* (1819)

9

4. *North Front of Windsor Castle*
Print. T Sutherland after a drawing by
G Samuel.
From W M Pyne, *The History of the Royal
Residences* (1819)

Director of the new Royal Picture Gallery in Berlin, who on seeing the Castle in 1835 wrote, 'You would fancy that you had before you a grand fantastic dream of the middle ages, realized by magic, and a castle in which the old kings of chivalry held their court'.

The interior of Windsor Castle was similarly transformed. George IV aspired to higher creature comforts than George III and Queen Charlotte. His parents, together with their numerous children, had chosen to retain their Private Apartments on the colder north side of the Upper Ward and whenever architectural changes were being made they had preferred to live in the temporary structure designed by Sir William Chambers known as the Queen's Lodge situated outside the walls on the south side of the Castle. It would seem that George IV elected to expunge not only the memory of his father's mental instability associated with his confinement at Windsor, but also the physical discomforts that he himself had doubtless suffered while staying there over the years. George IV, therefore, moved the Private Apartments to the south-eastern side and extended the State Apartments on the north side into the north-eastern corner. Thus were created the Grand Reception Room, St George's Hall, and the Waterloo Chamber, as well as the Crimson, Green, and White Drawing Rooms. George IV was concerned both with the settings and with a more logical use of the space, including a better system of communication from one part of the Castle to another. For this purpose the Grand Corridor, which extends along the eastern side, was designed to connect the Private Apartments situated towards the south with the State Apartments on the north.

Although the Grand Corridor served a functional purpose, it was also ideal for the display of paintings and works of art. This was in accordance with the tradition of the Long Gallery in aristocratic houses dating back to the sixteenth century (fig. 5). Such spaces were used for perambulation, and their walls were usually hung with paintings. In its earliest form the Long Gallery principally displayed portraits of ancestors. This was particularly the case, in the context of the Royal Collection, at Whitehall Palace, Somerset House, St James's Palace, and later at Kensington Palace. During the eighteenth century, at the height of the Grand Tour, the emphasis in the Long Gallery changed to include

paintings acquired in France or Italy, although such works were also distributed through the main rooms of a residence. At Carlton House George IV did not have a gallery and his paintings were hung in the principal rooms. The redesigning of Buckingham Palace and Windsor Castle afforded an opportunity to incorporate a Long Gallery into both residences. Thus the King was able to display numerous paintings from his collection to excellent effect and to reinstate an important architectural feature to the principal royal residences. The collection amassed at Carlton House (a surprising proportion of which was kept in store) was gradually dispersed temporarily into various royal residences when the house was pulled down. Many of the pictures were shown at the British Institution – an exhibition space in Pall Mall – in 1826 and 1827, and for a time the collection was placed in St James's Palace. As it happened, George IV did not live long enough to finalise the Picture Gallery at Buckingham Palace but, as we shall see, he personally presided over the arrangement of the Grand Corridor at Windsor Castle.

George IV's collection was diverse. His strong dynastic sense encouraged him to give a place of honour to portraits of his forbears and members of his immediate family. Amongst his interests was a fascination for the Stuarts and the Brunswicks, whose likenesses were well represented. He frequently acquired or commissioned portraits of historical figures and distinguished contemporaries, either friends or otherwise worthy of honour. A similar enthusiasm for military matters and uniforms resulted in numerous paintings relevant to the British Army and Navy, as well as of significant events from his own time. The most spectacular of these was the downfall of Napoleon – an event with which the King identified so closely that he created the Waterloo Chamber with its portraits of the main protagonists specially commissioned from Sir Thomas Lawrence. George IV also acquired paintings as an expression of his own personal taste and in this respect he stands comparison with the greatest British collectors of the nineteenth century – the Marquess of Hertford, the Marquess of Stafford, and the Duke of Bridgewater. The King's taste was primarily for Dutch and Flemish painters of the seventeenth century. He acquired outstandingly fine works by Rembrandt, Steen, de Hooch, Rubens, Teniers, Terborch, the Ostades, Metsu, Maes and Wouwermans either at auction or privately, as in 1814, when he acquired the whole collection of the banker Sir Francis Baring. After his death many of these were hung in Buckingham Palace. Less numerous, but by no means insignificant, were the works by French artists (Le Nain, Claude Lorrain, Vigée-Lebrun). In addition, George IV was a great devotee of British painting, who supported Stubbs, Reynolds, Gainsborough, Hoppner, Beechey, Turner, Haydon, Mulready, and Wilkie. Although he formed a large collection, George IV was not interested in acquiring simply for its own sake. His generosity in giving away paintings and his desire to exchange them was notable, so that for several years the collection was constantly changing.

As a collector George IV was less active after he acceded to the throne and the creation of the Grand Corridor perhaps indicates a desire to bring a certain stability to the collection. The installation of pictures in the Corridor at Windsor Castle, therefore, is the ultimate expression of the King's taste for paintings and works of art, as well as of his remarkable sympathy for interior decorative schemes. The Grand Corridor is 550 feet long and 22 feet wide (167.6 × 6.7 m). It is divided into two straight sections of different lengths that meet at an angle (figs 1, 2 and 6). The style of the architecture and the fixtures is Neo-Gothic. The ceiling is panelled and the ornamental bosses and cornice

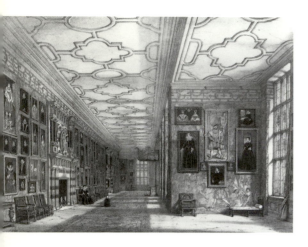

5. Gallery. Hardwicke Hall, Derbyshire
Print.
From J Nash, *The Mansions of England in The Olden Times*
Second series, 1840

6. Joseph Nash, Windsor Castle. The Corridor. South
Watercolour. *c.*1840.
The Royal Library

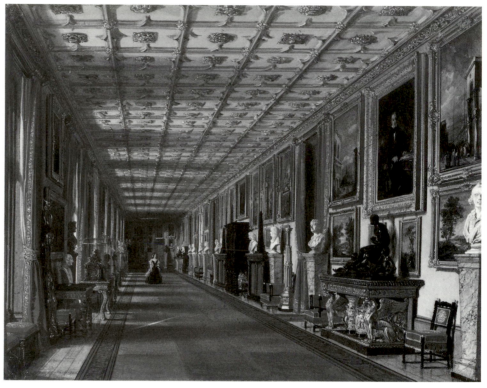

lavishly gilded. One side of the Corridor overlooks the quadrangle and has twenty-six windows, whereas the wall on the other side is pierced only by doorways and fireplaces. Artificial lighting was provided by forty-six tall gilded candelabra. The Grand Corridor was built not solely for the display of paintings, but also for sculpture (marbles and bronzes), porcelain placed in cabinets, furniture, and clocks. The overall effect was of richness and quality reflected both in the decorative features of the ceiling and in the carpet and curtains. The arrangement of all these was so ordered that a certain rhythm became evident as the eye took in the Corridor. The white marble busts set on yellow *scagliola* pedestals alternating with the gilded candelabra were punctuated by pieces of furniture, while above on the fabric covered walls were grouped the pictures in their elaborate frames. Many were set off by new matching frames made specially for the Corridor by Joseph Crouzet or George Morant. Crouzet, for example, was given the task of widening the frames surrounding the Venetian paintings bought by George III in 1762. The lighting – a contentious matter during the nineteenth century as much as today – was from the side, which was satisfactory for those pictures on the inner wall, but led to problems of *contre jour* when looking towards the windows. George IV aimed to create an ensemble and there can be no doubt that he succeeded, as Lady Dover readily acknowledged in a letter of 2 January 1829:

The first *coup d'oeil* of the long gallery or corridor is the most strikingly beautiful thing you can conceive ... it is now splendidly furnished and lighted, filled with pictures and admirably arranged, and with busts and bronzes which make it as interesting as it is magnificent. There is perhaps too much gilding: but this heightens the fairy-like appearance, and excepting this, all the ornaments and decorations are in the best possible taste.

To create this 'fairy-like appearance' (a description that the King would have relished) George IV enlisted the help of the painter Sir David Wilkie and the sculptor Sir Francis Chantrey. Sir Walter Scott's biographer and son-in-law, John Lockhart, wrote to the novelist on 28 November 1828:

Yesterday we dined with Chantrey who has been down to Windsor to assist in placing the pictures and statues in that noble place. He & Wilkie were two days, 3 hours each day, last week with the King, and the Sculptor [and] he walked an hour each day and seemed every way well and cheerful. David Wilkie being asked on his return how he liked his trip answered: "Why, I begin to get inured to the thing". Chantrey said the King's kindness to Wilkie was beautiful. Your picture [cat no 34] has an honourable place in the Gallery between Pitt and Eldon.

The Grand Corridor stands as testimony to George IV's unerring sense of quality, but it is also an expression of his personal loyalties. The space was not suitable for the hanging of grand full-length portraits, so the pictures selected were of a more intimate kind enabling the King to honour the acquisitions of his grandfather, Frederick, Prince of Wales (1707-51), who had a similar interest in Flemish, French and British painting, and his father, George III, who had in 1762 acquired the collection, mainly of Venetian paintings, formed by Consul Joseph Smith. The landscapes by John Wootton which show Frederick, Prince of Wales out hunting (cat nos 53 & 54), for example, were put in matching frames made by Crouzet. These paintings, together with the Venetian pictures, therefore, were given a certain uniformity. The half- and three-quarter length portraits of George IV's friends and famous personalities of his day were framed according to similar principles by Morant. The portraits by Sir Thomas Lawrence of William Pitt the Younger (cat no 31), Sir Walter Scott (cat no 34), and Lord Eldon were treated in this way, considerably enhancing their impact. The portraits are a dominant feature of the Grand Corridor, but it is unlikely that they were hung in a row as in the traditional Long Gallery. It is more probable, although the matter is not documented, that the Venetian pictures by Canaletto (cat nos 3-20), Zuccarelli and Visentini (cat nos 51 & 52), as well as the hunting scenes by Wootton, were used to divide up the portraits. This orchestrated arrangement was not that adopted initially for the National Gallery established in 1824 at the house (100 Pall Mall) of the late John Julius Angerstein. His paintings formed the basis of the national collection, where at first works of several different schools jostled for attention (fig.7). There was a greater clarity in the hanging of the Grand Corridor in so far as the paintings were limited predominantly to the Italian and British schools. This was a principle closer to that applied on a far more extensive scale to the Grande Galerie in the Musée Napoléon (in essence the Musée du Louvre) in 1810-15, where paintings were shown according to specific schools and interspersed by marble busts. Similar principles also applied to other major European galleries, particularly in Germany and Russia.

Unfortunately, there is no detailed record of the appearance of the Grand Corridor during the time of George IV. The earliest visual representations (figs 1, 2 and 6) are those made by Joseph Nash in about 1840 for his publication *Views of the Interior and Exterior of Windsor Castle* (1848). Even though these watercolours post-date the King's reign, the selection and arrangement portrayed must closely reflect his original intentions, as indeed the Corridor does to this day. Nash himself wrote in the text accompanying his prints, 'In traversing this noble gallery, the unity of design, of tone, of decoration, and of contour or general form, will at once strike the eye of the spectator, and impress him with

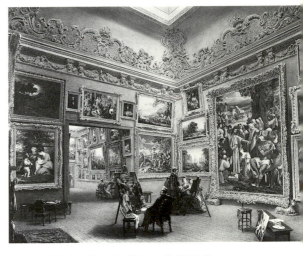

7. Frederick Mackenzie, No.100 Pall Mall
Watercolour. *c*.1824.
London, Victoria and Albert Museum

13

a sentiment of admiration at the wonderful effect produced by the assemblage of so many objects of art and virtu in all their various departments'. Queen Victoria added more pictures, mainly of a ceremonial type illustrating important events of personal significance – her Coronation, her Accession Council, the marriages of her elder children, and the christening of her grandchildren. These paintings by such artists as Wilkie, C R Leslie, G H Thomas, G Hayter, Laurits Tuxen and F X Winterhalter blended in well with George IV's scheme, although they are usually on a larger scale.

The Grand Corridor is situated in the Private Apartments at Windsor. It was not often open to the public in the nineteenth century. The essayist and critic William Hazlitt found the interior of the Castle cold, damp, and unwelcoming in 1823, but the changes made by George IV were very much admired by Waagen in 1835. Hazlitt only saw the State Apartments, but Waagen was presented to Queen Victoria and so glimpsed the Private Apartments. 'While Lord Howe went to announce us, we looked round an inner court. The ceiling is most admirably carved in oak, in a rich manner of Gothic architecture, which attained its perfection in England at the end of the fifteenth century. The walls are adorned with many pictures, among which are a great number by Canaletto, many of them amongst the best of that master'. Waagen was unable to make detailed notes of the paintings in the Grand Corridor and as a result his perceptive account of the pictures at Windsor is limited to the State Apartments. However, Anna Brownell Jameson, a writer with wide-ranging interests who pioneered the study of religious iconography, did gain access to the Corridor and included an account of the pictures in her *Companion to the Most Celebrated Private Galleries of Art in London* (1844), which begins:

Another portion of the private collection of the Queen [Victoria], to which visitors are occasionally admitted, is arranged in the grand corridor in Windsor Castle which runs round two sides of the quadrangle and opens into the private apartments of the sovereign; it is therefore very properly closed against all intrusion, and only in the absence of her Majesty may be visited by an especial ticket of admission from the Lord Chamberlain.

George IV would have been delighted that Mrs Jameson's *Companion* included accounts of other famous collections in London in addition to those at Buckingham Palace and Windsor Castle. These included the Bridgewater Gallery, the Sutherland Gallery (at Stafford House), the Grosvenor Gallery, Lansdowne House, and the collections of Sir Robert Peel and Samuel Rogers. It would have further satisfied the King that the book was dedicated to the Prime Minister of the day, Sir Robert Peel, who was also a firm admirer of Dutch painting.

The opportunity to see these paintings at the National Museum of Wales is a special occasion. It is, in fact, comparable only with the selection of forty-eight pictures from the State Apartments lent to Cardiff nearly thirty years ago, in 1961. That exhibition was of continental old masters, principally sixteenth- and seventeenth-century works from the collections of Henry VIII and Charles I. The present display continues the history of the Royal Collection under the Hanoverian dynasty to the accession of Queen Victoria.

CHRISTOPHER LLOYD

Catalogue

This publication seeks to place the paintings and their artists in a contemporary context. The opinions of sovereigns, travellers and men of letters are quoted to encourage the reader to see these pictures through a 'period eye'. Full details of dating, other versions, and related matters will be found in the volumes of the *Catalogue Raisonné* of The Queen's pictures and the other scholarly monographs referred to in the bibliographies beside each entry.

The following abbreviations are used for references to frequently cited works, followed by catalogue numbers where appropriate:

ML	M Levey, *The Later Italian Pictures in the Collection of Her Majesty The Queen*, London 1964.
OM 1-649	O Millar, *The Tudor, Stuart and Early Georgian Pictures in the Collection of Her Majesty The Queen*, 2 vols, London 1963.
OM 650-1238	O Millar, *The Later Georgian Pictures in the Collection of Her Majesty The Queen*, 2 vols, London 1969.
WC	W G Constable (revised J G Links), *Canaletto*, 2 vols, Oxford 1976.
CA	O & C Millar, *Canaletto*, Queen's Gallery, London 1980.
DNB	*The Dictionary of National Biography* (ed L Stephen & S Lee), vols I-XXII, Oxford 1885-90 (repr 1921-22).

1

Pompeo Batoni 1708-87
Edward Augustus, Duke of York 1764

Oil on canvas
137.8 × 100.3 cm (54¼ × 39½ in)
signed and dated: P. BATONI PINXIT ROMAE
1764

ML 359

ML 358

OM 723

A M Clark, *Pompeo Batoni*, Oxford 1985, pp 43, 50 & 294-95

J Brooke, *King George III*, London 1972, pp 41, 111, 140 & 270-71

C King, 'The Evolution of British Naval Uniform', *The Connoisseur*, vol 103, April 1939, pp 192-94

Batoni was the most distinguished Roman painter of the eighteenth century and a favourite with British visitors to Italy on the Grand Tour, who provided the sitters for three-quarters of his surviving portraits. This is one of three identical autograph versions of the same portrait given by the sitter to friends, in this case James Duff, 2nd Earl of Fife, whose descendants presented it to George V. Another is still with the family of its original recipient, Richard, Earl Howe. The third, probably the prototype, was given to Sir Horace Mann, English Resident in Florence, who organised the Duke's accommodation in Rome. Presented by Mann's nephew to George III in 1787, this is at Buckingham Palace.

The Duke of York travelled to Italy *incognito* in 1763, arriving at Rome on 15 April 1764. Thomas Jenkins, the banker and dealer in antique sculpture, acted as his guide to the sights and the great German art historian Winckelmann gave advice on his purchases of antiquities. Although in Rome for only two weeks, the Duke found time to sit both to Batoni and to the English painter Nathaniel Dance, whose full-length portrait of him in garter robes is at Buckingham Palace. He left Genoa on 17 August and landed at Dover on the last day of the month. In Batoni's portrait the Duke is wearing the undress uniform of an admiral with the order of the Garter. His cocked hat and sword are on the table beside him and he gestures towards a view of the Colosseum in the background. The first-century amphitheatre had often appeared in the backgrounds of portraits of northern visitors to Italy since the sixteenth century and is a common accessory in Batoni's paintings of British Grand Tourists.

Edward Augustus, Duke of York (1739-67) was the brother of George III. He entered the navy as a midshipman in 1758, seeing active service at Cherbourg under Sir Richard Howe. When French landings were feared the following year, he made a tour through the west of England to raise morale. The Duke served as rear-admiral with Lord Hawke in 1761 and was promoted admiral in 1766. His relations with his elder brother became strained. In 1761 George III passed him over for the lucrative sinecure of Bishop of Osnabrück (cat no 56) and in 1765 tried to exclude him from the Council of Regency which would have ruled in the event of the King's premature death. The Duke of York became associated with the opposition party and in 1767 voted against the government in the House of Lords. That summer he departed a second time for Rome, via Paris and Marseilles. He was taken seriously ill at Monaco, where he died on 17 September. In 1752 Horace Walpole described the sitter as 'a very plain boy, with strange loose eyes, but...much the favourite'. Lady Louisa Stuart, the daughter of George III's favourite, the Earl of Bute, recalled 'He was silly, frivolous, and heartless, void alike of steadiness and principle; a libertine in his practice, and in society one of those incessant chatterers who must by necessity utter a vast deal of nonsense'.

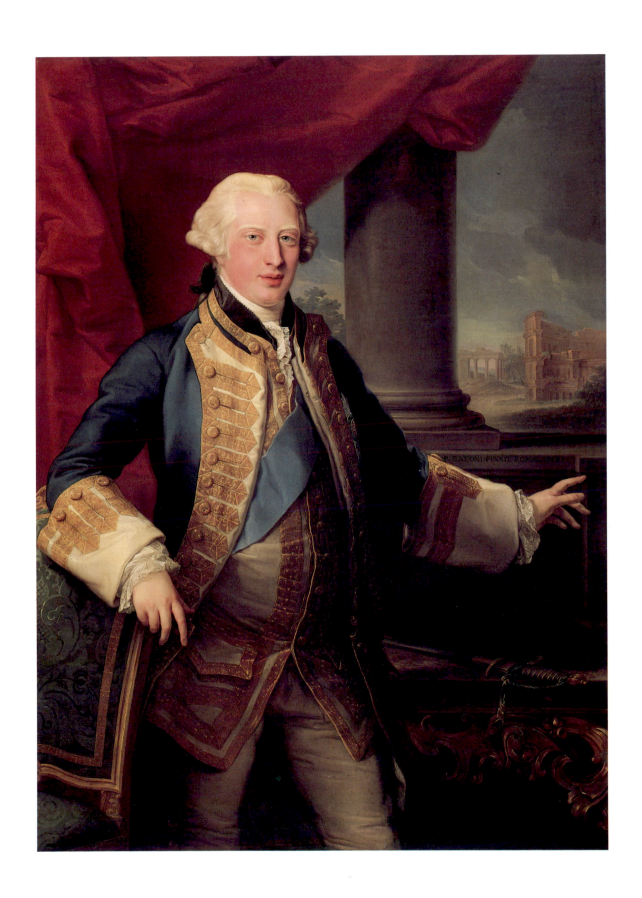

Sir William Beechey 1753-1839
George IV when Prince of Wales 1803

Oil on canvas
128.3 × 102 cm (50½ × 40 in)

OM 664

OM 660, 673, 1115

C Hibbert, *George IV*, Harmondsworth 1976
pp 163-64 & 220-23

A Ribeiro, 'Hussars in Masquerade', *Apollo*,
vol 105, February 1977, p 116

R Walker, *Regency Portraits*, National Portrait
Gallery, London 1985, vol 1, pp 200-13

Beechey became portrait painter to the Queen in 1793 and subsequently received numerous commissions from George III and the Prince of Wales, later George IV. In 1798 he was knighted and elected a full member of the Royal Academy. His diploma work, presented to the Academy on his election, was the first version of the present portrait. This second version cost £84 plus ten guineas for the frame. It was commissioned by the sitter for his younger brother Edward, Duke of Kent, the father of Queen Victoria. It passed into the collection of his nephew George, Duke of Cambridge, from whose sale it was purchased by Edward VII in 1904.

In 1797-98 Beechey painted for the King the monumental canvas (403.9 × 501.6 cm) of *George III at a Review*, exhibited at the Royal Academy in 1798. This equestrian group depicts the King, the Prince of Wales, the Duke of York and generals watching a mock battle between the 3rd Dragoon Guards and the 10th Light Dragoons. In this composition, Beechey's 1798 diploma work and the present painting, the Prince of Wales is wearing the uniform of the 10th Light Dragoons, whose Colonel Commandant he had been appointed on 29 January 1793, a few days after the execution of Louis XVI. Thrilled by his appointment, the Prince wrote a fulsome letter of thanks to his mother and commissioned Stubbs to paint a group portrait of soldiers from the regiment (cat no 48). After Revolutionary France declared war on Britain on 1 February 1793 the Prince wrote to Vienna requesting permission to serve in the Imperial army, but was forbidden to do so by his father. Subsequently, despite the Prince's entreaties, his father refused to countenance his promotion to general, explaining 'My younger sons can have no other situations in the State ... but what arise from the military lines they have been placed in. You are born to a more difficult one, and which I shall be most happy if I find you seriously turn your thoughts to; the happiness of millions depend on it as well as your own'.

The Prince of Wales had been portrayed in hussar costume by Reynolds in about 1785 and under his colonelcy the 10th Light Dragoons adopted elements of hussar dress. This change was officially sanctioned in 1805, when the regiment was one of four designated as hussars. In the present painting, the Prince's uniform has the rich braiding across the chest and the Austrian knots at the cuffs typical of hussar costume, although the sitter is not wearing the characteristic fur-trimmed dolman slung over the left shoulder. On his left chest is the star of the Garter.

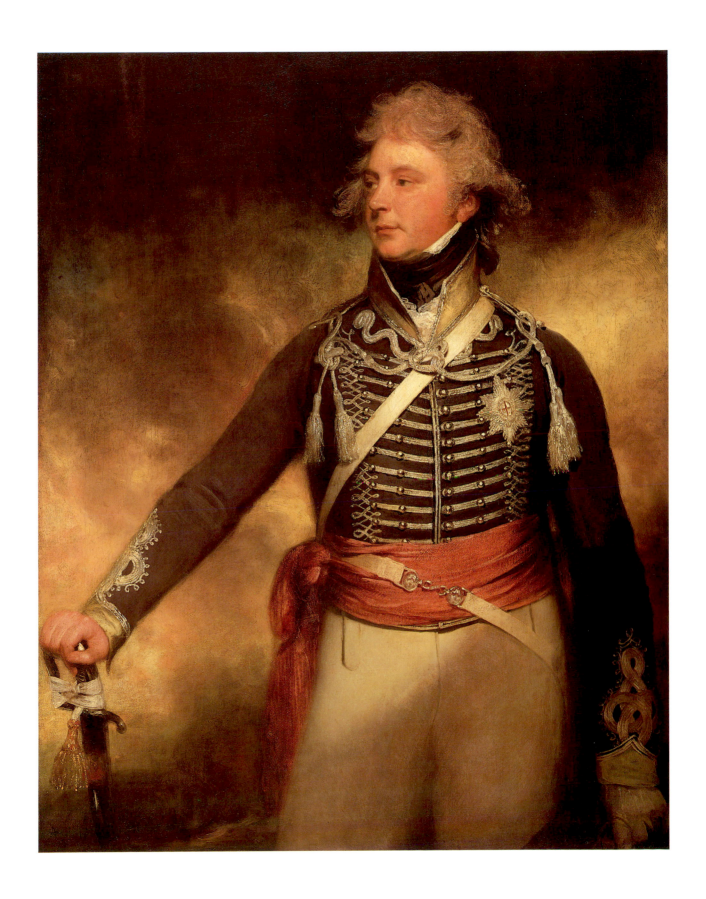

Giovanni Antonio Canal, called Canaletto 1697-1768
Venice: The Grand Canal from the Carità towards the Bacino di San Marco

Oil on canvas
47.6 × 80 cm (18¾ × 31½ in)

ML 386

ML 387-389

WC 196

CA 9

J G Links, *Canaletto*, Oxford 1982, pp 39-40

K Baetjer & J G Links, *Canaletto*, Metropolitan Museum of Art, New York 1989, pp 160-62

F Vivian, *The Consul Smith Collection*, Munich 1989, pp 11-21

F Haskell, *Patrons and Painters*, London 1963, pp 287-92, 305 & 337

D Succi, *Canaletto & Visentini Venezia & Londra*, Gorizia 1986, p 224

Trained first by his father as a theatrical designer, Canaletto subsequently specialised in views of his native Venice. These reveal the influence of Luca Carlevaris and other earlier topographical painters, as well as an appreciation of Marco Ricci's atmospheric effects. An Irish impresario, Owen McSwinny (cat no 42), who had engaged Canaletto and other Venetian painters to work on a series of large allegorical paintings commemorating major figures from recent British history, probably introduced him to the man who became his greatest patron, Joseph Smith (*c.*1674-1770). Smith had moved to Venice as a young man, became British Consul there in 1744 and was a merchant, banker, art collector and art dealer. His first commission from Canaletto, a series of six large views around the Piazza San Marco now in the Royal Collection, dates from about 1727-29. The present work is one of fourteen Canaletto views of parts of the Grand Canal painted for Smith between this date and 1735, when engravings of them were published by Giambattista Pasquali as the *Prospectus Magni Canalis Venetiarum* ('A view of the Grand Canal of the Venetians'), illustrated by the architect, painter and printmaker Antonio Visentini, who was also a protégé of Smith (cat nos 51 & 52). Seven other paintings from this series are included in the exhibition (cat nos 4-10). This painting was engraved as plate III in the *Prospectus*. Together with the rest of Consul Smith's collection, it was purchased by George III in 1762. Originally placed in the Gallery at Kew Palace, it was transferred to the Grand Corridor at Windsor in 1828.

The viewpoint is towards the south end of the Grand Canal and was first employed by the painter in a picture of 1726. At the right is the Gothic convent of Sta Maria della Carità, the bell tower of which collapsed in 1744. Secularised in 1807, the building was converted into Venice's principal art gallery, the Gallerie dell'Accademia. A wooden footbridge built in 1932, the Ponte dell'Accademia, now leads across the Grand Canal from the Campo della Carità to the left of the church. Opposite, the palace with a red cloth hanging from the upper balcony is the fifteenth-century Palazzo Cavalli. Beyond it are the Palazzi Barbaro and, on the bend of the canal, the Palazzo Corner della Ca'Grande (cat no 4). In the distance, towards its mouth, are visible on the right bank of the canal the dome of Sta Maria della Salute (cat no 5) and the tower of the Dogana di Mare (cat no 6). Beyond is the open water of the Bacino di San Marco, filled with shipping and, closing the vista, the buildings lining the Riva degli Schiavoni.

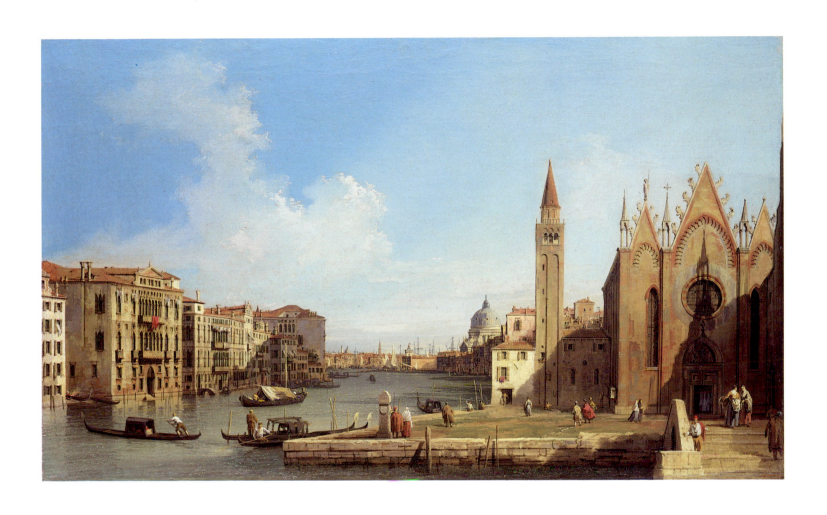

4

Giovanni Antonio Canal, called Canaletto 1697-1768
Venice: The Grand Canal from Campo San Vio towards the Bacino di San Marco

Oil on canvas
47 × 78.7 cm (18½ × 31 in)

ML 387

ML 386, 388 & 389

WC 182-92

CA 10

J G Links, *Canaletto*, Oxford 1982, pp 28-30

K Baetjer & J G Links, *Canaletto*, Metropolitan Museum of Art, New York 1989, pp 70-73

F Haskell, *Patrons and Painters*, London 1963, pp 336-37

F Vivian, *The Consul Smith Collection*, Munich 1989, pp 13-14

D Succi, *Canaletto & Visentini Venezia & Londra*, Gorizia 1986, p 225

L H Heydenreich & W Lotz, *Architecture in Italy 1400 to 1600*, Harmondsworth 1974, pp 238-39

J Addison, *Remarks on Several Parts of Italy, &c*, London 1753, p 59

J W Goethe (trans W H Auden & E Meyer), *Italian Journey*, Harmondsworth 1970, p 80

This is one of fourteen views of the Grand Canal painted for Consul Smith, who published them in the *Prospectus Magni Canalis Venetiarum* illustrated by Antonio Visentini in 1735. Smith had a controlling interest in the publishing house of Giambattista Pasquali, which produced this volume and several other works for him. Seven other paintings from this series are included in the exhibition (cat nos 3 & 5-10). This picture, plate IV in the *Prospectus*, depicts the view down the Grand Canal from a couple of hundred metres nearer its mouth than the previous work. Purchased by George III in 1762, and originally in the Gallery at Kew Palace, it was transferred to the Grand Corridor at Windsor in 1828.

One of Canaletto's favourite views, he painted this scene repeatedly from the early 1720s. At the right, facing on to the Campo San Vio is the Palazzo Barbarigo. On the opposite side of the Grand Canal is the three-storey Palazzo Corner della Ca'Grande. Designed by the distinguished Venetian Renaissance architect Jacopo Sansovino, its foundation stone was laid in 1537, although it was not finished for many years. Its rusticated basement and upper storey arcades framed with attached columns were influential upon Venetian palace design until the end of the seventeenth century. The dome of Sta Maria della Salute (cat no 5) and the tower of the Dogana di Mare (cat no 6) are visible on the right bank of the canal before the Bacino di San Marco and the enclosing bank of the Riva degli Schiavoni.

The unique topography of Venice dazzled foreigners. After visiting the city at the beginning of the eighteenth century, the essayist and poet Joseph Addison noted '*Venice* has several Particulars, which are not to be found in other Cities, and is therefore very entertaining to a Traveller. It looks, at a distance, like a great Town half floated by a Deluge. There are Canals everywhere crossing it, so that one may go to most Houses either by Land or Water. This is a very great Convenience to the Inhabitants; for a *Gondola* with two Oars at *Venice*, is as magnificent as a Coach and six Horses with a large Equipage, in another Country; besides that it makes all other Carriages extremely cheap. The Streets are generally paved with Brick or Freestone, and always kept very neat; for there is no Carriage, not so much as a [Sedan] Chair, that passes thro' them'. However, in 1786 Goethe complained 'I was struck by the uncleanliness of the streets... There appears to be some kind of police regulations on this matter, for people sweep the rubbish into corners and I saw large barges stopping at certain points and carrying the rubbish away. They came from the surrounding islands where people are in need of manure. But there is no logic or discipline in these arrangements. The dirt is all the more inexcusable because the city is as designed for cleanliness as any Dutch town. All the streets are paved with flagstones'.

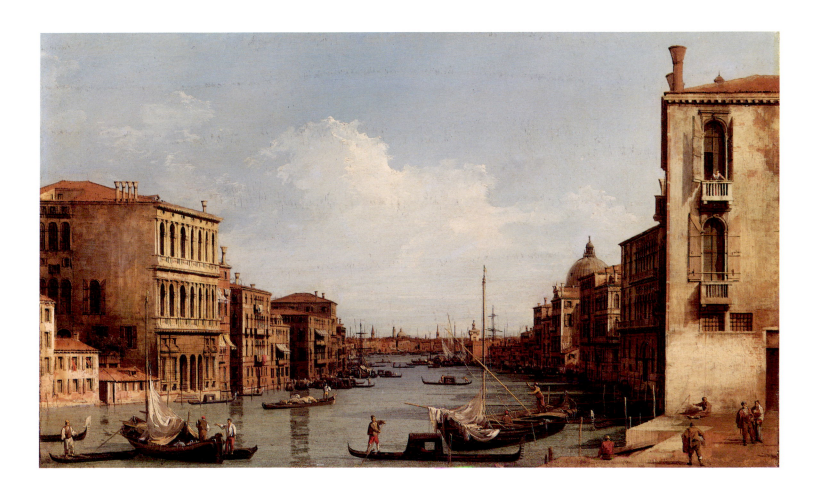

Giovanni Antonio Canal, called Canaletto 1697-1768
Venice: The Grand Canal with Sta Maria della Salute looking towards the Riva degli Schiavoni

Oil on canvas
47.6 × 80 cm ($18\frac{3}{4}$ × $31\frac{1}{2}$ in)

ML 388

ML 374, 375, 389 & 397

WC 168-76

CA 11

J F Links, *Canaletto*, Oxford 1982, pp 30-31

D Succi, *Canaletto & Visentini Venezia & Londra*, Gorizia 1986, p 226

R Wittkower, *Art and Architecture in Italy 1600 to 1750*, Harmondsworth 1958, pp 191-95

J Addison, *Remarks on Several Parts of Italy, &c*, London 1753, pp 58-59

The present work is one of the views of the Grand Canal painted for Consul Smith and published in the *Prospectus Magni Canalis Venetiarum* in 1735. Smith was active as an art dealer and the publication was probably a means of advertising his stock and the special relationship which he enjoyed with Canaletto. Seven more paintings from this series are included in the exhibition (cat nos 3, 4 & 6-10). This one was engraved as plate V in the *Prospectus*. It depicts the view across the mouth of the Grand Canal to the Bacino di San Marco from a high point on the east end of the medieval abbey of San Gregorio, over 300 metres beyond that of the previous work. Together with the rest of Consul Smith's collection, this picture was purchased by George III in 1762. Originally in the Gallery at Kew Palace, it appears to have been transferred in 1828 to the Grand Corridor at Windsor.

One of Canaletto's most popular views, he painted a series of variants of this composition from the 1720s. At the right, facing on to the monumental stairs of the Campo della Salute is the octagonal church of Sta Maria della Salute. After the outbreak of plague which devastated northern Italy in 1629-30 and left 50,000 dead in Venice, the Republic decided to erect a church in thanksgiving for the deliverance of the city. The Venetian architect Baldassare Longhena was commissioned to build this *ex voto*, which was begun in 1631 and completed in 1687. The most important Venetian Baroque church, its distinctive shape and prominent location make it one of the most outstanding landmarks in the city. Beyond the church is the tower of the Dogana di Mare (cat no 6) and, on the left, are the principal buildings on the Molo; the Zecca, Libreria, column of San Marco, the Palazzo Ducale and the Prisons (cat no 10). Beyond is the curving bank of the Riva degli Schiavoni ('The Quay of the Dalmatians').

Although the Bacino di San Marco continued to throng with shipping, by this date Venice was in terminal political and economic decline which culminated in the abolition of the Republic by Napoleon in 1797. At the beginning of the eighteenth century, Joseph Addison acutely observed 'their Trade is far from being in a flourishing Condition for many Reasons. The Duties are great that are laid on Merchandises. Their Nobles think it below their Quality to engage in Traffic. Their Merchants who are grown rich, and able to manage great Dealings, buy their Nobility, and generally give over Trade. Their Manufactures of Cloth, Glass, and Silk, formerly the best in *Europe*, are now excell'd by those of other Countries. They are tenacious of old Laws and Customs to their great Prejudice, whereas a Trading Nation must be still for new Changes and Expedients, as different Junctures and Emergencies arise. The State is at present very sensible of this Decay in their Trade'. These economic considerations help to explain Canaletto's numerous foreign patrons and his decision to visit London (cat nos 19 & 20).

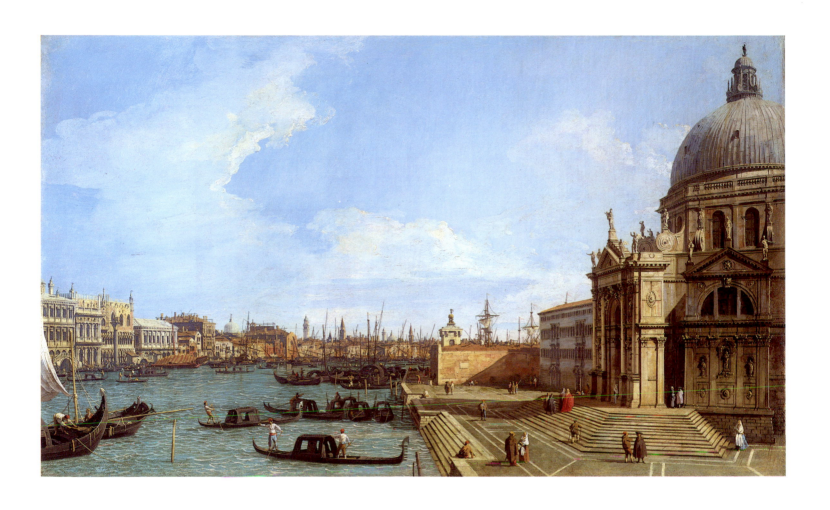

6

Giovanni Antonio Canal, called Canaletto 1697-1768
Venice: The Grand Canal from Sta Maria della Salute looking towards the Carità

Oil on canvas
47.6 × 78.7 cm ($18\frac{3}{4}$ × 31 in)

ML 389

ML 386 & 388

WC 158 & 160-67

CA 12

J G Links, *Canaletto*, Oxford 1982, p 67

K Baetjer & J G Links, *Canaletto*, Metropolitan Museum of Art, New York 1989, pp 150-51

D Succi, *Canaletto & Visentini Venezia & Londra*, Gorizia 1986, p 227

C Burney (ed H Edmund Poole), *Music, Men, and Manners in France and Italy 1770*, London 1969, p 72

J W Goethe (trans W H Auden & E Meyer), *Italian Journey*, Harmondsworth 1970, p 77

Probably a pendant to the previous work, this is one of the views of the Grand Canal published in 1735. Seven from the series are included in the exhibition (cat nos 3-5 & 7-10). This one was engraved as plate VI in the *Prospectus*. Plates I-V and their corresponding paintings portrayed, in stages, an imaginary journey down the Grand Canal from the Rialto Bridge to Sta Maria della Salute. The present work depicts the view from some distance out in the Bacino di San Marco, as though the observer had turned back to look into the entrance of the Grand Canal. Purchased by George III in 1762, it probably hung in the Gallery at Kew and was transferred in 1828 to the Grand Corridor at Windsor.

At the left is the promontary forming the tip of the south bank of the Grand Canal, upon which stands the Dogana di Mare, the customs house. Built to the plans of Giuseppe Benoni in 1676-82, its façade is surmounted by a tower with a golden globe supporting a weather-vane of Fortune bearing a sail. Beyond is Sta Maria della Salute with its subsidiary cupola and bell tower over the east end visible to one side of its main dome. Just to the right of centre stands the fifteenth-century tower of the Palazzo Venier della Torreselle. Demolished during the nineteenth century, it adjoined the unfinished Palazzo Venier dei Leoni, which now houses the Peggy Guggenheim Collection. At the end of the vista is the bell tower of Santa Maria della Carità, now the Gallerie dell'Accademia (cat no 3). The first building on the right side of the canal is the seventeenth-century Palazzo Tiepolo.

Traditionally the Dogana di Mare was visited by all new arrivals at Venice, so this view was one of the first seen by tourists. The experience could be disconcerting, as the musicologist Charles Burney discovered in 1770; 'The water was smoother than the Thames at this time of the year – and Venice swelled upon the sight, but one forms such romantic ideas of this city from its singular formation about which one reads so much, that it did not at all answer my expectation ... But behold in the midst of my contemplations I am carried to the dogana or custom house, which stands alone in the middle of the sea and am accosted by 10 or 12 officers, who row along side me with the same speeches as the others assuring me *they* were the true servants of the state. I offered them my keys and bid them do their office, but they said they hoped for a buona mano [gratuity] for their civility, which I complied with, and there it ended'. In 1786 Goethe was better prepared; 'At last we entered the lagoons and, immediately, gondolas swarmed around our boat. A passenger from Lombardy, a man well known in Venice, invited me to join him in one so that we might arrive in the city more quickly and avoid the ordeal of the Dogana. Some people wanted to detain us, but, with the help of a modest tip, we succeeded in shaking them off and, in the peaceful sunset, went gliding quickly towards our goal'.

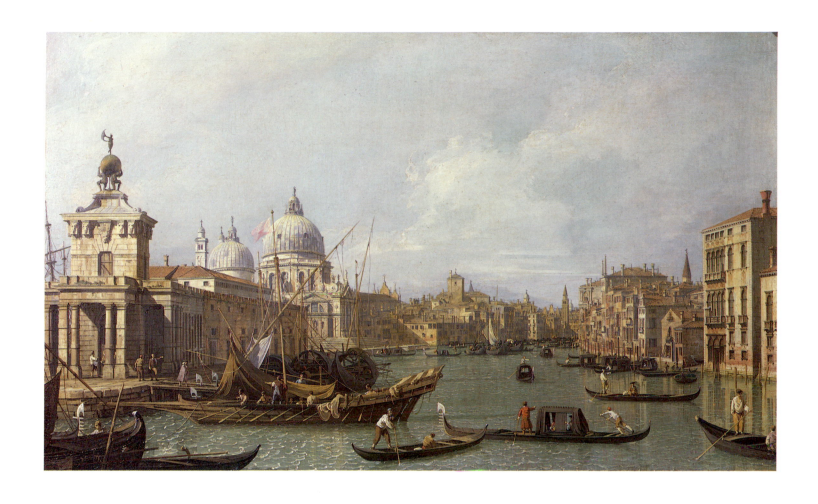

7

Giovanni Antonio Canal called Canaletto 1697–1768
Venice: The Grand Canal, the Rialto Bridge from the North

Oil on canvas
46.4 × 80 cm (18¼ × 31½ in)

ML 390

ML 391, 408

WC 234-38

CA 13

J G Links, *Canaletto*, Oxford 1982, pp 36-38

K Baetjer & J G Links, *Canaletto*, Metropolitan Museum of Art, New York 1989, pp 88-89, 105-08, 124-25 & 280-81

D Succi, *Canaletto & Visentini Venezia & Londra*, Gorizia 1986, p 228

This is one of the views of the Grand Canal painted for Consul Smith which were published with engraved illustrations by Visentini in 1735. Seven others are included in the exhibition (cat nos 3-6 & 8-10). The present work is plate VII in the *Prospectus*. In contrast to plates I-VI which depict a succession of views from the middle of the Grand Canal to its mouth in the Bacino di San Marco, this one depicts the Rialto Bridge, the middle point of the canal, viewed from the north. It was probably a pendant to the following work. Purchased by George III in 1762, it hung first in the Gallery at Kew Palace and was transferred to the Grand Corridor at Windsor in 1828.

Although Luca Carlevaris had previously painted this view, Canaletto's composition is a flexible arrangement of the buildings in the scene, which cannot all be seen in this precise relationship from a single viewpoint. He painted it probably for the first time in 1725, as a pair with another composition looking north from the bridge: a viewpoint repeated in the following work. At the extreme left the edge of a palace provides a framing element to the composition. Beyond it is the façade of the Fondaco dei Tedeschi, where German merchants had their warehouses and offices, built in 1505 by Giorgio Spavento and completed by Lo Scarpagnino according to plans by the German architect Hieronymus of Augsburg. Above the roof line of the Fondaco is the spire of San Bartolomeo, previously the church of the German community. To the right is the Rialto Bridge, which takes its name from the principal island of Venice, the commercial and economic centre of the city, here on the left bank of the Grand Canal. Replacing an earlier wooden structure, it was built by Antonio da Ponte in 1588-92 and remained the only bridge over the Grand Canal until the nineteenth century. Palladio's rejected design for a classicising bridge survives and appears in its intended location in a fantasy composition by Canaletto, now also in the Royal Collection. Immediately to the right of the Rialto Bridge is the asymmetrical Palazzo dei Camerlenghi. Restored by Guglielmo dei Grigi in 1523-25, it was the seat of the city treasurers and a prison. The quay to its right is the Erberia or wholesale vegetable market, behind which is the long arcaded market building of the Fabbriche Vecchie di Rialto, built in the early sixteenth century by Lo Scarpagnino.

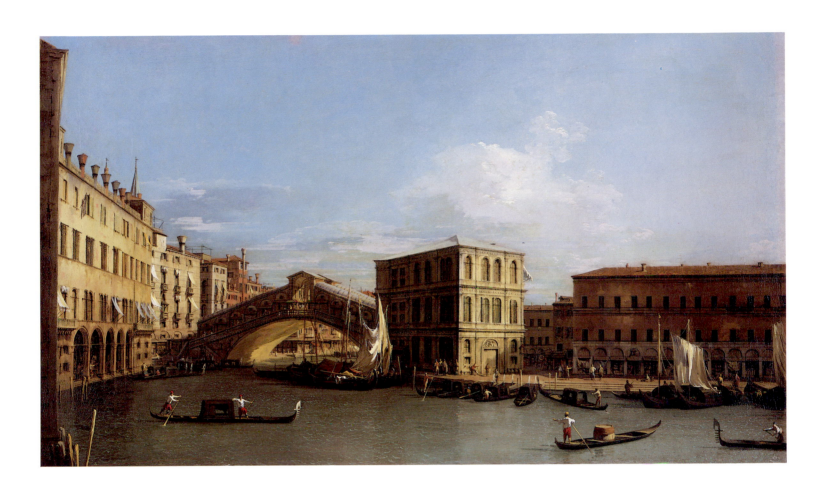

Giovanni Antonio Canal, called Canaletto 1697-1768
Venice; The Grand Canal looking North from the Rialto

Oil on canvas
47.6 × 79.4 cm (18¾ × 31¼ in)

ML 391

ML 390

WC 230-33

CA 14

J G Links, *Canaletto*, Oxford 1982, pp 35-36

K Baetjer & J G Links, *Canaletto*, Metropolitan Museum of Art, New York 1989, pp 162-64

D Succi, *Canaletto & Visentini Venezia & Londra*, Gorizia 1986, p 229

F Haskell, *Patrons and Painters*, London 1963, p 302

F Vivian, *The Consul Smith Collection*, Munich 1989, pp 14-16, 22-28, 32-41, 108-09 & 116-23

F Vivian, 'The Last Months of the Life of Joseph Smith', *Apollo*, vol 131, no 339, May 1990, pp 309-12

R Wittkower, *Art and Architecture in Italy 1600 to 1750*, Harmondsworth 1958, p 196

J W Goethe (trans W H Auden & E Meyer), *Italian Journey*, Harmondsworth 1970, p 96

Probably a pendant to the previous work, this is one of the views of the Grand Canal painted for Consul Smith which were published in 1735. Seven other paintings from the series are included in the exhibition (cat nos 3-7 & 9-10). This one is plate VIII in the *Prospectus*. It depicts the view up the northern half of the Grand Canal from the Rialto Bridge. Acquired by George III in 1762, it originally hung at Kew Palace and was transferred to the Grand Corridor at Windsor in 1828.

Albeit at a quite different angle of view, it continues the scene from the right of the previous composition. At the left is the Erberia and the end of the Fabbriche Vecchie di Rialto at the point where it joins the later Fabbriche Nuove di Rialto. This big arcaded market building, begun by Jacopo Sansovino in 1554 and now the seat of the assize court, fills most of the left half of the composition. Above it stands the thirteenth-century bell tower of San Cassiano, from which flags are fluttering. Beyond is the open air fish market and, at the curve of the canal, the Palazzo Pesaro of 1663-1710. Built to the designs of Baldassare Longhena, it now houses the Gallery of Modern Art. On the centre-line of the composition, the vista is closed by the medieval bell tower of San Geremia. At the bottom right foreground, the coping is part of the approach to the Rialto bridge. Above the first palace on the right stands the bell tower of Santi Apostoli, built in 1672. Another example of Canaletto's flexible handling of topographical motifs, it would not actually be visible from the viewpoint depicted. Here, it serves as a framing element to balance the opposite side of the composition. The next palace is the thirteenth-century Ca'da Mosto, well known as the Leon Bianco inn since the Renaissance.

The fourth palace on the right is the Palazzo Magnilli-Valmarana. Since at least 1709 it had been leased as the town house of Consul Smith, who acquired its freehold in 1740. Having previously remodelled Smith's villa at Mogliano, Visentini was commissioned to rebuild the façade of the palace in a Palladian manner, a task which he completed in 1751. The woman of letters Mme du Boccage visited the residence in 1757 and found it 'entirely in the English taste; the very tables and locks of the gates are made after the manner of that country'. Since the old Gothic façade of the palace is recorded in the 1735 engraving and would originally have appeared in this painting, Smith must have had Canaletto paint in the new façade after 1751. He lived in considerable style in his town house filled with paintings, his famous library and collections of manuscripts, drawings, gems, coins and medals. Every Sunday he visited his villa, where he received guests and showed them his treasures, including what Robert Adam described as 'as pretty a collection of pictures as I have ever seen'. Even when he sold most of his collection to George III in 1762 for £20,000 to secure 'the Comfort and Happiness of my future Life', he held some works back and continued to collect more. Owing to a failed business deal which left substantial debts, he was obliged to sell the Mogliana villa in 1770, the year of his death. His second wife continued to live in the Palazzo Magnilli-Valmarana until 1775, retiring to England two years later. Although his residences were sold and his collections disappeared abroad, Smith was not completely forgotten in his adopted city. When Goethe visited Venice in 1786 he went to the Lido where 'Not far from the beach lies the Cemetery for the English and, a little further on, that for the Jews, neither of whom are allowed to rest in consecrated ground. I found the graves of good consul Smith and his first wife. To him I owe my copy of Palladio, and I offered up a grateful prayer at his unconsecrated grave, which was half buried in the sand'.

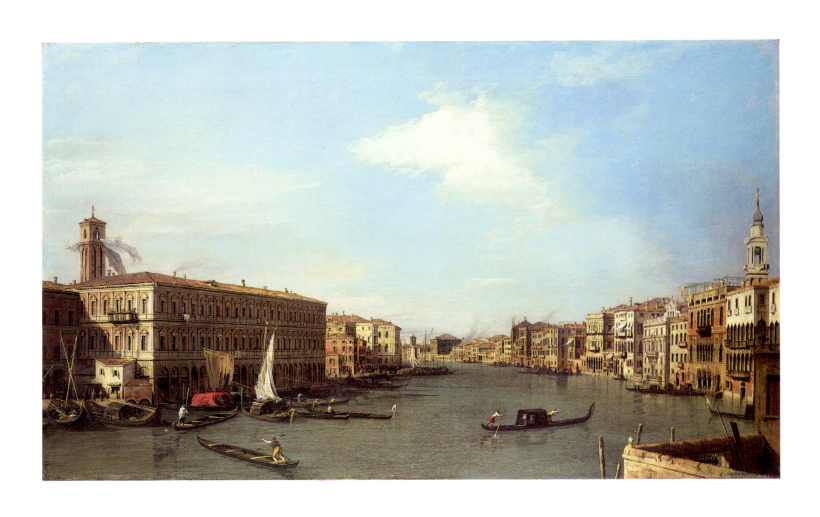

9

Giovanni Antonio Canal, called Canaletto 1697-1768
Venice: A Regatta on the Grand Canal

Oil on canvas
76.8 × 125.1 cm (30¼ × 49¼ in)

ML 396

ML 397

WC 347-54

CA 19

J G Links, *Canaletto*, Oxford 1982, pp 73-74

K Baetjaer & J G Links, *Canaletto*, Metropolitan Museum of Art, New York 1989, pp 166-71

D Succi, *Canaletto & Visentini Venezia & Londra*, Gorizia 1986, p 234

M Levey, *The Seventeenth and Eighteenth Century Italian Schools*, National Gallery, London 1971, pp 36-38

M Wortley Montague (ed R Halsband), *The Complete Letters of Lady Mary Wortley Montagu*, vol II, Oxford 1966, pp 160, 178 & 190-92

J Addison, *Remarks on Several Parts of Italy, &c.* London 1753, p 65

A pendant to the following work, this is one of the views of the Grand Canal published for Consul Smith in 1735. Seven more paintings from the series are included in the exhibition (cat nos 3-8 & 10). This one was engraved as plate XIII in the *Prospectus*. The first twelve views are the same size, but this painting and its pair are considerably larger and were probably painted after the others. An approximate date is provided by the Doge's coat of arms at the top of the structure in the left foreground – that of Carlo Ruzzini, who reigned from June 1732 until January 1735. The view looks north-east along a middle stretch of the canal, from a sharp bend known as the 'Volta del Canal' towards the Rialto Bridge, visible at the end of the vista. Purchased by George III in 1762, this picture hung in the Gallery at Kew before transfer to the Grand Corridor at Windsor in 1828.

The annual Venetian regatta had been held since 1315 on the Feast of the Purification of the Virgin, 2 February. Its course ran from south-east Venice across the Bacino di San Marco and the length of the Grand Canal, before turning back to finish at the 'macchina della regatta', the large decorated floating platform anchored at the mouth of the Rio Foscari, in the left foreground of this painting. The race depicted is that of the light one-man gondolas, here speeding up the central channel between ranks of gondolas and the larger, decorated piotes and bichones. Prominent at the left is the Palazzo Balbi, built in 1582-90. Beyond it is the Palazzo Civran Grimani, from which the inveterate traveller Lady Mary Wortley Montagu watched a regatta in 1740. Her letters amused her correspondents, one of whom replied, 'Your Descriptions of Venice are delightfull. Cagnioletti [Canaletto] never drew any Views of it half so amusing; I prefer your mezzotintos to all the Arts of his colouring'. Lady Mary's account of the regatta dwells on the boats of the nobles: 'It is a race of Boats; they are accompany'd by vessells which they call Piotes and Bichones, that are built at the Expence of the nobles and strangers that have a mind to display their magnificence. They are a sort of Machines, adorn'd with all that sculpture and gilding can do to make a shineing appearance. Several of them cost £1,000 sterling and I believe none less than 500. They are row'd by Gondoliers dress'd in rich Habits suitable to what they represent. There was enough of them to look like a little Fleet, and I own I never saw a finer sight … the Bichones … are less vessels, quite open, some representing Gardens, others apartments, all the oars being gilt either with Gold or Silver, and the Gondoliers' Liverys either velvet or rich silk with a profusion of Lace fringe and Embrodiery'.

Canaletto's composition was based upon Luca Carlevaris's earlier painting of the special regatta given in 1709 for the King of Denmark. However, the annual regatta depicted here was part of the festivities of Carnival, which ran from 26 December until Lent. Many of the spectators are wearing carnival dress and masks, which could also be worn between 5 October and 16 December. This tradition intrigued foreigners, such as Joseph Addison, who wrote in 1705: 'The great Diversion of the Place at that time, as well as on all other high Occasions, is Masking. The *Venetians*, who are naturally Grave, love to give into the Follies and Entertainments of such seasons, when disguised in a false Personage … These Disguises give Occasion to abundance of Love-Adventures; for there is something more intriguing in the Amours of *Venice*, than in those of other Countries; and I question not but the secret history of a Carnival would make a Collection of very diverting Novels'.

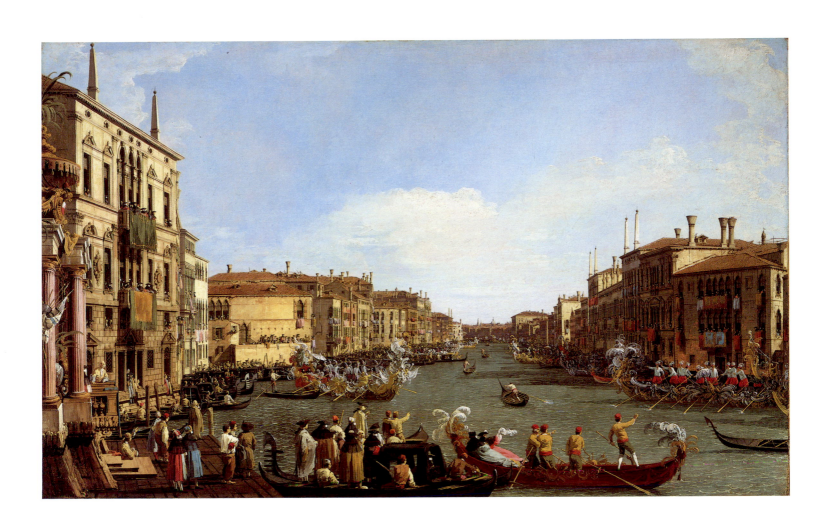

Giovanni Antonio Canal, called Canaletto 1697–1768
Venice: The Bacino di San Marco on Ascension Day

Oil on canvas
76.8 × 116.8 cm (30¼ × 46 in)

ML 397

ML 396 & 403–06

WC 332–46

CA 20 & 50

J G Links, *Canaletto*, Oxford 1982, pp 74–77

K Baetjer & J G Links, *Canaletto*, Metropolitan Museum of Art, New York 1989, pp 171–76

D Succi, *Canaletto & Visentini Venezia & Londra*, Gorizia 1986, p 235

M Levey, *The Seventeenth and Eighteenth Century Italian Schools*, National Gallery, London 1971, pp 33–36

J W Goethe (trans W H Auden & E Meyer), *Italian Journey*, Harmondsworth 1970, pp 87–88

Like the previous picture, its pendant, this work is one of the views of the Grand Canal in the collection of Consul Smith published in 1735 with illustrations by Visentini. Seven more paintings from the series are included in the exhibition (cat nos 3–9). This picture was engraved as the last plate, XIV in the *Prospectus*. Like its pair, it is larger than the other paintings and probably dates from 1732–35. The view looks north from the Bacino di San Marco towards the Molo and the principal public buildings of Venice. Purchased by George III in 1762, this picture hung in the Gallery at Kew before transfer to the Grand Corridor at Windsor in 1828.

The scene portrayed was one of the principal festivals of the Venetian Republic. Canaletto painted several versions of the composition, some paired with pictures of the Regatta on the Grand Canal (cat no 9). Every Ascension Day, on the sixth Thursday after Easter, the Venetians celebrated the Wedding of the Sea. This commemorated the victory in around 1000 of Doge Pietro Orseolo II over Slav pirates in the Adriatic, which subsequently became a Venetian 'Lake' from which the Republic launched its Mediterranean empire. On Ascension Day, the Doge and the Signoria proceeded from the Palazzo Ducale (cat nos 15 & 16) through the Piazzetta, where the canvas stalls of the market visible in the painting had been erected, to the state galley known as the Bucintoro, which fills the right background of the composition. They then proceeded to the mouth of the Lido where the Doge threw a ring blessed by the Patriarch of Venice into the water, as a symbolic marriage between the Republic and the Sea. Here, the ceremony has been completed and the Bucintoro with the Doge, Signoria and ambassadors, navigated by the High Admiral standing before the flagpole, is about to dock. Smaller craft throng about, filled with spectators, some of whom are unseasonally wearing carnival masks.

This Bucintoro was designed in 1728–29 by Stefano Conti of Lucca and decorated by the sculptor Antonio Corradini. It was the last to be built, being destroyed by the French in 1798 after the fall of the Republic. In 1741 Lady Pomfret described it: 'What was really very curious to see, was the Bucentoro, in which the doge and senate go out every year on Ascension-day to wed the sea. This is a galley of a hundred feet in length, divided into two galleries, with a seat at the upper end for the doge, and benches down the sides for the senate; with a covering overhead, all made of wood, carved inside and outside in the richest ornaments, with bas-relievos, and whole figures, all gilt. In the hollow of the vessel are seated the rowers; four men to each oar, and forty-two oars on each side. This machine is only made use of upon this occasion, and lasts a hundred years. The present one is about six years old, and cost ten thousand pounds'. In 1786, Goethe observed: 'To describe the *Bucentaur* in one word, I shall call it a show-galley ... worthy of carrying the heads of the Republic on their most solemn day to the sacrament of their traditional sea power ...One should not say that it is overladen with ornaments, for the whole ship is one single ornament. All the wood carving is gilded and serves no purpose except to be a true monstrance showing the people their masters in a splendid pageant. As we know, people who like to decorate their own hats like to see their superiors elegantly dressed as well. This state barge is a real family heirloom, which reminds us of what the Venetians once believed themselves to be, and were'.

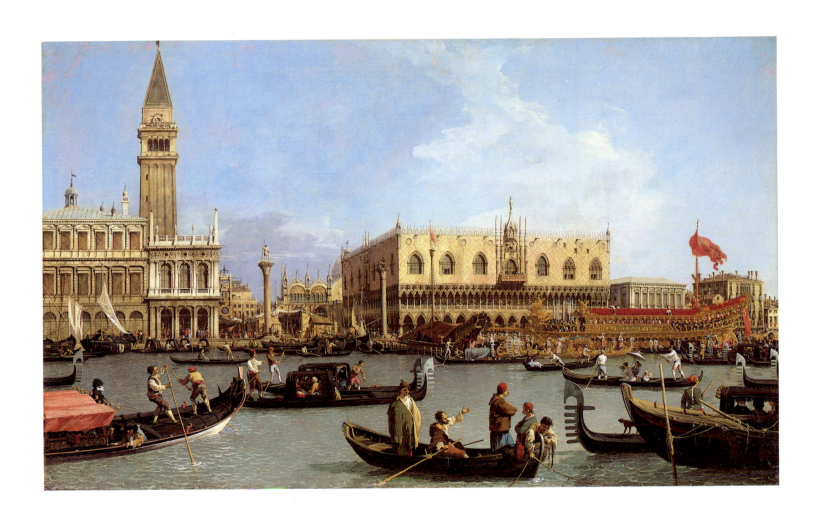

11

Giovanni Antonio Canal, called Canaletto 1697-1768
Venice: Campo SS Giovanni e Paolo

Oil on canvas
46.4 × 78.1 cm (18¼ × 30¾ in)

ML 402

WC 304-10

CA 21

J G Links, *Canaletto*, Oxford 1982, pp 85-86 &
90-91

K Baetjer & J G Links, *Canaletto*, Metropolitan
Museum of Art, New York 1989, pp 178-81

D Succi, *Canaletto & Visentini Venezia & Londra*,
Gorizia 1986, p 248

L H Heydenreich & W Lotz, *Architecture in Italy
1400 to 1600*, Harmondsworth 1974, pp 91-92

J Pope-Hennessy, *Italian Renaissance Sculpture*,
London 1958, p 315

C Burney (ed H Edmund Poole), *Music, Men, and
Manners in France and Italy 1770*, London 1969,
pp 74-75

J Spence (ed S Klima), *Letters from the Grand
Tour*, Montreal & London 1975, p 90

The second edition of *Prospectus Magni Canalis Venetiarum*, with illustrations of Consul Smith's collection of paintings by Canaletto, was published in 1742. In addition to the works previously mentioned (cat nos 3-10), it included more views of the Grand Canal and other parts of the city. This picture was included, as plate I of part III. The view looks south-east across the Rio dei Mendicanti towards the Campo Santi Giovanni e Paolo. Purchased by George III in 1762, this picture probably hung in the Gallery at Kew before transfer to Windsor in 1828.

Santi Giovanni e Paolo is the principal Dominican church in Venice, begun in 1246 and completed in 1430. From the fifteenth century it was the burial place of the Doges and one of the principal basilicas in the city. In August 1770 Charles Burney watched as 'The Doge went in procession to the church of *S Giovanno e Paulo* and was attended by all the nobles who were well and in town … Yesterday they were all in black – to day the robes were a crimson kind of uncut velvet, very rich and over the left shoulder a kind of velvet scarf of the same colour. At the church they were met by prodigious number of secular and regular priests. I thought the procession would never end. Such a quantity of silver supports for the wax candles carried 2 and 2 by the whole fraternity, major and minor!' In this painting a Venetian senator dressed in red stands prominently before the main portal of the church, a short distance from three Dominican friars. As the main door was rebuilt in 1739 and the old one appears here, it is likely that this work dates from 1735-38.

The elaborate Renaissance façade to the left is that built in 1487-95 by Giovanni di Antonia Buora, Mauro Codussi and Pietro Lombardo for the Scuola Grande di San Marco. Originally one of the six great philanthropic confraternities of the Venetian Republic, this is now part of Venice's main hospital. The Campo is dominated by the equestrian statue of Bartolomeo Colleoni, dated 1479-96, by the Florentine Andrea del Verrocchio. The most famous post-classical statue in Venice, it commemorates a mercenary general from Bergamo in the Venetian service, who bequeathed much of his fortune to the Republic on condition that a statue in his memory was erected in the Piazza San Marco. To avoid commemorating him on such a prominent site, the Senate resolved that his monument be placed in the square before the Scuola di San Marco. In 1732 the Oxford don Joseph Spence mentioned it as 'an equestrian statue set up S.C. to Bartolomeo Colleoni, just after they had taken care to have him poisoned'. His mistaken belief that Colleoni was murdered, which possibly arose from confusion with his master Carmagnola who was executed for treason in 1432, reflects the reputation for ruthlessness often attributed to the Venetian government (cat no 16).

Meticulous preparatory drawings for this painting exist, probably made from the edge of the Campo, just before the Rio dei Mendicanti. However, in the final composition the artist has dovetailed two widely separate viewpoints, as the whole panorama from the bridge at the left, across the façades of the Scuola Grande and the church and the whole extent of the Campo cannot be taken in from any single location. Similarly, the height of the dome has been accentuated to give it greater prominence from this low vantage-point. These adjustments were crucial to present a lucid and unified view of an irregular site which can only be seen, in reality, from too near a viewpoint to be appreciated in its entirety.

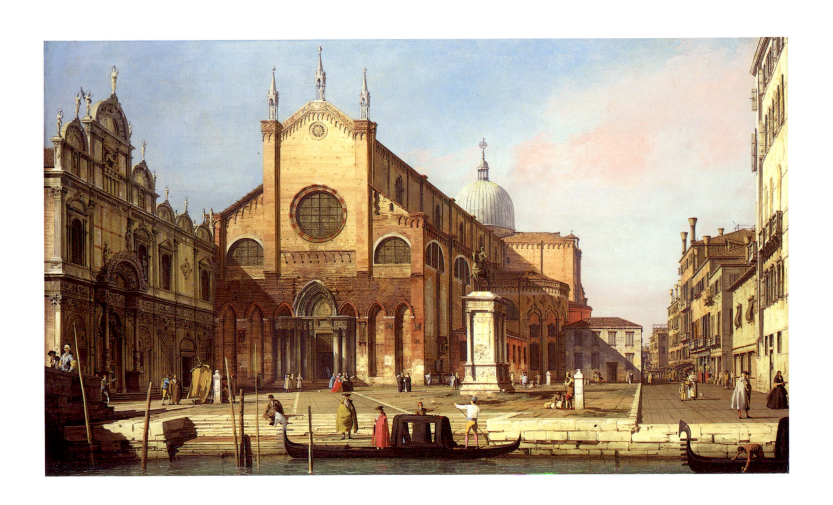

12
Giovanni Antonio Canal, called Canaletto 1697-1768
Rome: The Arch of Titus 1742

Oil on canvas
190.8 × 105.4 cm (75⅛ × 41½ in)
signed and dated: ANT. CANAL FECIT/ANNO
MDCCXLII

ML 368

ML 369-72

WC 386 & I, pp 29-32 & 122-26

CA 29

J G Links, *Canaletto*, Oxford 1982, pp 107 &
118-24

K Baetjer & J G Links, *Canaletto*, Metropolitan
Museum of Art, New York 1989, pp 210-11

F Haskell, *Patrons and Painters*, London 1963,
p 307

J Spence (ed S Klima) *Letters from the Grand
Tour*, Montreal & London 1975, pp 92-96

C Burney (ed H Edmund Poole), *Music, Men, and
Manners in France and Italy 1770*, London 1969,
pp 85-136

P P Bober & R Rubinstein, *Renaissance Artists &
Antique Sculpture*, London 1987, pp 210-12

J Addison, *Remarks on Several Parts of Italy, &c.*,
London 1753, p 210

The present work is one of five Roman views purchased from Consul Smith by George III in 1762. Originally in the Hall at Buckingham House, it was transferred to the Grand Corridor at Windsor in 1828. Two others from this group are included in the exhibition (cat nos 13 & 14). All date from 1742 and are the first of Canaletto's paintings to be signed and dated. Their tall, narrow format suggests that they were designed for a specific location, perhaps built into panelling or between windows.

It has been suggested that Smith commissioned them because the War of Austrian Succession (1740-48) had interrupted the passage to Venice of the visitors who were Canaletto's main customers. Canaletto painted few further Roman views, so if these works were a deliberate attempt to develop a new range of landscapes, they would appear to have failed to stimulate widespread interest. It may have been that the market for architectural views of Rome was too firmly in the hands of Giovanni Paolo Panini and his contemporaries for a Venetian artist to enter it successfully. Canaletto was in Rome in around 1720 but is not documented as having returned there later in life. For this reason, it is usually supposed that the 1742 cycle was painted from reference to drawings made two decades earlier and the sketches of Canaletto's nephew Bernardo Bellotto, who had recently visited Rome. It seems implausible that such large and impressive compositions, which represent a quite new direction in the painter's activity, depend solely on fading memories and a handful of drawings. Canaletto's new practice of signing and dating these landscapes on pieces of masonry in the foreground of the compositions reflects a method common in Panini's own Roman views. Similarly, the decision to sign his works argues against a dependence upon the drawings of Bellotto. The itineraries of Joseph Spence in 1732 and Charles Burney in 1770 indicate that the journey from Venice to Rome could be accomplished in ten days, so a sketching visit prior to the 1742 Roman views could have been completed in as little as a month.

The Arch of Titus stands at the south-eastern end of the Forum at the head of the Sacred Way. The oldest of the great Roman triumphal arches, it was erected in AD 81 to commemorate the capture of Jerusalem by the Emperor Titus. During the Middle Ages it was embedded within the fortifications of the Frangipane family, which remain visible in Canaletto's view and were not removed until the arch was restored in 1821. Through the archway is visible, to the left, the wall of the sixteenth-century Farnese Gardens with its gateway by Vignola which was demolished during the excavation of the Palatine Hill during the nineteenth century. At the end of this vista stand the columns of the Temple of Castor and Pollux (cat no 13) and the rising ground of the Capitoline Hill. On account of its relief sculptures of the trophies from the Temple of Jerusalem being carried off to Rome, the Arch of Titus was popular with visitors, and Canaletto has included a group of three gentlemen with their guide or 'cicerone' at the left of the composition. After Joseph Addison visited the arch at the beginning of the eighteenth century he wrote that he was 'much disappointed not to see the Figure of the Temple of *Jerusalem* on that of *Titus*, where are represented the Golden Candlestick, the Table of Shew-bread and the River *Jordan*. Some are of Opinion, that the composite Pillars of this Arch were made in imitation of the Pillars of *Solomon's* Temple, and observe that these are the most ancient of any that are found of that Order'.

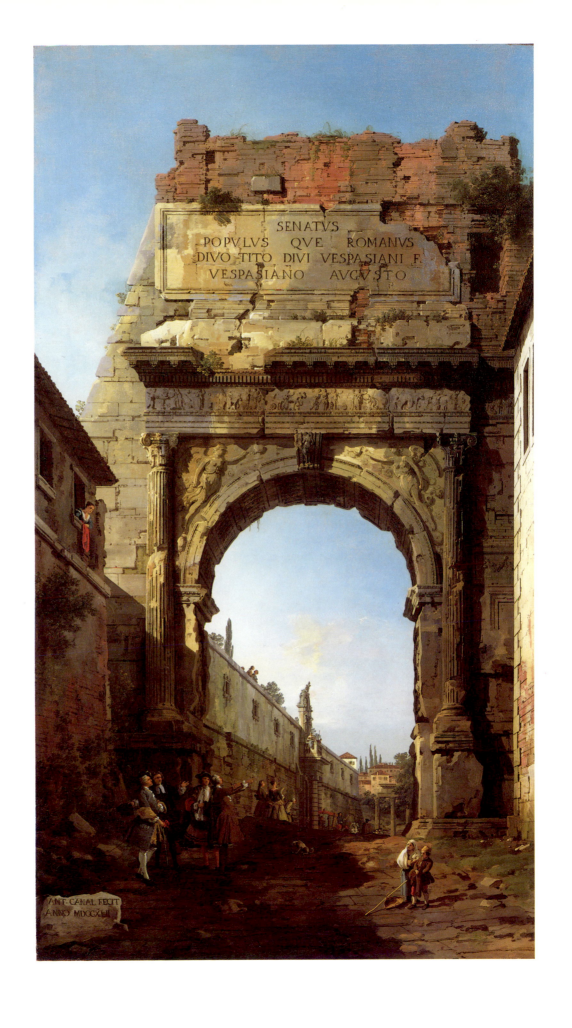

13

Giovanni Antonio Canal, called Canaletto 1697–1768
Rome: Ruins of the Forum looking towards the Capitol 1742

Oil on canvas
190.5 × 105.4 cm (75 × 41½ in)
signed and dated: ANT. CANAL FECIT/ANNO
MCCXLII
[the painter has omitted the D from the date]

ML 372

ML 368–371, 418

WC 378–379 & 713

CA 30

J G Links, *Canaletto*, Oxford 1982, pp 120–21

K Baetjer & J G Links, *Canaletto*, Metropolitan
Museum of Art, New York 1989, p 210

L H Heydenreich & W Lotz, *Architecture in Italy
1400 to 1600*, Harmondsworth 1974, pp 249–53

J Addison, *Remarks on Several Parts of Italy, &c.*,
London 1753, p 204

This is one of five Canaletto views of Rome painted in 1742, of which two others are included in the exhibition (cat nos 12 & 14). All were were purchased by George III in 1762. Originally in the Hall at Buckingham House, it was transferred to the Grand Corridor at Windsor in 1828.

A related, but wider angled horizontal view of the same scene appears in a drawing made, or copied from one drawn, by Canaletto during his visit to Rome in around 1720. This served as a design for several oil paintings, usually attributed to Bellotto or Canaletto's workshop. In the present work, the artist has shifted the angle of vision, lining up the two temples and the Palazzo Senatorio sharply in echelon, and has narrowed the composition so that the three columns of the Temple of Castor and Pollux echo the narrow, vertical format of the canvas. The viewpoint has also been lowered to near ground level, giving the impression that the lofty columns and the Capitoline Hill tower above the head of an observer, such as the gentlemen admiring the ruins in the foreground. Whereas the drawing of around 1720 and its derivatives depict an evenly balanced landscape, the present work is dramatic.

The Temple of Castor and Pollux is one of the oldest in the Forum, originally dedicated in 484 BC to the legendary brothers of Helen of Troy who brought the news of the victory of Lake Regillus to Rome, and rebuilt during the reign of Augustus. Behind it appears the colonnade of the Temple of Saturn, built in the third century AD on an earlier foundation. It was the state treasury and the centre of the ancient festival of Saturnalia. Joseph Addison evokes the immense impression which such columns surviving from Roman temples made upon eighteenth century visitors on the Grand Tour: 'Next to the Statues, there is nothing in *Rome* more surprising than that amazing Variety of ancient Pillars of so many kinds of Marble. As most of the old Statues may be well suppos'd to have been cheaper to their first Owners, than they are to a modern Purchaser, several of the Pillars are certainly rated at a much lower Price at present than they were of old. For, not to mention what a huge Column of *Granite*, *Serpentine*, or *Porphyry* must have cost in the Quarry, or in its Carriage from *Aegypt* to *Rome*, we may only consider the great Difficulty of hewing it into any Form, and of giving it the due Turn, Proportion and Polish. It is well known how these sorts of Marble resist the Impressions of such Instruments as are now in use … The Ancients had probably some Secret to harden the Edges of their Tools, without recurring to those extravagant Opinions of their having an Art to mollify the Stone, or that it was naturally softer at its first cutting from the Rock, or, what is still more absurd, that it was an artificial Composition, and not the natural Product of Mines and Quarries'.

In the background of the picture appears the rear façade of the medieval Palazzo Senatorio, the principal façade of which had been rebuilt during the sixteenth century by Michelangelo to provide the central element of the Piazza del Campidoglio. As the traditional seat of Roman government, it had powerful historical and imperial associations.

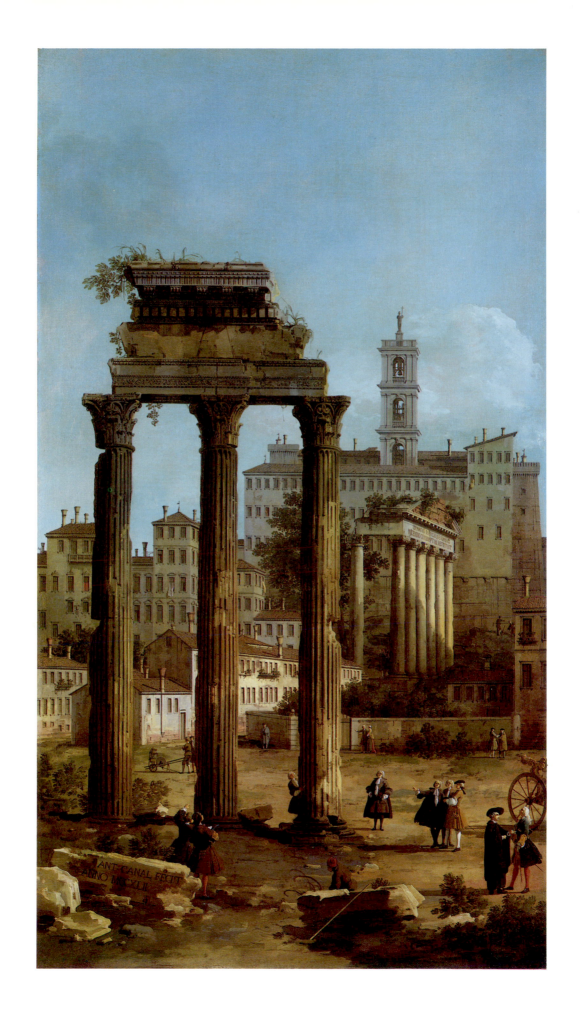

Giovanni Antonio Canal, called Canaletto 1697–1768
Rome: The Arch of Septimus Severus 1742

Oil on canvas
180.3 × 105.4 cm (71 × 41½ in)
signed and dated: ANT. CANAL FECIT/ANNO
MDCCXLII

ML 369

ML 368 & 370–72

WC 384–85 & 713

CA 31

J G Links, *Canaletto*, Oxford 1982, pp 22–23

K Baetjer & J G Links, *Canaletto*, Metropolitan
Museum of Art, New York 1989, pp 210–11

P P Bober & R Rubinstein, *Renaissance Artists &
Antique Sculpture*, London 1987, p 214

J Addison, *Remarks on Several Parts of Italy, &c.*,
London 1753, p 176

Of the five Roman views painted by Canaletto in 1742, this and two others are included in the exhibition (cat nos 12 & 13). All were purchased from Consul Smith by George III in 1762. Originally in the Hall at Buckingham House, it was transferred to the Grand Corridor at Windsor in 1828.

A related, but much wider angled horizontal view of the Arch of Septimus Severus appears in a drawing made, or copied from one drawn, by Canaletto during his visit to Rome in around 1720. This served as a design for an oil painting which he executed probably during the mid-1740s. The present work also reveals a degree of dependence upon the earlier drawing in the steps leading up to the Capitol, visible through the archway. A characteristic instance of Canaletto's manipulation of landscape motifs, these steps are based on those which lead up the opposite side of the Capitoline Hill to the Piazza del Campidoglio.

The Arch of Septimus Severus stands a few metres north of the portico of the Temple of Saturn (cat no 13), a short distance before the seventeenth-century church of Sante Martina e Luca by Pietro da Cortona, the façade of which is just visible at the right of the present work. Commemorating the Parthian campaigns of the Emperor Septimus Severus in AD 195–99 with a lengthy inscription and relief sculptures, the triumphal arch was erected in AD 203. It had a considerable influence upon artists and architects from the Renaissance until the eighteenth century (cat no 52), the raised ground level around it making study of its reliefs easier in Canaletto's time than at present.

Joseph Addison prefaced the chapter on Rome in his 'topographical poem' *Remarks on Several Parts of Italy*, first published in 1705, with the remarks: 'It is generally observ'd, that Modern *Rome* stands higher than the Ancient; some have computed it about fourteen or fifteen Feet, taking one Place with another. The Reason given for it is, that the present City stands upon the Ruins of the former; and indeed I have often observed, that where any considerable Pile of Building stood anciently, one still finds a rising Ground, or a little kind of Hill, which was doubtless made up out of the Fragments and Rubbish of the ruin'd Edifice. But besides this particular Cause, we may assign another that has very much contributed to the raising the Situation of several Parts of *Rome*: It being certain the great Quantities of Earth, that have been wash'd off from the Hills by the Violence of Showers have had no small share in it'. In this picture the higher ground level, which blocked most of the side gates to the arch and completely concealed the reliefs on the bases of its attached columns, is clearly apparent. Although trial excavations were carried out as early as 1563, these interrupted traffic in the vicinity and the arch was not unearthed until the nineteenth century.

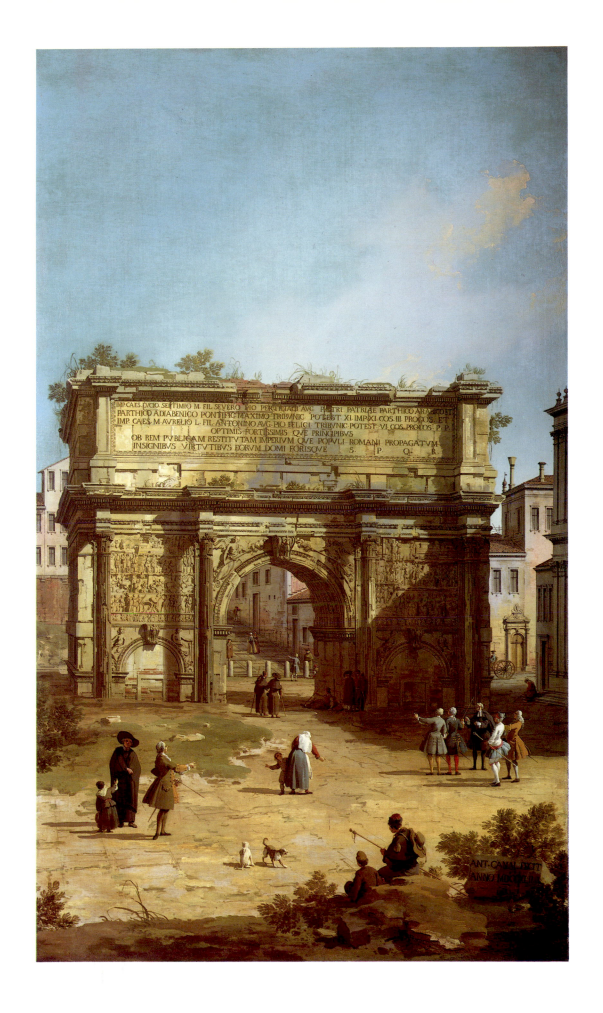

15

Giovanni Antonio Canal, called Canaletto 1697-1768
Venice: The Piazzetta looking towards the Torre dell'Orologio 1743

Oil on canvas
59.7 × 94.6 cm (23½ × 37¼ in)
signed and dated: *A. Canal Fecit XXIV Octobris MDCCXLIII*

ML 405

ML 403, 404 & 406

WC 68

CA 22

J G Links, *Canaletto*, Oxford 1982, p 127

D Succi, *Canaletto & Visentini Venezia & Londra*, Gorizia 1986, p 270

L H Heydenreich & W Lotz, *Architecture in Italy 1400 to 1600*, Harmondsworth 1974, pp 87 & 234-37

J W Goethe (trans W H Auden & E Meyer), *Italian Journey*, Harmondsworth 1970, pp 79-80 & 98-99.

A pendant to the following work; both were engraved by Visentini together with a further pair of Canaletto views of the Piazza San Marco (cat nos 17 & 18) from the collection of Joseph Smith. Like the earlier *Prospectus*, this set of engravings, of which the present work is plate I, constituted an advertisement to prospective patrons. Purchased by George III in 1762, this picture hung in the Gallery at Kew before transfer to Windsor in 1828.

The Piazzetta extends northwards from the waterfront of the Molo, between the Libreria Marciana and the Palazzo Ducale, as far as the Campanile, where it adjoins the Piazza San Marco which runs eastwards from the façade of the basilica of San Marco. This view is from a short distance offshore in the Bacino, looking north along the length of the Piazzetta. In the left foreground, somewhat to one side of its actual location, is the granite column surmounted with the lion of St Mark, patron saint of Venice, which was erected in the twelfth century. To its left stands the long façade of the Libreria Marciana, built between 1537 and 1588 to the plans of the Florentine architect Jacopo Sansovino to house the Library of St Mark's. The library made an immense impression, no less an authority than Andrea Palladio describing it as 'the richest and most ornate building since antiquity'. Beyond it is the medieval Campanile of the San Marco. In 1786 this was twice ascended by Goethe, who noted 'I could recognize both close and distant places without a telescope. The lagoons are covered at high tide, and when I turned my eyes in the direction of the Lido, a narrow strip of land which shuts in the lagoons, I saw the sea for the first time ... North and west, the hills of Padua and Vicenza and the Tirolean Alps made a beautiful frame to the whole picture'. At the end of the vista is the eastern end of the north front of the Piazza San Marco. This comprises the long arcade of the Procuratie Vecchie, built at the end of the fifteenth century as the residence of the Procurators in charge of the fabric of the basilica, which terminates with the Torre dell'Orologio, built to the designs of Mauro Codussi in 1496-99. As its name implies, the Torre is surmounted by an elaborate clock, which has mechanical figures of the Virgin and the Magi and a pair of bronze figures which strike the hours. Diagonally, in echelon before the Torre dell'Orologio are the south-east corners of the basilica of San Marco and the Palazzo Ducale.

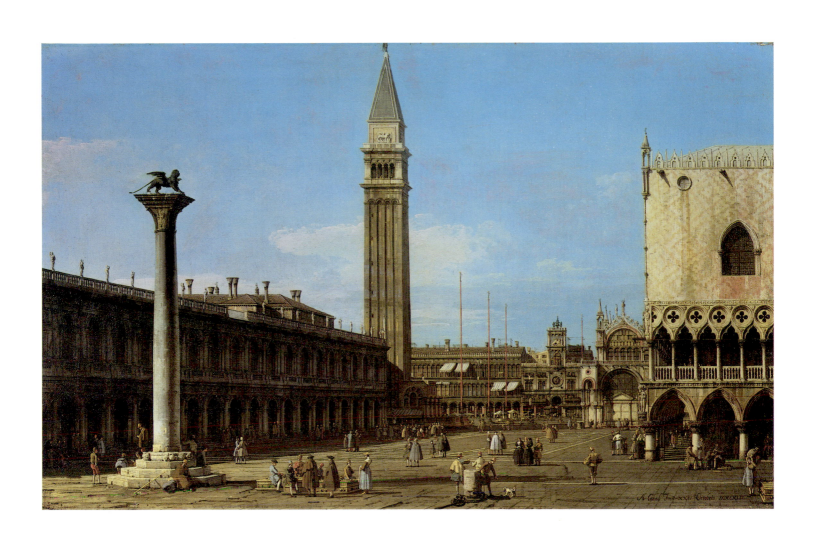

16

Giovanni Antonio Canal, called Canaletto 1697–1768
Venice: The Molo with the Prisons and the Palazzo Ducale 1743

Oil on canvas
60.3 × 95.6 cm (23¾ × 37⅝ in)
signed and dated: *A. Canal Fecit/ xxiv Octobris/ MDCCXLIII*

ML 406

ML 403-05

WC 85

CA 23

J G Links. *Canaletto*, Oxford 1982, pp 125-27

D Succi, *Canaletto & Visentini Venezia & Londra*, Gorizia 1986, p 271

L H Heydenreich & W Lotz, *Architecture in Italy 1400 to 1600*, Harmondsworth 1974, pp 92-94, 237-38 & 316

J J Norwich, *Venice The Greatness and the Fall*, London 1981, pp 26-27

J Addison, *Remarks on Several Parts of Italy, &c*, London 1753, pp 63-64

Like its pendant, the previous picture, this is one of four paintings from the collection of Consul Smith engraved by Visentini in around 1744. The present work was reproduced as plate II in this set. Purchased by George III in 1762, it hung in the Gallery at Kew before being transferred to the Grand Corridor at Windsor in 1828.

Unlike many of Canaletto's townscapes, in which the field of vision is artificially widened or motifs rearranged to provide a more balanced composition, this view from a boat a short distance from the Riva degli Schiavoni looking north-west along the Molo is, more or less, topographically accurate. Widely disseminated by Visentini's engraving, this view has been frequently repeated from Canaletto's own day to the postcard photographers of the twentieth century. At the extreme left are the public granaries, demolished and replaced by gardens at the beginning of the nineteenth century. The three-storey building between them and the Libreria Marciana is the Zecca, the mint and treasury of the Republic, built by Jacopo Sansovino in 1537-47. Its massive, rusticated stonework is in keeping with the fortress-like nature of the building. Before the east façade of the Libreria are the two columns brought to Venice from the Levant in the twelfth century. One is surmounted by a statue of the original patron of Venice, St Theodore, and the other by the lion symbolic of his successor St Mark, who became patron saint after his body was stolen from Alexandria by Venetian merchants in 828-29.

The centre right of the composition is filled by the Palazzo Ducale, built between the mid-fourteenth and early fifteenth centuries. The Palazzo was the residence of the Doge and the seat of government. Venice had an electorate of 1,500-2,000 nobles with votes in the Great Council. This body elected the Doge for life, who was assisted by a Senate of 160 members, a Council of Ten and an inner cabinet of six, the Signoria. On account of its longevity, effectiveness and unscrupulousness, Venetian government was regarded with awe by outsiders. Towards the end of its existence, an observer as mindful of the problems confronting the Republic as Joseph Addison (cat no 5) wrote: 'it is certain the *Venetian* Senate is one of the wisest Councils in the World, tho' at the same time, … a great part of their Politics is founded on Maxims, which others do not think consistent with their Honour to put in practice. The Preservation of the Republic is that to which all other Considerations submit. To encourage Idleness and Luxury in the Nobility, to cherish Ignorance and Licentiousness in the Clergy, to keep alive a continual Faction in the Common People, to connive at the Viciousness and Debauchery of Convents, to breed Dissensions among the Nobles of the *Terra Firma*, to treat a brave Man with Scorn and Infamy, in short, to stick at nothing for the Public Interest, are represented as the refined Parts of the *Venetian* Wisdom. Among all the Instances of their Politics, there is none more admirable than the great Secrecy that reigns in their public Councils, The Senate is generally as numerous as our House of Commons, if we only reckon the sitting Members, and yet carries its Resolution so privately, that they are seldom known 'till they discover themselves in the Execution'. Immediately to the right of the Palazzo Ducale, to which it is linked by the infamous passage known as the 'Bridge of Sighs', is the gloomy, rusticated façade of the Prisons, built in 1560-1614.

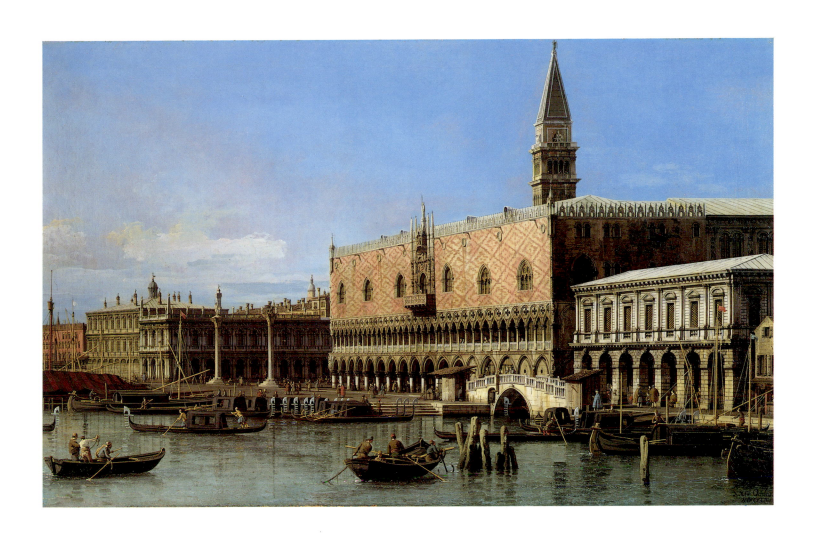

17

Giovanni Antonio Canal, called Canaletto 1697–1768
Venice: The Piazza from the Piazzetta with the Campanile and the south side of the Basilica di San Marco 1744

Oil on canvas
78.4 × 121.3 cm (30⅞ × 47¾ in)
signed and dated: *Ant. Canal Fecit* MDCCXLIV

ML 403

ML 404-06

WC 37

CA 24

J G Links, *Canaletto*, Oxford 1982, pp 127–29

D Succi, *Canaletto & Visentini Venezia e Londra*, Gorizia 1986, pp 141–46, 273 & 346–49

L H Heydenreich & W Lotz, *Architecture in Italy 1400 to 1600*, Harmondsworth 1974, p 237

J Spence (ed S Klima), *Letters from the Grand Tour*, Montreal & London 1975, p 89

C Burney (ed E Edmund Poole), *Music, Men, and Manners in France and Italy 1770*, London 1969, p 73

Although considerably larger than the previous pair of views, this painting and its pendant (cat no 18) were engraved with them by Visentini as a set of four. This work was reproduced as plate IV. No reference to the post of Consul, which Smith received in June 1744, appears on the prints, indicating that they were published early in that year. Purchased by George III in 1762, this picture was hung in the Hall at Buckingham House before transfer to the Grand Corridor at Windsor in 1828.

This viewpoint looks south-west from a high point on the Piazzetta façade of the Palazzo Ducale. Once again, the location of buildings has been subtly adjusted to show part of the far end of the Piazza San Marco and the south façade of the basilica of San Marco. In the Piazzetta several groups of people are watching open air performances by mountebanks. At the left is the arcade of the Libreria Marciana, beyond which is the Piazza lined by the arcade of the Procuratie Vecchie. This vista is partly blocked by the Campanile, at the base of which is the Loggetta. Designed by Jacopo Sansovino and begun in 1537, it was used as a hall for meetings and, subsequently, as a guard house.

In the right foreground is the south façade of the San Marco. Founded in 832 to house the body of St Mark which had recently been brought to Venice, it was rebuilt in the eleventh century. Throughout the Republic it was the chapel of the Doge, only becoming the cathedral of the city in 1807. Already richly decorated with mosaics and marble facing, after the conquest of Constantinople in 1204 the basilica became a treasure house of Christian relics, classical sculptures and fragments and Byzantine metalwork. The Gothic pinnacles and statues on the upper façade were added at the turn of the fourteenth and fifteenth centuries. During the early eighteenth century a new, antiquarian interest in the basilica is manifest in Visentini's accurate elevations, plan and perspectives, which were published in 1726 and reissued in 1761 with a 64-page description. Although firmly on the tourist itinerary, eighteenth-century visitors to Venice were more likely to enjoy the music at the San Marco than its architecture. In 1732 Joseph Spence wrote of it: 'Of all the celebrated buildings one of the most ugly is the *Church of St Mark.* 'Twas built by the Greeks in the Greek manner. The top of it is heaped with domes and the inside is dark and ill-contrived'. In 1770 Charles Burney found the basilica lacking in decorum: 'The church of St Marc is too full of fine things – it seems loaded with ornaments – which tho' inestimable in their intrinsick worth, yet by being jumbled together have less effect than half the number would have if well placed'. Only in the following century, in the watercolours of Turner and *The Stones of Venice* by Ruskin, was Venice's medieval heritage rediscovered.

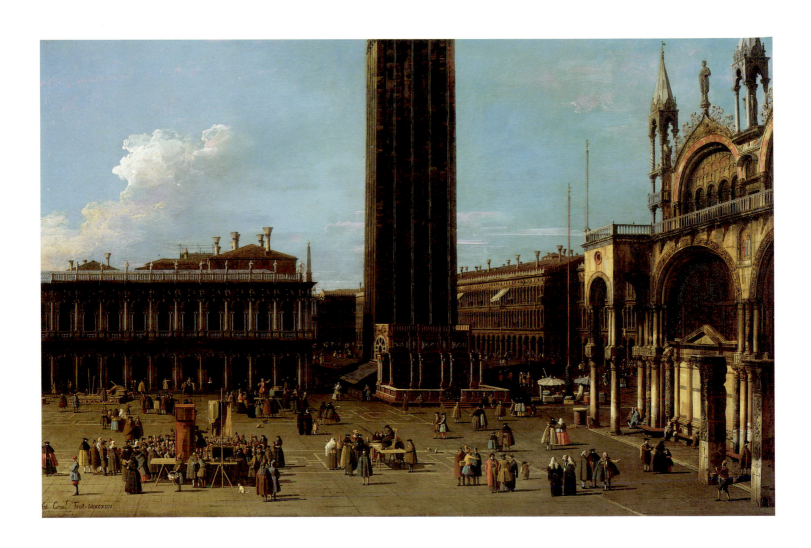

Giovanni Antonio Canal, called Canaletto 1697-1768
Venice: The Piazza and Piazzetta from the Torre dell'Orologio towards S Giorgio 1744

Oil on canvas
77.2 × 120.7 cm (30⅜ × 47½ in)
signed and dated: *Ant. Canal Fecit. MDCCXLIV*

ML 404

ML 403, 405, 406, 671 & 672

WC 48

CA 25

J G Links, *Canaletto*, Oxford 1982, pp 129-30

D Succi, *Canaletto & Visentini Venezia & Londra*, Gorizia 1986, p 272

L Heydenreich & W Lotz, *Architecture in Italy 1400 to 1600*, Harmondsworth 1974, pp 306-08 & 318

F Haskell & N Penny, *Taste and the Antique*, New Haven & London 1988, pp 236-40

F Vivian, *The Consul Smith Collection*, Munich 1989, p 22

C Burney (ed H Edmund Poole), *Music, Men, and Manners in France and Italy 1770*, London 1969, p 75

J W Goethe (trans W H Auden & E Meyer), *Italian Journey*, Harmondsworth 1970, pp 94 & 96

Like its pendant, the previous work, this painting was engraved by Visentini with two other townscapes in Consul Smith's collection as a set, in which the present picture was plate III. Purchased by George III in 1762, it hung in the Gallery at Kew Palace until its transfer to the Grand Corridor at Windsor in 1828.

This viewpoint looks south along the length of the Piazzetta from the Torre dell'Orologio and may be based upon an earlier composition by Gaspar van Wittel. At the extreme right, beyond the Campanile and Loggetta, is the east end of the Procuratie Nuove, begun by Vincenzo Scamozzi in 1583 and finished by Baldassare Longhena in about 1640, which adjoins Sansovino's Libreria Marciana and faces the Procuratie Vecchie on the other side of the Piazza San Marco. In the left foreground is the west front of the basilica of San Marco with above its main portal the four Antique bronze horses brought from Constantinople after the Fourth Crusade. They could be closely examined from the loggia off the organ gallery of the basilica. Goethe did so in 1786, noting: 'We are told that once they were gilded, and at close quarters one sees that they are scored all over, because the barbarians could not be bothered to file away the gold but hacked it off with chisels. Still, it might have been worse; at least their forms have been preserved'. In 1797 the horses were carried off to Paris, being returned to Venice after the fall of Napoleon. Beyond the basilica are the Piazzetta façade of the Palazzo Ducale and the columns of St Mark and St Theodore on the Molo.

On the vista, at the other side of the Bacino di San Marco, is the monastic church of San Giorgo Maggiore, begun by Palladio in 1566. For northern and, especially, British visitors to Venice during the eighteenth century Palladio was the definitive Renaissance architect. Consul Smith commissioned views of his major buildings and British Palladian monuments (cat nos 51 & 52). Through the Pasquali press, he also published the facsimile edition of Palladio's *Quattro Libri di Architettura* which Goethe found so useful during his own visit (cat no 8). In 1770 Charles Burney thought San Giorgio 'the most perfect building in Venice. There is such a noble elegance and simplicity in this structure that it inclines one to prostrate one's self upon entering it, as it has the true appearance of a temple to the Supreme Being; ... At the front of this church, placed on an island facing the Gran piazza di S. Marco I could not help stepping back 17 or 1800 years in history and supposing myself in view of some ancient Greek city – the number of public buildings had so beautiful an appearance across the water, which was smooth as glass – the sun just setting and there was a sky as we never see in England except in the landscapes of Claude Lorraine'. In 1786 Goethe took this pictorial analogy a step further: 'Since our eyes are educated from childhood on by the objects we see around us, a Venetian painter is bound to see the world as a brighter and gayer place than most people see it. We northerners ... cannot instinctively develop an eye which looks with such delight at the world. As I glided over the lagoons in the brilliant sunshine and saw the gondoliers in their colourful costume, gracefully posed against the blue sky as they rowed with easy strokes across the light green surface of the water, I felt I was looking at the latest and best painting of the Venetian school'.

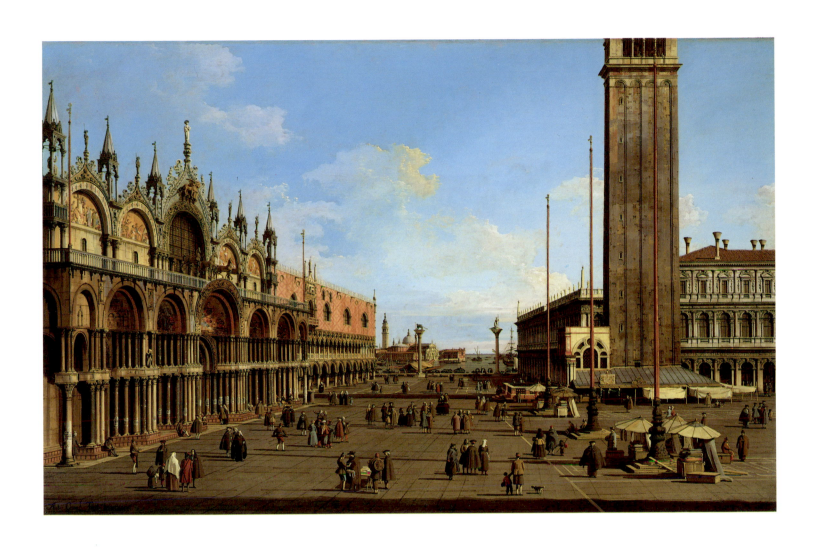

19

Giovanni Antonio Canal, called Canaletto 1697-1768
The Thames and the City of London from the Terrace of Old Somerset House

Oil on canvas
106.7 × 187 cm (42 × 73⅝ in)

ML 374

ML 375 & 674

WC 424-26, 428-29, 745-46 & I, p 143

CA 38-39 & 86-87

J G Links, *Canaletto*, Oxford 1982, pp 148-54 & 163-66

K Baetjer & J G Links, *Canaletto*, Metropolitan Museum of Art, New York 1989, pp 233-36

F Vivian, *The Consul Smith Collection*, Munich 1989, pp 148-51

The Princes Gate Collection, Courtauld Institute Galleries, London 1981, pp 91-92

J Summerson, *Architecture in Britain 1530 to 1830*, Harmondsworth 1970, pp 193, 216-19, 224-34 & 255

J Summerson, *Georgian London*, Harmondsworth 1962, p 124

M Warner (ed), *The Image of London*, Barbican Art Gallery, London 1987, pp 29-41 & 126-27

R Hyde, *Gilded Scenes and Shining Prospects*, Yale Centre for British Art, New Haven 1985, pp 44-45, 50-51, 64-65 & 120-121

Canaletto arrived in London in 1746 with a letter from Consul Smith to the impresario Owen McSwinny, who had himself commissioned work from the young artist while in Venice during the 1720s (cat no 3 & 42). McSwinny introduced Canaletto to the Duke of Richmond, from the terrace of whose London house he painted a view of the Thames looking towards the City. He also painted a pair of views of the river, looking towards the City and towards Westminster from different locations on the south bank for the Bohemian visitor Prince Lobkowicz. Canaletto remained for most of the next nine years in London. This picture is usually dated to around 1750 and was either painted in London or worked up from drawings during a brief return to Venice in 1750-51. Like the following painting, it is one of a pair painted for Consul Smith and purchased by George III in 1762. Originally in the Gallery at Kew Palace, they were transferred to the Grand Corridor at Windsor in 1828.

These oils are closely related to the pair of ink and wash drawings, which also belonged to Consul Smith and are now in the Royal Collection. It has been pointed out that the drawing for the present work is inferior to a larger one of the same composition in the Courtauld Institute Collection, which suggests that the drawings from Smith's collection may be autograph replicas. Old Somerset House on the north bank of the Thames was a highly distinguished building. Its New Gallery facing the river had been built in 1661-62 for Henrietta Maria, the Queen Mother. Perhaps designed by Inigo Jones, it was one of the English Palladian buildings included in the series painted by Visentini and Zuccarelli for Consul Smith in 1746 and now also in the Royal Collection (cat nos 51 & 52). Subsequently the home of the Royal Academy (cat no 59), it was demolished and rebuilt during the 1770s by Sir William Chambers. Part of it is now occupied by the Courtauld Institute of Art. The skyline is dominated by St Paul's cathedral, completed in 1709. In both of Canaletto's drawings, its dome is viewed in profile, but in the present work its viewpoint has been lowered to make the building seem loftier in relation to its surroundings. Beyond it stretches a horizon dominated by the steeples of the City churches, largely built by Wren following the Great Fire of 1666. At the right is visible the Monument to the Fire, erected in 1671-77, Old London Bridge with its houses which were demolished in 1757, and part of the south bank.

This pair of landscapes must be considered with reference not only to Canaletto's Venetian scenes, but also to the long tradition of topographical views of London dating back to the beginning of the previous century. Earlier engraved prospects of London were usually printed on several sheets to include the whole riverside from Westminster to the Tower. However, C J Visscher in around 1600, Wenceslaus Hollar in 1647, David Mortier in around 1710 and Samuel and Nathaniel Buck in 1749 all depicted London stretched out in a line from a bird's eye view over the south bank. Canaletto adopted a high viewpoint from the south for his paintings for Prince Lobkowicz in 1746, but employed a lower one from a window of Richmond House on the north bank the following year. The latter concept is further developed here, where the viewpoint is brought down almost to ground level and the bold curve of the Thames in either direction from Somerset House becomes the dominant feature of each composition. The old convention has been supplanted by seemingly natural views which nevertheless include most of the principal sights of the waterfront.

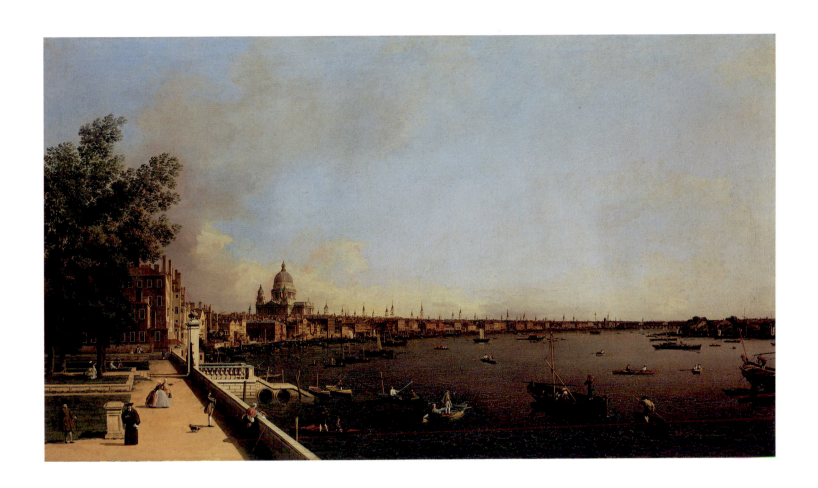

Giovanni Antonio Canal, called Canaletto 1697-1768
The Thames and the City of Westminster from the Terrace of Old Somerset House

Oil on canvas
107.3 × 187.6 cm ($42\frac{1}{4}$ × $73\frac{7}{8}$ in)

ML 375

ML 374, 669 & 674

WC 424-26, 428-29, 745-46 & I, pp 38 & 143

CA 38-39 & 86-87

J G Links, *Canaletto*, Oxford 1982, pp 145-54 & 163-66

K Baetjer & J G Links, *Canaletto*, Metropolitan Museum of Art, New York 1989, pp 223 & 236-38

F Vivian, *The Consul Smith Collection*, Munich 1989, pp 11-12 & 148-53

J Summerson, *Architecture in Britain 1530 to 1830*, Harmondsworth 1970, pp 120-25, 216-19, 234-36. 306, 360 & 395

J Summerson, *Georgian London*, Harmondsworth 1962, pp 82 & & 114-16

M Warner (ed), *The Image of London*, Barbican Art Gallery, London 1987, pp 29-41 & 126-27

N Pevsner, *London*, vol 1, Harmondsworth 1973, pp 53 & 532

Like the previous painting, this work was either painted in London during Canaletto's long stay from 1746 or executed from drawings during his brief return to Venice in 1750-51. It and its pair belonged to Consul Smith and were purchased with the rest of his collection by George III in 1762. Originally in the Gallery at Kew Palace, they were transferred to the Grand Corridor at Windsor in 1828. Both are very closely related to a pair of drawings in the Royal Collection which may have been among those mentioned by P A Orlandi in his *Abecedario Pittorico*, of 1753, which states that Canaletto returned home in 1750 'bringing with him various sketches of views and of the most important sights of that spacious city which, it is to be hoped, he will at his leisure transfer to canvas'.

Like its pendant, the present work depicts the view along the waterside from the terrace of Old Somerset House, but in the direction of Westminster. The wooden tower immediately beyond the terrace is that of the York Buildings Waterworks built after 1675 and demolished in 1829. Connected with reservoirs at Marylebone, the company supplied houses in the surrounding area with water. Further down is visible the roof of Inigo Jones's Banqueting House of 1619-22, another of the English Palladian buildings included in the series painted by Visentini and Zuccarelli for Smith in 1746 and now also in the Royal Collection (cat nos 51 & 52). The skyline is dominated by Westminster Abbey with its 'Gothick' towers begun by Nicholas Hawksmoor in 1735, to the left of which are Westminster Hall and the four towers of Thomas Archer's church of St John, Smith Square, built in 1714-28. Westminster Bridge, which closes the vista down the river, was built in 1739-48 by the Swiss architect Charles Labelye. This was the first bridge to be built across the Thames since Old London Bridge, over 500 years earlier, and cost the immense sum of £393,189. One of the great civil engineering projects of its day, Canaletto painted various views of it at different stages of completion.

Most of the principal landmarks in this view of Westminster had been built during the eighteenth century. The same is true of Canaletto's painting of the City of London (cat no 19). The dome, west front and towers of St Paul's were all built between 1698 and 1709 and many of the steeples of the City churches were added in the early eighteenth century. Born in around 1674, Joseph Smith went out to Venice in about 1700 as a junior partner to the merchant banker Thomas Williams. He does not seem ever to have visited Britain after his departure for Italy, where he died in 1770. Accordingly, Canaletto's views of the Thames presented a prospect of a city which had been transformed almost beyond recognition since Smith had last seen it.

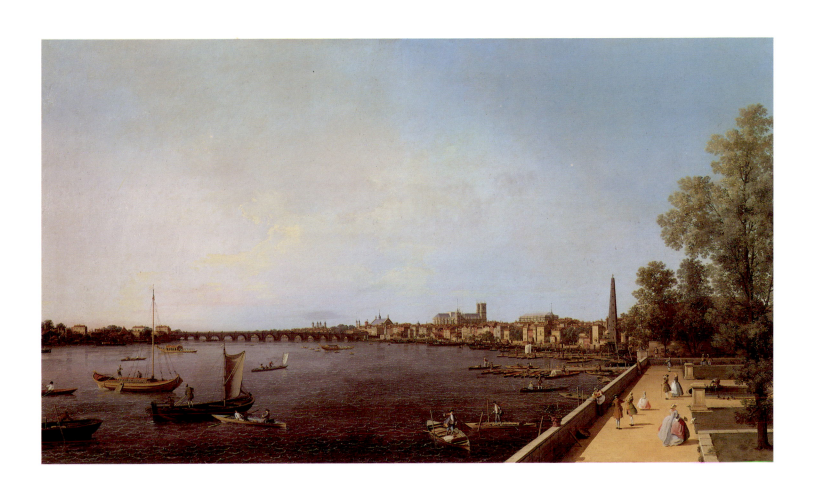

Thomas Gainsborough 1727-88
Richard Hurd, Bishop of Worcester

Oil on canvas
75.9 × 62.9 cm (29$\frac{7}{8}$ × 24$\frac{3}{4}$ in)

OM 801

OM 774, 775, 802 & pp 127-28

DNB X, pp 314-16

E K Waterhouse, *Gainsborough*, London 1958,
pp 19 & 75

J Brooke, *King George III*, London 1972,
pp 242-43

C Hibbert, *George IV*, Harmondsworth 1976,
pp 25-27

Born in Suffolk, Gainsborough trained in London before moving to Bath in 1759. There he became a highly fashionable portrait painter. A founder-member of the Royal Academy in 1768, he moved to London in 1774. This is one of two Gainsborough likenesses of Richard Hurd in the Royal Collection. The other is the same size and portrays the sitter in the same ecclesiastical dress, but facing to the right and with a hand across his chest. A number of versions of the present painting were commissioned by the Bishop. This, the original version, was exhibited at the Royal Academy in 1781, together with Gainsborough's full lengths of George III and Queen Charlotte. Painted for the Queen, it hung in her bedroom at Buckingham House together with Opie's portrait of another royal favourite, Mrs Delany, famous for her paper mosaics of flowers.

Educated at Emmanuel College, Cambridge, Richard Hurd (1720-1808) published numerous pamphlets and sermons, as well as editions of Horace and the complete works of his patron, William Warburton. He is best known for his *Letters on Chivalry and Romance* of 1762 which analyses the differences between medieval writing and the classical models admired in his own day. For this reason he ranks beside Horace Walpole as a forerunner of Romanticism. Hurd became Archdeacon of Gloucester in 1767 and was nominated Bishop of Lichfield and Coventry in 1774 on the recommendation of Lord Mansfield, the author of the Royal Marriage Act (cat nos 25 & 39).

As a bishop he soon attracted royal favour and in 1776 was appointed Preceptor to the Prince of Wales and Prince Frederick (cat no 56), in charge of their education. This included religion, morals, mathematics, history, a few English authors, music, fencing, drawing and the elements of agriculture, in addition to the classics. He apparently found the Prince of Wales 'an extremely promising pupil'. In 1781 Hurd was appointed Bishop of Worcester, but two years later he declined the King's offer of the Archbishopric of Canterbury 'as a charge not suited to his temper and talents'. He assisted in drawing up the programme for the ultimately abortive cycle of monumental paintings illustrating revealed religion commissioned by George III from Benjamin West. In 1788 the Royal Family visited him at Worcester. According to Walpole, Hurd was 'a gentle, plausible man, affecting a singular decorum that endeared him highly to devout old ladies'.

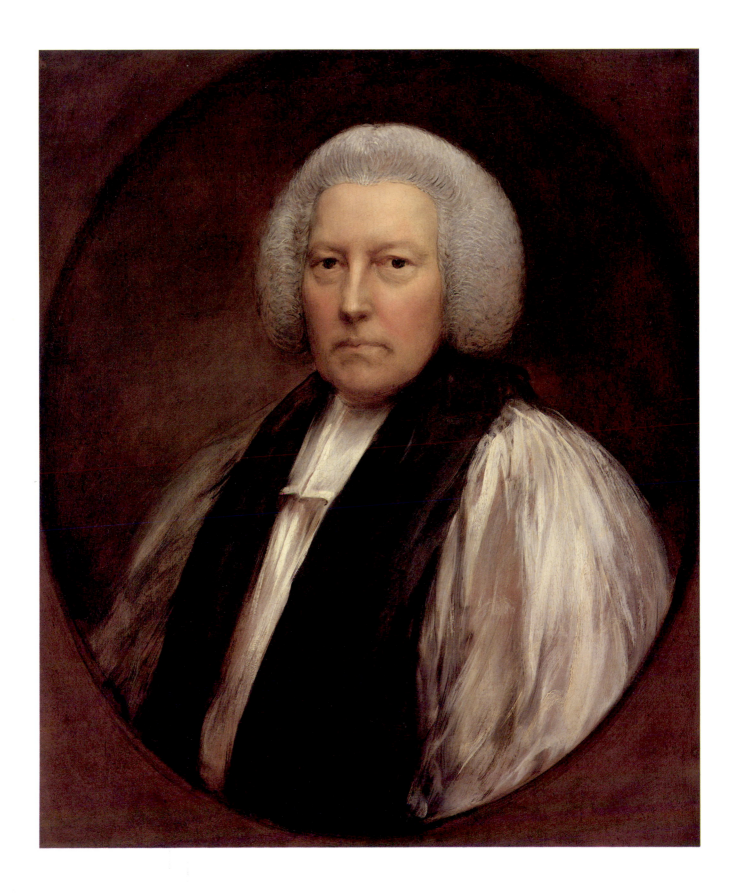

Thomas Gainsborough 1727–88
Charles, second Earl and first Marquess Cornwallis

Oil on canvas
76.2 × 63.5 cm (30 × 25 in)

OM 799

DNB IV, pp 1159–66

E K Waterhouse, *Gainsborough*, London 1958,
p 61

This picture was painted for the Prince of Wales for 30 guineas, Gainsborough's normal price for a small portrait of a head. It is probably contemporary with a similar portrait of the same sitter, painted for the Marquess of Hastings, which was exhibited in the Royal Academy in 1783 and is now at the National Portrait Gallery. Both must post-date Cornwallis's return to England in January 1782. The present work was at Carlton House by 1819 and was moved to Windsor in 1829.

It depicts the sitter in the uniform of a Lieutenant-General. Eldest son of the 1st Earl Cornwallis, Charles Cornwallis (1738–1805) was educated at Eton and was commissioned as an ensign in the Grenadier Guards in 1756. As aide-de-camp to the Marquess of Granby he was present at the Battle of Minden and commanded the 12th Foot during the Seven Years War. Elected MP for the family borough of Eye in 1760, he succeeded his father as 2nd Earl in 1762. A Whig, he opposed the resolution asserting the right of taxation in America. In 1765–66 he was aide-de-camp to the King. Sent to America in 1776, he served with distinction but was unable to avoid the capitulation at Yorktown in 1781 which brought the War of American Independence to an end.

Cornwallis was not blamed for the defeat, as is evident from the popularity of his portrait shortly after and from the offer by Pitt (cat no 31) in 1782 of the posts of Governor-General of Bengal and commander-in-chief in India, which he took up in 1786. In India he sought to reform the army and the civil service and won the third Mysore war against Tippu Sahib, for which victory he was made Marquess Cornwallis in 1792. In 1798 Cornwallis was dispatched to Ireland as Lord Lieutenant and commander-in-chief, where he suppressed the Irish rebellion and implemented the Act of Union. After the government's proposals for Catholic emancipation were rejected, he and Pitt resigned in 1801. The following year he negotiated the treaty of Amiens with Napoleon. When Marquess Wellesley (cat no 32) was recalled in 1805, Cornwallis returned to India as Governor-General and commander-in-chief. He died shortly after on a diplomatic mission up the Ganges. Cornwallis was praised to the Prince of Wales as 'an officer so distinguished for his abilities & so universally ador'd by the Army'. However, by 1789 Cornwallis was so disillusioned with the Prince's conduct as to 'lament that I ever was acquainted with him'.

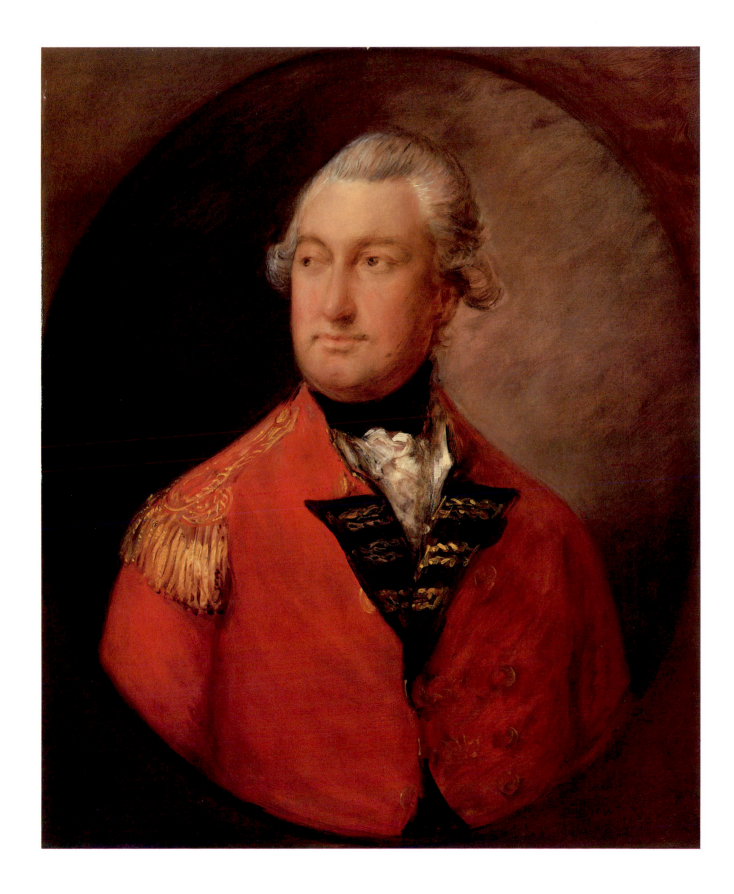

23
Thomas Gainsborough 1727-88
Mrs Mary Robinson

Oil on canvas
76.2 × 63.5 cm (30 × 25 in)

OM 804

DNB XVII, pp 30-33

E K Waterhouse, *Gainsborough*, London 1958,
pp 19 & 87

J Ingamells, *The Wallace Collection Catalogue of
Pictures*, vol I, London 1985, pp 93-97

J Brooke, *King George III*, Harmondsworth 1972,
pp 244-45

C Hibbert, *George IV*, London 1976, pp 34-39

Watteau 1684-1721, Schloss Charlottenburg,
Berlin 1985, pp 304-306

J Ingamells, *Mrs Robinson and her Portraits*,
London 1978, pp 4-31

Together with the other members of the Royal Family, the Prince of Wales was an enthusiastic patron of Gainsborough and at the time of the artist's death owed him £1,246 10s 6d. During the early 1780s Gainsborough charged 100 guineas for a large full-length portrait. This is a study for the life-size painting commissioned by the Prince for the sitter in 1781 and now in the Wallace Collection. The large version was submitted to the Royal Academy in 1782, but withdrawn by the artist after adverse comparisons between his portrait and others of the same sitter by Reynolds and Romney. It was later purchased by the Prince of Wales who presented it to the Marquess of Hertford in 1818. The present picture, described as a 'small whole length of Mrs Robinson' was among the unfinished works included in the artist's nephew's sale in 1797 when it was purchased for the Prince. By 1816 it was at Carlton House.

It has been pointed out that the composition recalls an engraving after *The Dreamer* by Jean-Antoine Watteau and probably alludes to the sitter's most celebrated stage role, Perdita in *The Winter's Tale*, a king's daughter brought up as a shepherdess. She holds a portrait miniature, presumably that given to her by the Prince of Wales in 1780. Mary Darby (1758-1800) married the clerk Thomas Robinson in 1774 and made her stage début as Juliet at Drury Lane in 1776. She was an immediate success, playing numerous leading roles before leaving the stage in 1780. In December 1779 she appeared in a royal command performance of Garrick's adaptation of *The Winter's Tale*. Mrs Robinson subsequently became the Prince of Wales's mistress on the promise of £20,000. The affair ended in 1781. George III paid £5,000 to retrieve his son's love letters and the Prince granted her an annual pension of £500. She subsequently became the mistress of Colonel Sir Banastre Tarleton, the famous light cavalry officer and MP for Liverpool. Following a miscarriage in 1783 she was paralysed from the waist down and turned to writing. Her numerous publications include volumes of poems, novels, a *Monody to the Memory of Sir Joshua Reynolds*, her correspondence with the Prince of Wales under the title *Effusions of Love, Thoughts on the Condition of Women* and a *Letter to the Women of England on the Injustice of Mental Subordination*. She also wrote the farce *Nobody*, a satire on female gamblers, performed at Drury Lane in 1794. During her later years the Prince of Wales subscribed to her poems and visited her regularly. On her deathbed she is reported to have sent him a lock of hair as 'a mark of her regard'.

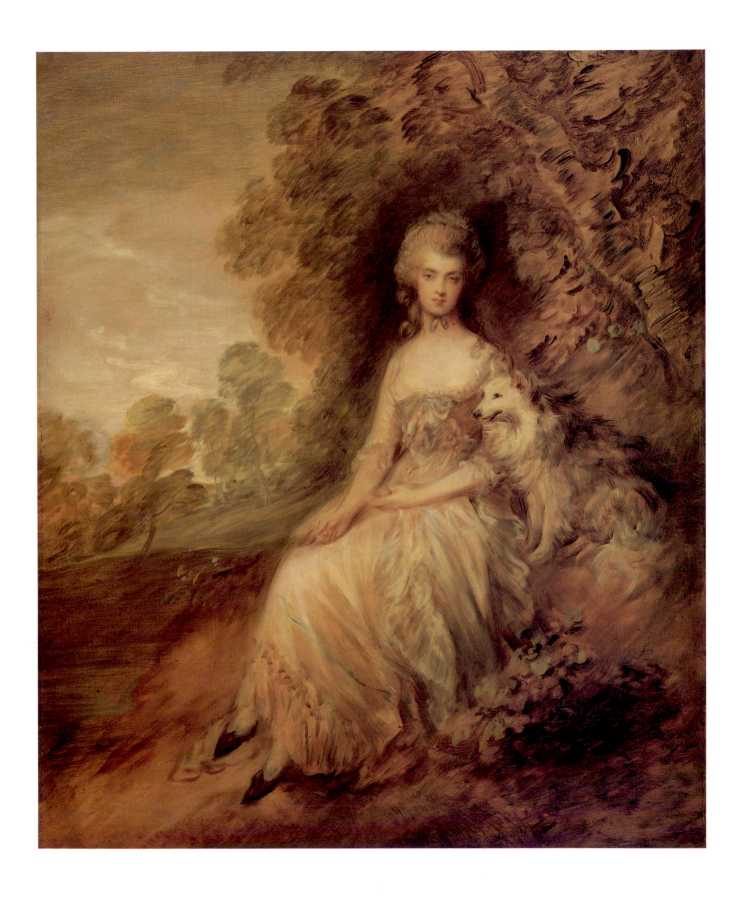

24

Thomas Gainsborough 1727-88
The three eldest daughters of George III and Queen Charlotte

Oil on canvas
129.5 × 179.7 cm (51 × 70¾ in)

OM 798

OM 782, 784 & 785

E K Waterhouse, *Gainsborough*, London 1958, pp 27 & 59

J Hayes, *Thomas Gainsborough*, Tate Gallery, London 1980, pp 35-36

J Brooke, *King George III*, London 1972, pp 361-63

C Hibbert, *George IV*, Harmondsworth 1976, pp 337-43 & 510-16

R Walker, *Regency Portraits*, National Portrait Gallery, London 1985, vol 1, pp 105-07

Originally a full-length portrait, subsequently cut down, this painting was completed early in 1784 and dispatched to Buckingham House for a private viewing by the three sitters before being submitted to the Royal Academy. It was commissioned by their brother, the Prince of Wales, for a fee of 300 guineas, three times the artist's standard price for a single full-length. A special setting was built for it at Carlton House. Still there in 1816 it subsequently alternated between Windsor and Buckingham Palace. Early in the reign of Queen Victoria, to the disgust of Sir Edwin Landseer, the portrait was severely cut at the bottom and trimmed at the top by the Inspector of Household Deliveries at Windsor Castle, so that it could be fitted into an overdoor. An early print records it original appearance.

Charlotte, Princess Royal (1766-1828) stands between her sisters Princess Augusta (1768-1840) on the left and Princess Elizabeth (1770-1840), seated on the right. All had previously sat to Gainsborough for the series of bust portraits of the Royal Family painted at Windsor during the autumn of 1782. The Princess Royal married the Duke of Württemberg in 1797 and subsequently lived in Germany, becoming a queen in 1806 when the duchy was elevated to a kingdom. In 1818 Princess Elizabeth married the Landgrave of Hesse-Homburg and also subsequently lived in Germany.

At the Royal Academy in 1784 the portrait was the cause of a disagreement between Gainsborough and the Hanging Committee, which had established a height from the floor of nine feet for full-length portraits. The painter insisted that 'he has painted this Picture of the Princesses in so tender a light, that notwithstanding he approves very much of the established Line for Strong Effects, he cannot possibly consent to have it placed higher than five feet & a half, because the likenesses & Work of the Picture will not be seen any higher; therefore at a Word, he will not trouble the Gentlemen against their Inclination, but will beg the rest of his Pictures back again'. Gainsborough never showed at the Royal Academy again and the present work was well received later the same year when he included it in the first of an annual series of exhibitions held in his own studio.

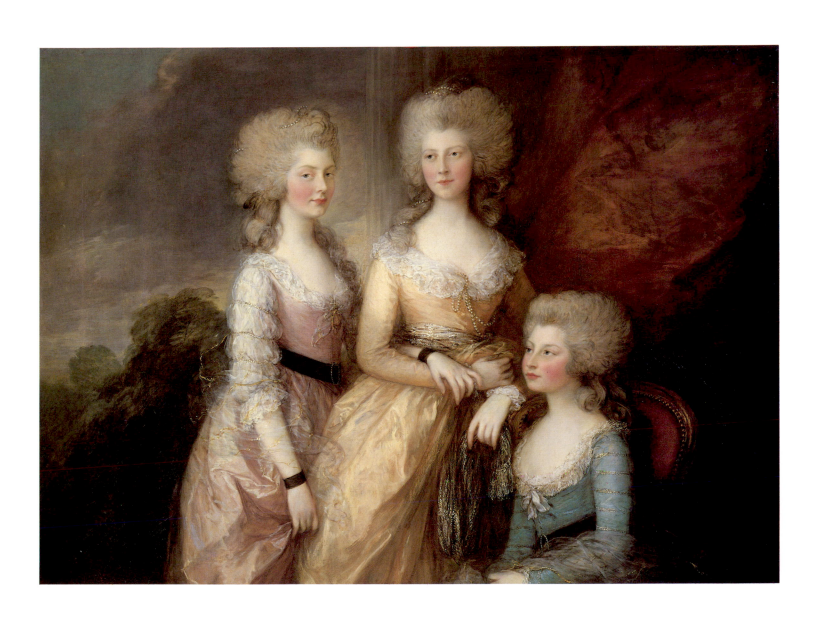

Thomas Gainsborough 1727-88
Henry Frederick, Duke of Cumberland, with his wife Anne, Duchess of Cumberland attended by Lady Elizabeth Luttrell

Oil on canvas
163.8 × 124.5 cm (64½ × 49 in)

OM 797

OM 793, 794 & pp 34-35

DNB IX, pp 560-61

E K Waterhouse, *Gainsborough*, London 1958, p 62

E K Waterhouse, *Reynolds*, London 1941, p 63 & pl 146

J Hayes, *The Drawings of Thomas Gainsborough*, London 1970, pp 125-26

D Manning, 'Gainsborough's Duke and Duchess of Cumberland with Lady Luttrell', *The Connoisseur*, vol 183, June 1973, pp 85-93

J Hayes, *Thomas Gainsborough*, Tate Gallery, London 1980, pp 36 & 138-40

J Brooke, *King George III*, London 1972, pp 272-82

Gainsborough's full-length portraits of the Duke and Duchess of Cumberland were exhibited at the Royal Academy in 1777, four years after Reynolds's full-lengths of the couple. The present picture of both sitters and the Duchess's sister Elizabeth was painted some years later, around 1783-88, at the Duke's request. It was neither delivered nor paid for and was offered for sale by the painter's widow at Christie's in 1792, when it was purchased, probably by the Prince of Wales. By 1816 it was at Carlton House and was sent to Cumberland Lodge in Windsor Great Park in 1823.

Gainsborough painted a magnificent series of full-length double portraits of couples in a landscape. Uniquely, in the present work the scale of the sitters relative to their surroundings has been drastically reduced, making them more figures in a landscape than figures with a landscape background. The setting of their promenade is in the grounds of their country home, Cumberland Lodge. Two preparatory drawings show that the artist first experimented with a horizontal format before settling on the final, vertical composition. He also added an further piece of canvas at the top, probably after he had started painting, to extend the height of the composition by one third. As the corners of the canvas, covered by the curved spandrels of the frame, were thinly painted with a continuation of the landscape setting, it is clear that the decision to make the picture an oval was an afterthought. This unusual format is most apt, the curved frame seeming to enfold the sitters as do the background trees. It has been pointed out that, like Gainsborough's *The Mall in St James's Park* of 1783 in the Frick Collection, the present work reveals the distinct influence of Jean-Antoine Watteau's poetic compositions of couples strolling in gardens.

Henry Frederick, Duke of Cumberland (1745-90) was a younger brother of George III. In 1770 he was named by Lord Grosvenor in an adultery suit and had to borrow £13,000 to pay the damages and costs. The following year he alienated the King with the announcement that he had secretly married Ann Horton (1743-1808), daughter of Lord Irnham. George III justified his objections to the match in the following terms: 'In any country a prince marrying a subject is looked upon as dishonourable, nay in Germany the children of such a marriage cannot succeed to any territories; but here, where the Crown is but too little respected, it must be big with the greatest mischiefs'. This scandal led the King to propose the Royal Marriage Act, requiring members of the Royal Family to obtain consent from the Crown prior to marriage, which was steered through Parliament with some difficulty by Lord North in 1772. Later that year another of the King's brothers, William, Duke of Gloucester, admitted that he had married secretly in 1766 (cat no 39). Lady Elizabeth Luttrell (d.1799) who appears, apparently sketching, at the right of the present picture was a notorious gambler. According to Lady Louisa Stuart, youngest daughter of the Earl of Bute, Lady Elizabeth 'more precisely what the Regent Orleans entitled a roué [debauchee] than one would have thought it practicable that anything clad in petticoats could be, governed the family with a high hand, marshalled the gambling table, gathered round her the men, and led the way in ridiculing the King and Queen'.

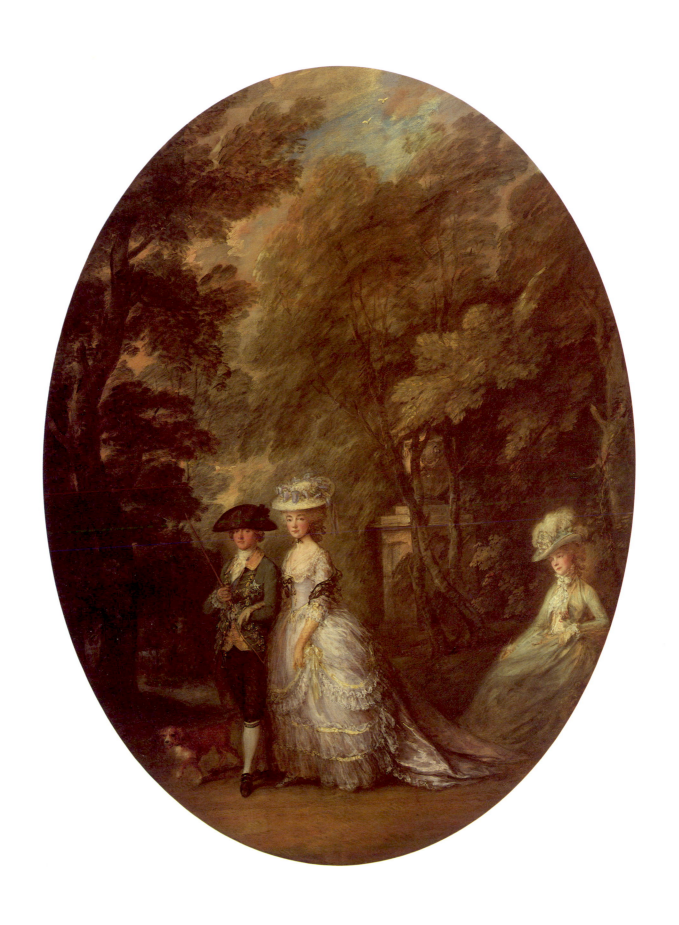

26
Sir Francis Grant 1803-78
Queen Victoria riding out 1839-40

Oil on canvas
99.1 × 137.5 cm (39 × 54⅛ in)

OM 143 & 144

DNB XI, pp 432-38

DNB VIII, pp 386-87

J Steegman, 'Sir Francis Grant, P.R.A: The Artist in High Society', *Apollo*, vol 79, June 1964, pp 479-85

Kings & Queens, Queens's Gallery, London 1982, pp 123-26

The Treasure Houses of Britain, National Gallery of Art Washington, New Haven & London 1985, pp 607-08

P Ziegler, *Melbourne*, London 1976, pp 257 & 362

R Ormond, *Early Victorian Portraits*, National Portrait Gallery, London 1973, vol 1, pp 310-15 & 474-93

Trained as a sporting artist, Grant's reputation as a fashionable portrait painter was established by the present work, exhibited at the Royal Academy in 1840. His career culminated in 1866 when he was elected President of the Royal Academy. Commissioned by Queen Victoria, sittings were held between April and October 1839. The artist's fee was £367 10s. When finished, the painting was hung in the Queen's Sitting Room at Windsor.

It records the 'ridings out' with Lord Melbourne and members of her household enjoyed by the young Queen. The scene is set near Sandpit Gate in Windsor Great Park with a view of Windsor Castle in the far distance. The Gothic archway through which the party is riding seems to be a compositional device of the artist. Preceded by her spaniel Dash (cat nos 28 & 29) and her terrier Islay, Queen Victoria (1819-1901) rides side-saddle on her horse Comus. At her side is her Prime Minister, William Lamb, 2nd Viscount Melbourne (1779-1848). She is turning towards her Lord Chamberlain, Lord Francis Conyngham (1797-1876), who doffs his hat. Under the arch are the Earl of Uxbridge, later Lord Chamberlain, and his brother-in-law George Byng, Comptroller of the Household, with Sir George Quentin, Equerry of the Crown Stables. At the extreme left background is Quentin's daughter Mary, a Maid-of-Honour and Lady Rider in the Master of the Horse's Department.

During the early years of her reign Queen Victoria depended very heavily upon Lord Melbourne, whom she met almost every day and considered 'very straightforward, honest, clever and good'. Maturity brought greater detachment and after Melbourne's death the Queen wrote 'tho' not a good or firm minister he was a noble, kind-hearted, generous being'. Both Melbourne and Byng (who purchased a reduced, autograph copy of the present work for £60) had previously commissioned work from Grant and presumably one of them commended the artist to the Queen. She described him as 'a very good-looking man, was a gentleman, spent all his fortune and now paints for money'.

Queen Victoria's Journal records that the horses were painted from life but also mentions visiting 'the Equerries room when Lord Melbourne was sitting to Grant ... on that wooden horse without head or tail, looking so funny with his white hat on, an umbrella, in lieu of a stick in one hand, and holding the reins, which were fastened to the steps, in the other ... Grant has got him so like, it is such a happiness for me to have that dear kind friend's face, which I do like and admire so, so like, his face, his expression, his air, his white hat, and his cravat, waistcoat and coat, all just as he wears it. He has got Conyngham in also very like, and Uxbridge and George Byng, and old Quentin, ludicrously like'.

The pose of the Queen's horse and its juxtaposition with an archway suggest that Grant was inspired by equestrian portraits of Charles I by Van Dyck in the Royal Collection. He painted two further portraits of the Queen on horseback, but subsequently fell from favour. In 1866, after he was elected President of the Royal Academy, the Queen wrote 'The Queen will knight Mr. Grant when she is at Windsor. She cannot say she thinks his selection a good one for Art. He boasts of *never* having been to Italy or studied the Old Masters. He has decidedly much talent, but it is much the talent of an Amateur'.

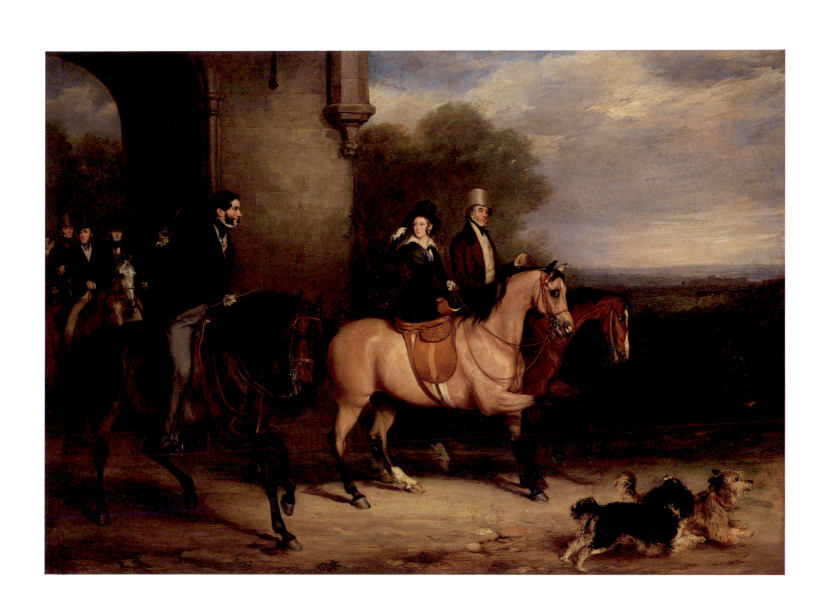

27

William Hogarth 1697-1764
The Popple and Ashley Families 1730

Oil on canvas
62.9 × 74.9 cm (23¾ × 29½ in)
signed and dated: *W^m Hogarth: pinx^t 1730*

OM 561

OM 559

M Brockwell, 'A Portrait Group by Hogarth in the Collection of His Majesty the King', *The Connoisseur*, vol 119, 1947, pp 126-28

R B Beckett, *Hogarth*, London 1949, pp 9 & 39

R Paulson, *Hogarth: His Life, Art, and Times*, New Haven & London 1971, vol I, p 218

J Brooke, *King George III*, London 1972, p 108

M Webster, *Johan Zoffany*, National Portrait Gallery, London 1976, pp 26 & 37-38

By 1730 Hogarth had married the daughter of Sir James Thornhill, the King's Serjeant-Painter, and had established a reputation as a painter of small 'conversation pieces' of family groups, often out of doors. He subsequently turned to the paintings and engravings of contemporary moral themes upon which his fame primarily rests. Hogarth became Serjeant-Painter in 1757, but was never a favourite at court and after his death George III proposed to abolish the post. The present work was probably painted for Alured Popple (1698-1744). Inherited by his daughter Marianne (1724-99) who married Vincent Mathias, Sub-Treasurer of the Queen's Household, it passed to her son Thomas Mathias (*d.*1835), Treasurer to Queen Charlotte and later Librarian at Buckingham House. In 1887 his niece Marianne Skerrett, First Dresser and secretarial assistant to Queen Victoria, bequeathed the painting to the Queen. It hung at Osborne House and was later transferred to Windsor.

The figures cannot be identified with certainty, but apparently portray members of the Popple family and their kinsfolk the Ashley-Coopers. Seated on the right is Alured Popple. Appointed Secretary of the Board of Trade in 1730, he subsequently became Governor of Bermuda, where he died 'of a bilious fever'. The central figure with a hat under his arm, a walking stick and a dog may be Alured's brother William (1701-64), who also became Governor of Bermuda, or their brother Henry (*d.*1743). The girl at the left is Alured's daughter Marianne, who is presumably standing before her mother Mary Popple (1704-73). The other seated woman and the man with the fishing rod may both be members of the Ashley-Cooper family. In the tree is an owl, a reference to the Popple family who used this bird as a heraldic crest. This painting is one of a number of Hogarth conversation pieces of 1730 to incorporate a fishing party – a theme resumed by Zoffany in some of his finest 'family pieces' over thirty years later.

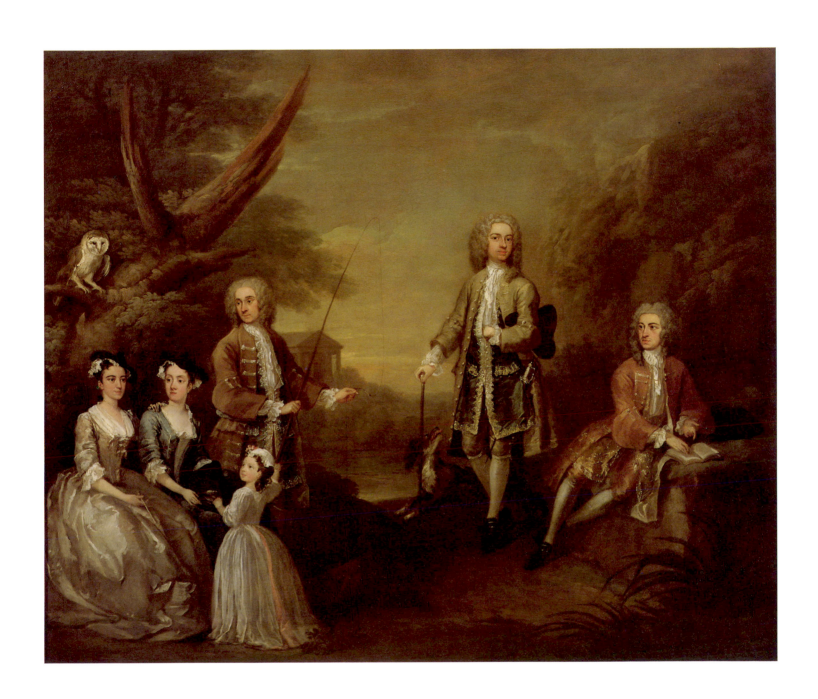

Sir Edwin Landseer 1803-73
Queen Victoria on horseback

Oil on millboard
52 × 43.2 cm (20½ × 17 in)

O Millar, *The Queen's Pictures*, London 1977, p 170

R Ormond, *Sir Edwin Landseer*, Philadelphia Museum of Art and Tate Gallery, New York & London 1981, pp 146-48

C Lennie, *Landseer The Victorian Paragon*, London 1976, pp 97-98

C Woodham-Smith, *Queen Victoria Her Life and Times*, vol I, London 1972, p 150

R Ormond, *Early Victorian Portraits*, National Portrait Gallery, London 1973, vol I, pp 474-93

Queen Victoria came to the throne on the death of her uncle William IV on 20 June 1837. This is probably one of the 'exquisite sketches' by Landseer 'intended for the picture he is to paint of me on horseback' which she mentioned in her Journal for 23 January 1838. Still in the artist's possession at the time of his death, it was given by his family to the Queen in 1874.

She is represented riding side-saddle on a rich saddle cloth, mounted on her favourite white horse Leopold. Her fur-trimmed black velvet gown is probably intended to approximate to sixteenth-century costume. At the horse's feet are a deerhound, a bloodhound and a black spaniel. The last, to which she turns a smiling glance, is probably her favourite Dash (cat nos 26 & 29). A contemporary recalled an event which took place on the day of the Queen's Coronation: 'She is very fond of dogs and has one very favourite little spaniel, who is always on the look-out for her return when she has been away from home. She had of course been separated from him on that day longer than usual, and when the state coach drove up to the steps of the palace, she heard him barking with joy in the hall, and exclaimed "There's Dash!", and was in a hurry to lay aside the sceptre and ball she carried in her hands, and take off her crown and robes *to go and wash little Dash*'.

In the present work, behind the Queen ride three soldiers from the 9th, 12th or 16th Lancers, wearing the red jackets with blue facings authorised by William IV in 1831. None of these regiments was in the household brigade, but a detachment of lancers was present with the Life Guards and the Grenadier Guards at a royal review held in Windsor Great Park on 28 September 1837. The battlements at the right suggest that Windsor provides the background to this composition. The overt pageantry recalls Van Dyck's equestrian portraits of Charles I in the Royal Collection, which may also have influenced Francis Grant two years later (cat no 26).

Between May and August 1838 Queen Victoria sat to Landseer six times, wearing a black velvet riding dress and mounted on Leopold. The large-scale version of this portrait depicts her alone, except for a spaniel and a deerhound, riding through an open landscape under a stormy sky. Although never finished, it was exhibited at the Royal Academy in 1873. The Keeper of the Queen's Privy Purse recommended: 'With regard to the great Picture of Your Majesty on horseback, Sir Thomas [Biddulph] fears it will never be satisfactory. The horse, a large grey, is well done and there are 2 dogs which he says were Your Majesty's, a spaniel & a Deerhound. But the figure of Your Majesty in a black velvet habit with a Hat of feathers is totally unlike. Sir Thomas did not well understand how the Picture originated as Sir Edwin was very wandering on the subject'. Accordingly, Queen Victoria declined to purchase the large-scale version of her portrait.

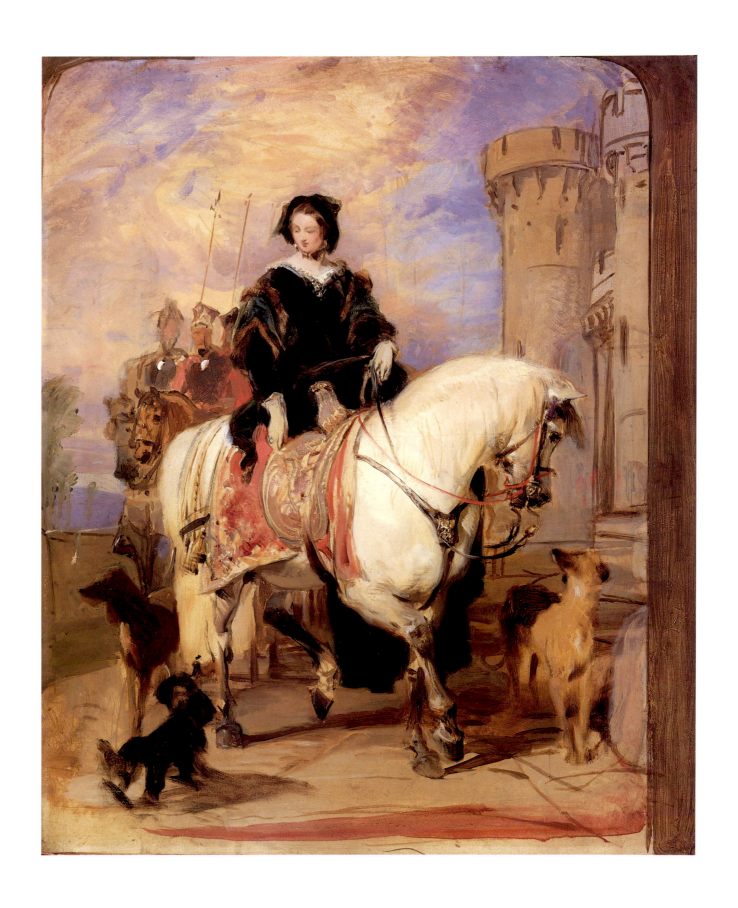

29
Sir Edwin Landseer 1803-73
Princess Victoire of Saxe-Coburg-Gotha 1839

Oil on canvas
44.5 × 35.6 in (17½ × 14 in)
signed and dated: *Sketch/EL 1839*

O Millar, *The Queen's Pictures*, London 1977,
pp 168-71

Landseer and his world, Mappin Art Gallery,
Sheffield 1972, pp 66-7

R Ormond, *Sir Edwin Landseer*, Philadelphia
Museum of Art and Tate Gallery, New York &
London 1981, pp 143-44 & 150

R Ormond & C Blackett-Ord, *Franz Xaver
Winterhalter and the Courts of Europe*, National
Portrait Gallery, London 1987, p 195

C Woodham-Smith, *Queen Victoria Her Life and
Times*, vol I, London 1972, p 285

At the age of twelve Landseer received a silver medal from the Society of Arts. In 1815 he began to study under the painter B R Haydon and in 1816 entered the Royal Academy schools. By 1826 he was established as a leading animal painter. Landseer's first royal commission was a picture of Princess Victoria's King Charles Spaniel Dash (cat nos 26 & 28) painted as a birthday present from her mother in 1836. He was subsequently commissioned to execute portraits, including a sketch of the young Queen, given in 1839 to Prince Albert before their marriage the following year. Landseer became a friend of Queen Victoria, to whom he gave lessons in drawing and etching, and was knighted in 1850. However, he had difficulty with large formal portrait commissions (cat no 28), which were increasingly given to Franz Xaver Winterhalter, although Landseer retained royal favour as an animal painter. On 10 September 1839 Queen Victoria recorded in her Journal how her former governess Baroness Lehzen 'brought in a lovely sketch in oils Landseer has done of Victoire's back, as a surprise for me; it is so like, – such a treasure – just the figure of that Angel'.

 With humour Landseer compares the attitude of the Princess with that of the pet spaniel beside her. Princess Victoire of Saxe-Coburg-Gotha (1822-57) was the daughter of Prince Ferdinand of Saxe-Coburg-Gotha and thus a first cousin of both the Queen and Prince Albert. Queen Victoria was devoted to her, recalling after her death 'She was so dear, so good – one of those pure, virtuous unobtrusive characters who make a home'. In 1840 Princess Victoire married the Duc de Nemours, second son of King Louis-Philippe of France. The 1848 Revolution forced the French Royal Family to flee to Britain, moving Queen Victoria to write 'the poverty of the poor exiles is most lamentable. I cannot say *how* dear and excellent dearest Victoire shows herself ... They really have hardly the means of living; it is a gt happiness for me to be able to help her in little trifles'. In 1852 the Queen and Princess Victoire sat to Winterhalter for a double portrait, as a birthday present for Prince Albert. Lady Canning, one of the Queen's ladies-in-waiting, was less taken with Princess Victoire, observing 'She is very pretty and nice to look at, but, besides having a tiresome voice, she has nothing to say'.

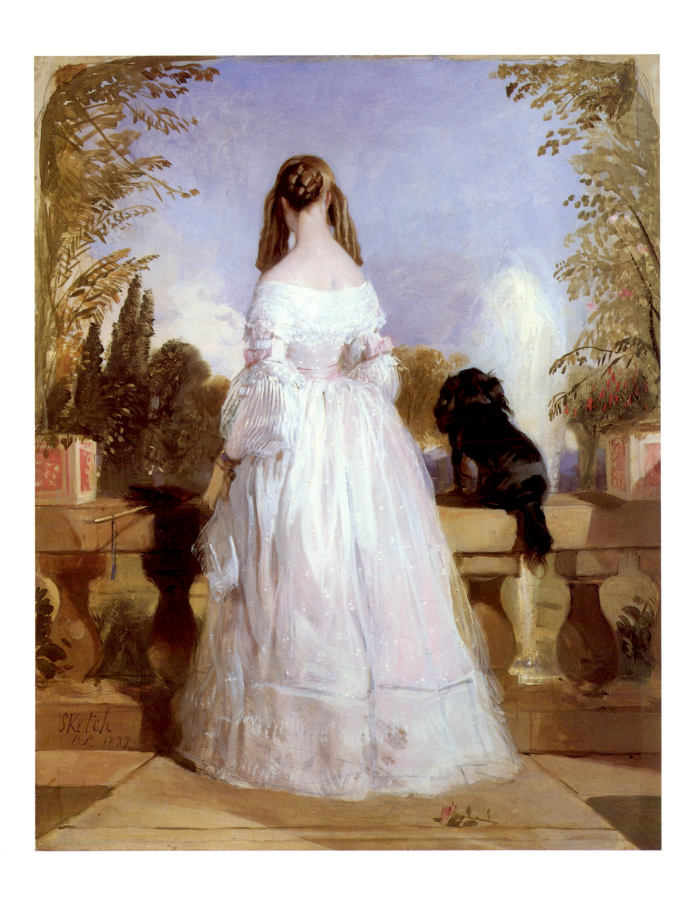

Sir Thomas Lawrence 1769-1830
Edward, first Lord Thurlow 1803

Oil on canvas
128.3 × 102.2 cm (50½ × 40¼ in)

OM 914

DNB XIX, pp 824-29

M Levey, *Sir Thomas Lawrence*, National
Portrait Gallery, London 1979, p 44

K Garlick, *Sir Thomas Lawrence*, Oxford 1989,
pp 19-20 & 272

L Namier & J Brooke, *The House of Commons
1754-1790*, vol III, London 1985,
pp 529-31

C Hibbert, *George IV*, Harmondsworth 1976,
pp 218, 255-56, 275, 288 & 309-10

E K Waterhouse, *Gainsborough*, London 1958,
p 19

A child prodigy, Lawrence was painting portraits professionally by his early teens. Having succeeded Sir Joshua Reynolds as Painter to the King in 1792, he enjoyed a highly distinguished reputation by 1803. That year he had to be persuaded to exhibit at the Royal Academy to 'keep his name before the world', despite the distraction of numerous small paintings on which he was engaged. This picture was intended for the estranged Princess of Wales, but was delivered to the Prince of Wales after exhibition at the Royal Academy in 1803. At the time, a half length of this type cost 80 guineas – the same fee as Gainsborough had charged in 1787. It hung in the Crimson Drawing Room of Carlton House and was removed to Windsor in 1828.

Lawrence claimed to have worked thirty-seven hours at a stretch on the portrait and a friend recalled that its entire lower part, including drapery and both hands, was painted on the last day for receiving pictures for the Royal Academy. At the exhibition it was greatly admired by the newspaper reviewers, by the painters John Opie and Henry Fuseli and by George III who told Benjamin West that it 'met his idea of a portrait being a true Representation of the man without artificial fancies of dress &c.'. Eleven years later Lawrence wrote to the Private Secretary of the Prince of Wales that 'The greatest honor that I have ever receiv'd, after the gracious notice of His Majesty, is that of having my picture of Lord Thurlow placed in his Royal Highnesses collection; and *so* placed as to fill me with the liveliest gratitude for such generous distinction'.

Edward, Lord Thurlow (1731-1806) was well known for his directness, severity and old-fashioned clothes and wig. Born in Norfolk, he left Gonville and Caius College, Cambridge without a degree, studied law and was called to the Bar in 1754. Thurlow entered Parliament as MP for Tamworth in 1765 and went over to the Government in 1767. He became Solicitor-General in 1770, Attorney-General in 1771 and Lord Chancellor in 1778. Created Baron Thurlow of Ashfield, he retained the Chancellorship for most of the period 1778-92. His deeply conservative views on such matters as American independence endeared him to George III, but at the time of the King's illness in 1788 he entered into negotiations with the Prince of Wales over the Regency question. Thurlow became a supporter of the Prince and in 1797 worked for a reconciliation between him and the Princess of Wales, although he also wryly observed that his patron 'was the worst anchoring ground in Europe'. At the end of his life he supported the 'Delicate Investigation' into the conduct of the Princess of Wales and concluded that she had been shown 'too great a degree of leniency' (cat nos 32 & 40). Horace Walpole wrote that 'Thurlow had a solid and deep understanding that penetrated to the marrow of an argument ... a manly soul that owed all its merits to vigorous nature, who had composed him of stern materials ... He was coarse in his manners, indelicate in his pleasures even to a contempt of decorum, though at the head of the law – rough, proud, sullen, and perhaps intrepid'. His political opponent Charles James Fox remarked 'no man could *be* so wise as Thurlow *looked*'.

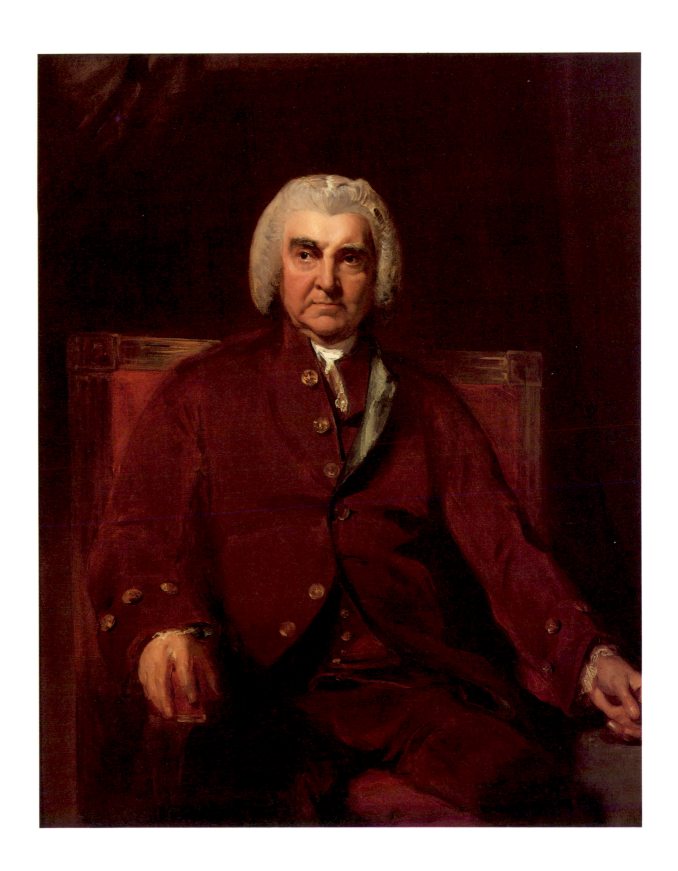

Sir Thomas Lawrence 1769-1830
William Pitt 1807-08

Oil on canvas
149.9 × 121.9 cm (59 × 48 in)

OM 908

DNB XV pp 1253-72

K Garlick, *Sir Thomas Lawrence*, Oxford 1989,
pp 20 & 252

M Whinney, *Sculpture in Britain 1530 to 1830*,
Harmondsworth 1964, pp 163 & 269 & pl 124

R G Thorne, *The House of Commons 1790-1820*
vol IV, London 1986, pp 807-824

C Hibbert, *George IV*, Harmondsworth 1976
pp 124, 126, 150 & 252

E K Waterhouse, *Reynolds*, London 1941, p 14

E K Waterhouse, *Gainsborough*, London 1958,
p 85

R Walker, *Regency Portraits*, National Portrait
Gallery, London 1985, vol 1, pp 391-97

William Pitt (1759-1806) sat to Gainsborough in 1787 and to Hoppner in 1804-05. In 1803-04 Lawrence was planning to paint portraits of him for the Princess of Wales and Lord Abercorn and had studied his face in anticipation. However, the politician died before these plans came to fruition and the present work was painted posthumously in 1807-08 for John Julius Angerstein, the financier whose collection formed the nucleus of the National Gallery in 1824. Exhibited at the Royal Academy in 1808, it was given by Angerstein to George IV in 1816 and was sent from Carlton House to Windsor in 1828. In 1807 Lawrence charged 100 guineas for a half length – the same as Sir Joshua Reynolds's fee in 1782.

After Pitt's death the sculptor Joseph Nollekens, to whom he had refused to sit during his lifetime, took a death mask, from which a portrait bust was made. This proved immensely popular and the sculptor made seventy-four marble replicas at 120 guineas each and 600 plaster casts at 6 guineas apiece. Lawrence's portrait was based upon one of these busts in the possession of Angerstein and his own recollections of Pitt's appearance. Nollekens had depicted his subject wearing classical drapery rather than contemporary dress and emphasised Pitt's aloof character by elongating his neck. In the present work the latter feature is masked by the cravat. Pitt is portrayed before a paper inscribed *Redemption of the National Debt*; an allusion to the ultimately abortive scheme to pay off the national debt by a 'sinking fund' which he introduced in 1786.

The younger son of Pitt the elder, the Earl of Chatham (1708-78), William Pitt studied at Cambridge and was called to the Bar in 1780. He entered the Commons the following year, became Chancellor of the Exchequer in 1782 and Prime Minister in 1783. He declined the King's reward of the order of the Garter in 1790, but accepted the post of Warden of the Cinque Ports in 1792. After the declaration of war in 1793, his principal task became the struggle against France. This was financed by such expedients as an income tax, introduced in 1798. That year he dispatched Marquess Cornwallis (cat no 22) to subdue the Irish rebellion. George III's trust in Pitt was undermined by his plans for Catholic emancipation in Ireland and he resigned in 1801. Following the resumption of war after the Peace of Amiens Pitt returned to office in 1804. The remainder of his life was devoted to an alliance with Austria and Russia against France. Despite the British victory at Trafalgar, the allies were shattered by Napoleon at the Battles of Ulm and Austerlitz.

Shortly after, worn out by overwork, Pitt 'died of old age at forty six, as much as if he had been ninety'. A consummate orator and brilliant statesman, Pitt's impact on his contemporaries was profound. A friend recalled, 'for a clear and comprehensive view of the most complicated subject; for that fairness of mind . . . to recognise the truth; for magnanimity . . .; for willingness to give a fair hearing to all . . .; for personal purity, disinterestedness, integrity, and love of his country, I have never known his equal'.

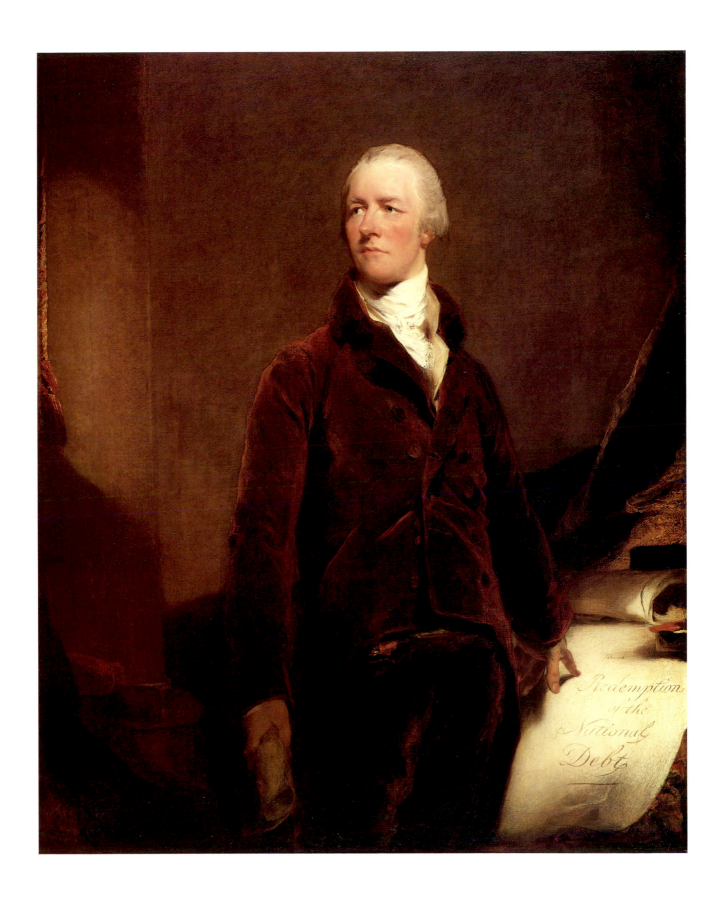

32
Sir Thomas Lawrence 1769-1830
Richard, Marquess Wellesley 1812-13

Oil on canvas
132.1 × 103.5 cm (52 × 40¾ in)

OM 916

OM 874

DNB XX, pp 1122-34

K Garlick, *Sir Thomas Lawrence*, Oxford 1989, pp 20-21 & 278

R G Thorne. *The House of Commons 1790-1820*, vol V, London 1986, pp 509-11

C Hibbert, *George IV*, Harmondsworth 1976, pp 388-89 & 392

R Walker, *Regency Portraits*, National Portrait Gallery, London 1985, vol 1, pp 523-25

Sittings for the present work took place in 1812 and it was exhibited at the Royal Academy the following year. Commissioned by the sitter, who subsequently presented it to Queen Victoria, it was in the Grand Corridor at Windsor by 1845.

Wellesley is portrayed wearing the Garter and the ribbon and star of the order. After a previous sitting the artist spoke to a friend of how Wellesley had 'ruined His fortune by His excessive expences on Women. – With all his abilities He has so great a share of vanity, that at the age of abt. 53 Lawrence has noticed when His Lordship sat to him for His Portrait, that His *Lips* were painted'.

Eldest son of the 1st Earl of Mornington and brother of the Duke of Wellington, Richard Wellesley (1760-1842) was educated at Harrow, Eton and Christ Church, Oxford. When he came of age he entered the Irish House of Lords in succession to his father as Earl of Mornington. In 1784 he entered the English House of Commons where he remained until 1797 as a supporter of Pitt (cat no 31). In 1797 Wellesley was sent to India as Governor-General. There he was confronted by a dangerous alliance between the French and Tippu Sahib, ruler of Mysore. In 1799 Tippu was defeated at the Battle of Seringapatam in which Wellesley's brother Arthur, the future Duke of Wellington, played a distinguished role. Created Marquess Wellesley in 1799 and commander-in-chief in 1800, he remained in India until 1805. His Indian policy was debated and approved in 1806 and three years later he was dispatched to the war in Spain as British ambassador-extraordinary.

In 1809-12 he was Foreign Secretary, becoming a favourite with the Prince Regent, who characterised him as a 'Spanish grandee grafted on an Irish potato'. The Prince backed him as a potential Prime Minister and when this proposal was rejected by the government Wellesley resigned 'in the highest style, state liveries and full dress', so moving the Prince Regent that he 'was, or appeared to be *deeply* affected and almost unable to speak'. Later in 1812, at the Prince's request, he tried – and failed – to form a coalition with the support of the Whigs. There followed a decade out of office, during which period he was quite overshadowed by the achievements of his brother, the Duke of Wellington. He was appointed Lord Lieutenant of Ireland in 1821, the same year as the coronation of George IV, at which he bore the sceptre with crown. He held this office until 1828 and in 1833-34, becoming Lord Chamberlain in 1835. A contemporary characterised him thus: 'Unlike most English politicians, he was rather a statesman than a man of business, and more capable of doing extraordinary things well than conducting ordinary transactions with safety or propriety ... there was a smack, a fancy of greatness in all he did: and though in his speeches, his manners, and his actions he was very open to ridicule, those who smiled and even laughed could not despise him'.

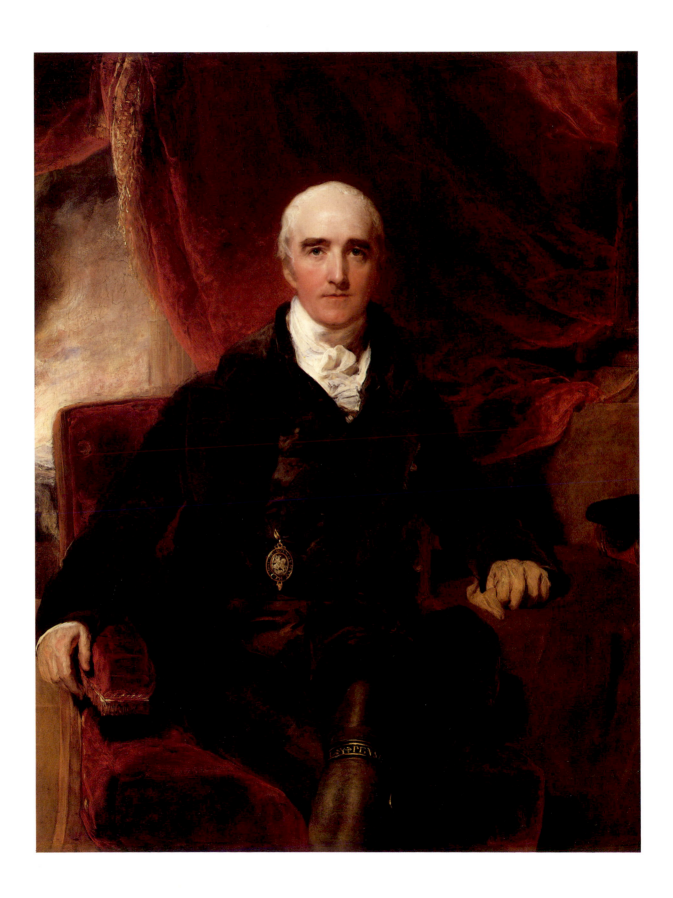

Sir Thomas Lawrence 1769-1830
Sir William Curtis 1823-24

Oil on canvas
90.8 × 71.7 cm (35¾ × 28¼ in)

OM 894

OM xxxiii-xxxvi & pp 59-60

DNB V, pp 349-50

K Garlick, *Sir Thomas Lawrence*, Oxford 1989,
p 176

R G Thorne, *The House of Commons 1790-1820*,
vol III, London 1986, pp 545-48

C Hibbert, *George IV*, Harmondsworth 1976,
pp 645, 674 & 689

J Prebble, *The King's Jaunt*, London 1988,
pp 228, 255-6 & 343

R Walker, *Regency Portraits*, National Portrait
Gallery, London 1985, vol 1, pp 140-41

Lawrence was knighted by the Prince Regent in 1815 and, following the death of Benjamin West, was elected President of the Royal Academy in 1820. The same year George IV ascended the throne. He was the artist's greatest patron, paying Lawrence a total of £24,500. This picture was commissioned by the King. Sittings took place in 1823 and it was exhibited at the Royal Academy the following year. Initially at Carlton House, the portrait had been transferred to Windsor by 1828.

In July 1823 John Constable wrote to a friend, 'We dined with Sir William Curtis; he is a fine old fellow, and is now sitting for his portrait to Lawrence for the king who desired it in these words, "D-n you, my old boy, I'll have you all in your canonicals, and then I can look at you every day". He is a great favourite, – birds of a feather'. A full-length portrait of the sitter had already been painted by Lawrence in 1812. In 1824 George IV ordered from Lawrence a copy of his own portrait for presentation to Curtis. Sir William Curtis (1752-1829) inherited a business in sea biscuits in Wapping. He extended its trade considerably and diversified into whaling, shipping to the East Indies, government contracting and banking, amassing a fortune of £300,000. He failed three times to enter Parliament between 1784 and 1789, before being returned for the City of London in 1790. He retained this seat until 1818, regaining it in 1820 for six more years.

Leader of the Tories in the City, Curtis supported Pitt (cat no 31) and the war with France. A poor but loquacious speaker, he was frequently ridiculed for his 'bold and plain language' by political opponents who attributed his speeches to 'the profound information he receives from his barber, whose opinions and intelligence, communicated to him in the morning, are conveyed to the House of Commons in the evening, no doubt to the great information of our national representatives'. President of the Honourable Artillery Company and a militia colonel, he accompanied the ill-fated expedition against Walcheren Island in 1809 on his yacht 'carrying delicate refreshments of all kinds to the military and naval commanders, and the principal officers'. He was subsequently caricatured in popular prints as 'Alderman *alias* Commodore Curtis'. Elected an alderman in 1785, he was sheriff in 1788-89, Lord Mayor in 1795-96 and became Father of the City in 1821. Here he is portrayed wearing the fur-trimmed scarlet robe of an alderman and the gold chain of a sheriff. George IV was a close friend, sending Curtis a Coronation Medal from Ireland in 1821 and spending the night at his house in Ramsgate before the state visit to Hanover. The following year Curtis accompanied the King to Edinburgh. There, like George IV, he appeared in full Highland uniform; a 'portentous apparition' which 'cast an air of ridicule and caricature over the whole of Sir Walter's celtified pageantry' (cat no 34) and inspired a cartoon by George Cruikshank. A contemporary recorded that when Curtis was ill 'A Quaker physician ... admonished him upon the necessity of becoming abstemious and told him he must live upon water gruel, to which he consented. The doctor then recommended to him to abstain from drinking champagne in future. This roused Sir William and he replied, "Not so, Doctor, I shall drink champagne whenever I can get it".'

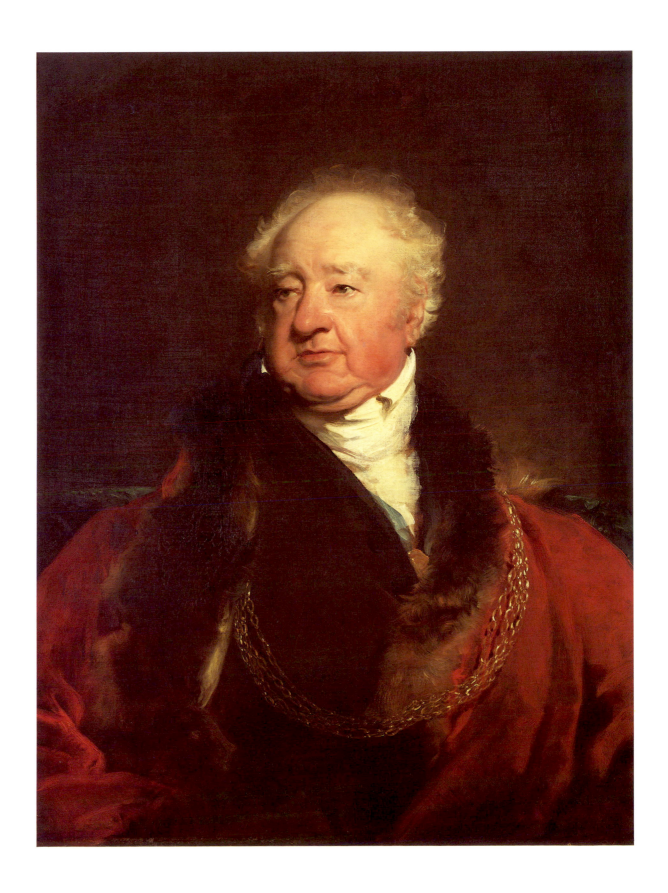

Sir Thomas Lawrence 1769-1830
Sir Walter Scott

Oil on canvas
161.9 × 133.3 cm (63¾ × 52½ in)

OM 913

OM 894, 1183

DNB XVII, pp 1018-43

K Garlick, *Sir Thomas Lawrence*, Oxford 1989, pl 86 & p 263

J Prebble, *The King's Jaunt*, London 1988, pp 11, 86-103, 228-30, 252-53 & 341-42

C Hibbert, *George IV*, Harmondsworth 1976, pp 399, 670-75, 689, 750-51 & 759

D L Macnie (ed), *The New Shell Guide to Scotland*, London 1977, pp 90-91 & 97-98

R Walker, *Regency Portraits*, National Portrait Gallery, London 1985, vol 1, pp 439-45

F Russell, *Portraits of Sir Walter Scott*, London 1987, pp 12-13, 56-58 & 112

After Lawrence's return from his 1818-20 visit to the Continent to paint the allied leaders of the war against Napoleon for the Waterloo Gallery at Windsor his prices rose considerably. He received 300 guineas for this portrait. Commissioned by George IV at the beginning of 1821, sittings were held in March of that year. Although the artist's progress was rapid at first, only in November 1826 did Scott 'sit to Sir T.L. to finish the picture for his Majesty, which every one says is a very fine one. I think so myself and wonder how Sir Thomas made so much out of an old weather-beaten block'. After exhibition at the Royal Academy in 1827, the portrait was delivered to Carlton House before its transfer to Windsor in 1828.

Pen in hand and with a walking stick between his knees, the writer is seated at a table bearing manuscripts inscribed *Waverley* and *Maid of Perth*. The former, the first of the Waverley novels, was published in 1814 but *St Valentine's Day* or the *Fair Maid of Perth* was not published until 1828, so its title was presumably added to the portrait between its exhibition at the Royal Academy and its delivery to the King. In November 1826 Scott wrote to the wife of his friend and cousin Hugh Scott of Harden for 'an outline of the Eildon hills to enable Lawrence to throw them into the back-ground of the portrait he has made of me for Windsor. Properly it should present them as seen from the west & if you have a sketch from that point I would prefer it'. This viewpoint would approximate to that from the writer's home at Abbotsford, near Melrose in Roxburghshire. Scott claimed 'I can stand on the Eildon Hills and point out forty-three places famous in war and verse'. One of the hills appears in the background of Lawrence's composition.

Sir Walter Scott (1771-1832) was born in Edinburgh where he studied law and was called to the Bar in 1792. A member of various literary societies, he rejected the classics in favour of German romantic dramas and traditional Scottish ballads. From 1799 he was sheriff-depute of Selkirkshire and from 1806 a clerk to the Court of Sessions; the posts providing an adequate income and ample time to pursue his literary interests. Scott's first important work, *The Minstrelsy of the Scottish Border* was published in 1802-03, followed in 1805 by *The Lay of the Last Minstrel* and in 1808 by *Marmion*, both of which were considerable financial successes. His medieval romances and Scottish novels were such bestsellers that in 1812 he was able to purchase the estate at Abbotsford where he built a baronial mansion which was soon a place of pilgrimage for his numerous readers. He became the favourite author of the Prince Regent, whom he persuaded to authorise the recovery and display of the Scottish regalia in 1818. In 1820 Scott was knighted, offered honorary degrees by Oxford and Cambridge and appointed president of the Royal Society of Scotland. Two years later he organised the receptions, parades and pageants for the state visit to Edinburgh of George IV (cat no 33), who greeted him as 'The man in Scotland I most wish to see'. This celebration reawakened Scottish historical consciousness and re-established the relationship between Scotland and the monarchy, interrupted in the seventeenth century, which flourished in the reign of Queen Victoria. Numerous portraits of Scott exist, including oil paintings of 1823 by Raeburn and of 1824 by Landseer. In 1826 Scott said of the present work 'The portrait is a very fair one and makes me think I have been a very ill-used gentleman on former occasions'.

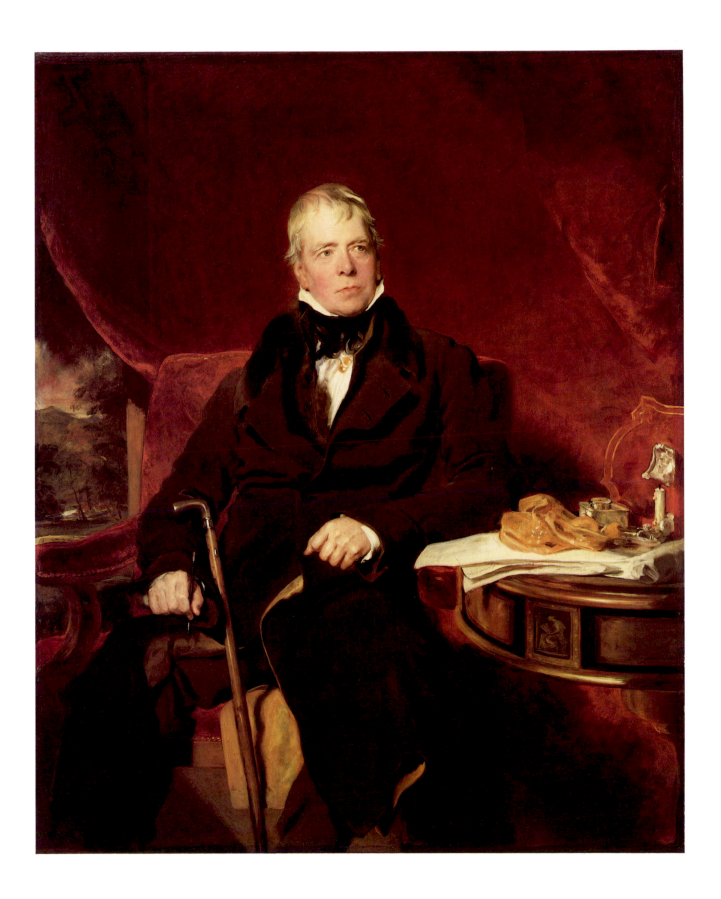

35
Jean-Baptiste Joseph Pater 1695-1736
Fête Champêtre

Oil on canvas
50.2 × 58.4 cm (19¾ × 23¾ in)

Sèvres Porcelain from the Royal Collection, Queen's Gallery, London 1979, pp 82-83

F Ingersoll-Smouse, *Pater*, Paris 1928, pp 40 & 103

Watteau 1684-1721, Schloss Charlottenburg, Berlin 1985, pp 342-44 & 367-72

M A Katritzky, 'Lodewyk Toeput: some pictures relating to the *commedia dell'arte*', *Renaissance Studies*, vol 1, no 1, March 1987, pp 85-94 & 109-24

J Ingamells, *The Wallace Collection Catalogue of Pictures*, vol III, London 1989, pp 285, 295-96 & 303-04

C M Kauffmann, *Victoria and Albert Museum Catalogue of Foreign Paintings*, vol I, London 1973, pp 212-13

With its pendant (cat no 36), this painting is first documented in 1819 in the Bathroom at Buckingham House, with an attribution to Watteau. It was probably hung there some years before by George III or Queen Charlotte, possibly as early as the 1760s or 1770s, when numerous paintings were bought for or transferred from other palaces to this recently acquired residence. There is evidence that the other pair of Paters in the Royal Collection (cat nos 37 & 38) had been acquired by 1757.

The theme of the *Fête Champêtre*, or 'rustic entertainment', was established in Venice by Giorgione and Titian and appears in the Netherlands in the work of Pieter Pourbus before the middle of the sixteenth century. A few decades later, Netherlandish paintings already associated the *Fête* with 'Commedia dell'arte' players (cat no 37); a subject which Jean-Antoine Watteau developed to a high level of refinement over a century later. From Valenciennes, Pater was a fellow townsman of Watteau, with whom he studied at Paris in 1711 and at Nogent-sur-Marne in 1721, shortly before the latter's death. The Paris Academy rigidly graded artists according to the subject-matter in which they specialised, admitting Pater as a painter of *fêtes galantes* in 1728 with one of his only three dated works, the *Rejoicing Soldiers*, at the Louvre. Pater's style is dependent upon that of Watteau, some of whose paintings he is reputed to have completed after his master's early death, and whose work he certainly copied. Watteau's *The Pleasures of the Ball* at Dulwich is probably the source for the semi-reclining figure of the man holding the lady's hand in the centre-right of the present work. Similarly, the gentleman leaning against the plinth at the left derives from Watteau's *Italian Recreation* in Berlin. The principal figure group of two couples at the right of this picture reappears with few alterations in a painting by Pater at the Victoria and Albert Museum.

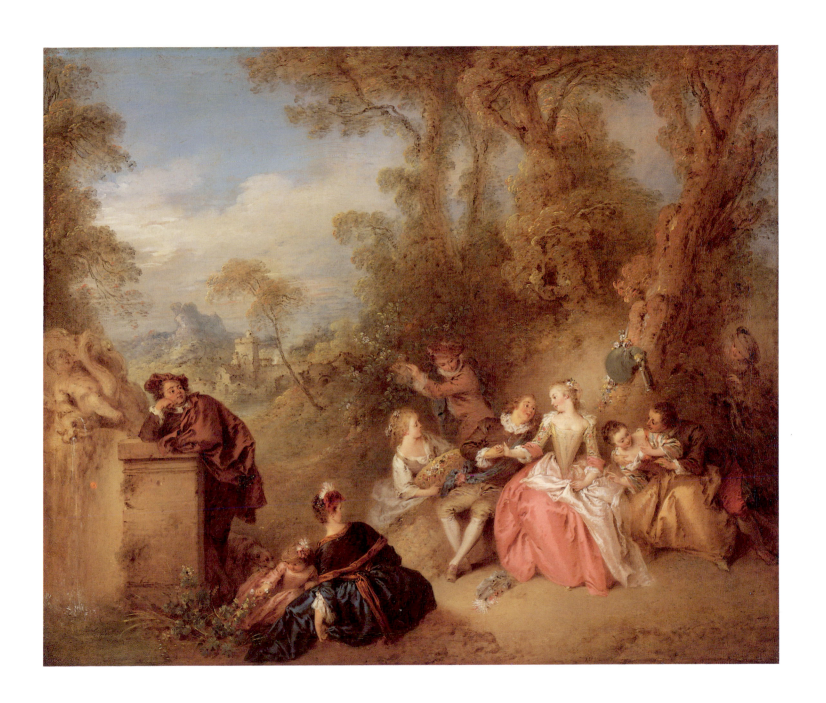

Jean-Baptiste Joseph Pater 1695-1736
Fête Champêtre with a flute player

Oil on canvas
50.2 × 60.3 cm (19¾ × 23¾ in)

Sèvres Porcelain from the Royal Collection, Queen's Gallery 1979, pp 82-83

F Ingersoll-Smouse, *Pater*, Paris 1928, pp 3, 39, 102 & 106

Philip Mercier 1689-1760, York City Art Gallery & Iveagh Bequest 1969, pp 15-20 & 23-35

O Millar, *The Queen's Pictures*, London 1977, pp 96-97

E K Waterhouse, 'English Painting and France in the Eighteenth Century', *Journal of the Warburg and Courtauld Institutes*, vol 15, 1952, pp 125 & 127-28

M Eidelberg, 'Watteau Paintings in England in the Early Eighteenth Century', *Burlington Magazine*, vol 117, no 870, September 1975, pp 576-78

Watteau 1684-1721, Schloss Charlottenburg, Berlin 1985, pp 553-62

C M Kauffmann, *Victoria and Albert Museum Catalogue of Foreign Paintings*, vol I, London 1973, pp 212-13.

Like the previous work, this picture is first documented in the Bathroom at Buckingham House in 1819, with an attribution to Watteau. As Pater's style directly imitated that of his master, this misattribution is not surprising. Watteau's reputation in Britain dated back at least to 1719-20, when he visited the doctor and collector Richard Mead in London. In England during the 1720s Philip Mercier issued a series of engravings, purportedly after Watteau, some of which were actually his own pastiches. Mercier received the posts of Principal Painter, Gentleman Page of the Bedchamber and Library Keeper to Frederick, Prince of Wales in 1729-30. Mercier's paintings for his master included a composition partly based upon a Watteau drawing. He also spent over £650 on books and paintings for the Prince, including an *Amphitrite* by Pater, purchased for £21 in 1735. Although the early provenance of the present work and its pendant is unknown, the other Paters in the Royal Collection (cat nos 37 & 38) seem to have been there since at least 1757. It is distinctly plausible that all four were purchased by the Prince of Wales. His interest in the French Rococo may be compared with the almost obsessive fascination of another North German prince, five years his junior. Probably encouraged by his French court painter Pesne, between 1736 and 1773 Frederick the Great acquired no less than 26 paintings attributed to Watteau, together with 32 pictures by his student Nicolas Lancret and 31 by Pater.

Like most of Pater's compositions, it is not possible to date this work precisely. It is no earlier than the late 1720s and a related picture may date from 1734. The figure group to the left, and especially the flute player, is reminiscent of that at the right of the previous work. Similarly, a painting by Pater at Valenciennes reproduces the figures in the right foreground, including the seated man, turning lady and the girl with a dog. In a painting at the Victoria and Albert Museum, the girl, dog and newel of the staircase reappear, albeit reversed.

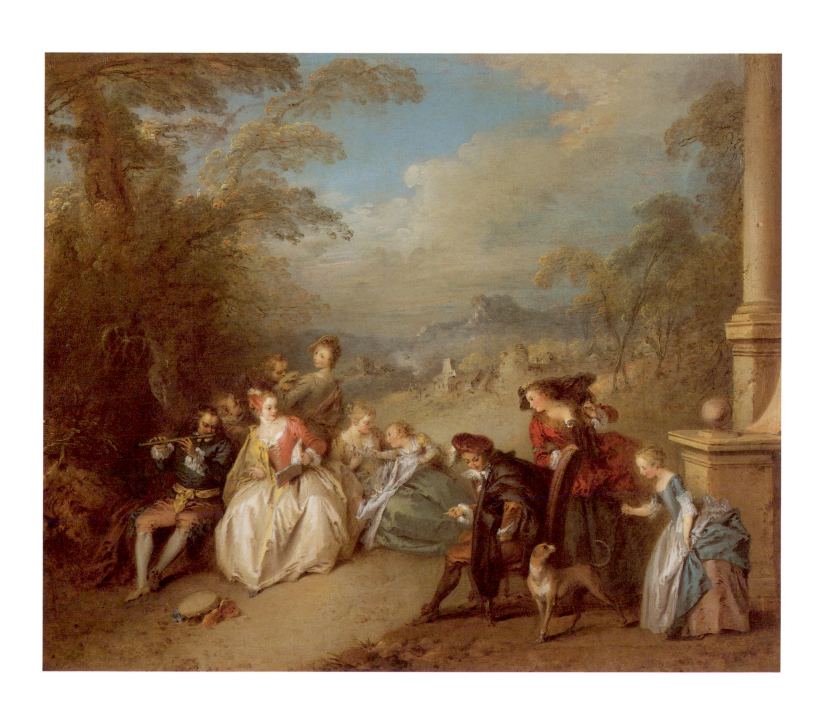

37

Jean-Baptiste Joseph Pater 1695-1736
Fête Champêtre with Italian Comedians

Oil on canvas
52.1 × 63.5 cm (20$\frac{1}{2}$ × 25 in)

Sèvres Porcelain from the Royal Collection, Queen's
Gallery, London 1979, pp 82-83

F Ingersoll-Smouse, *Pater*, Paris 1928, pp 17, 37
& 94

A Nicoll, *The World of Harlequin*, Cambridge
1963, pp 9-15, 44-55, 69-75, 82-95 & 174-91

Watteau 1684-1721, Schloss Charlottenburg,
Berlin 1985, pp 336-40, 346-48, 419-21, 436-44
& 511-32

J Addison, *Remarks on Several Parts of Italy, &c*,
London 1753, pp 67-68

A pendant to the following work, this painting is first recorded at Carlton House in 1816 with an attribution to Watteau. Given George IV's taste for eighteenth-century French furniture and Sèvres porcelain, it is possible that he bought this pair of pictures. However, its pendant was probably in the Royal Collection by 1757, suggesting that both may have been bought by Frederick, Prince of Wales (cat nos 35 & 36). In 1843 it was transferred to Buckingham Palace.

The 'Commedia dell'arte' originated in Italy during the sixteenth century and the first troupe of Italian players arrived in Paris in 1607-08. After sharing a theatre with Molière's company, they obtained a playhouse of their own in 1680, but were expelled in 1697. In 1716 a new Théâtre Italien was established, which survived until 1762. Watteau painted a pair of scenes contrasting it with the French comedians, who followed established texts (cat no 38). Improvisation was the essence of the Italian comedy, which followed a limited range of plots. The central characters were usually a pair of young lovers, whose relationship provided the framework for the escapades of several outrageous stereotyped characters. Each was identifiable by a given personality, role, mask and costume and was played by an actor who specialised in that particular part.

In the present work, the character entering from the right, as though from the wings of a stage, reflects a figure in an engraving after a lost composition by Watteau. He is Pantalon, an elderly and lecherous Venetian merchant, often the father or husband of the young female lover. Crouching at the right of the main group, wearing an academic hood and with one hand raised is Pantalon's companion, the Doctor, a pedantic graduate of the university of Bologna. The central figure, in a multi-coloured costume and hat in hand is the most famous of the characters, Arlequin, an acrobatic manservant from Bergamo. His companion, in modish hat and dress, is probably the adventuress Columbine. In the Italian comedy female costume was seldom distinctive, so the other two women are not identifiable. Leaning over Colombine, in a ruff and a floppy beret and pointing with one finger, is Mezzetin. Also a servant, he was a musician who played in the 'intermezzi' between acts. The figure in white is the lazy Pierrot, a French variation on the earlier Neapolitan Pulcinella. He was also a servant who played music during the interludes. By his side crouches the Fool in jester's costume, a character from the French comic opera, who had previously appeared in paintings of the 'Commedia dell'arte' by Watteau. At the far left, in profile, is the cloaked figure of Scaramouche, a vainglorious Spanish soldier.

Joseph Addison, who attended 'Commedia dell'arte' performances in 1701-03, described several of the principal characters thus: 'The *Doctor's* Character comprehends the whole Extent of a Pedant, that, with a deep Voice and a Magisterial Air, breaks in upon Conversation, and drives down all before him: Every thing he says is backed up with Quotations out of *Galen, Hippocrates, Plato, Virgil*, or any other Author that rises uppermost, and all Answers from his Companions are looked upon as Impertinencies or Interruptions. *Harlequin's* Part is made up of Blunders and Absurdities: He is to mistake one Name for another, to forget his Errands, to stumble over Queens, and to run his Head against every Post that stands in his way. This is all attended with something so comical in the Voice and Gestures, that a Man, who is sensible of the Folly of the part, can hardly forbear being pleased with it. *Pantalone* is generally an old Cully [fool]'. Addison also complained 'The Comedies that I saw at *Venice*, or indeed in any other Part of *Italy*, are very indifferent, and more lewd that those of other Countries. Their Poets have no Notion of gentile Comedy, and fall into the most filthy Double Meanings imaginable, when they have a mind to make their Audience merry'.

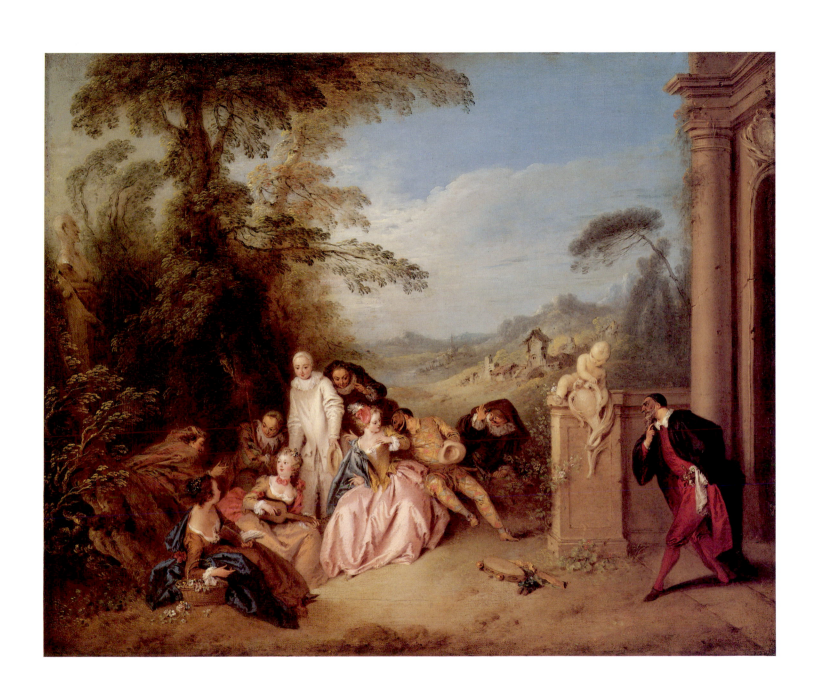

38
Jean-Baptiste Joseph Pater 1695–1736
Monsieur de Pourceaugnac

Oil on canvas
50.2 × 58.4 cm (19¾ × 23 in)

Sèvres Porcelain from the Royal Collection, Queen's Gallery, London 1979 pp. 82–83

F Ingersoll-Smouse, *Pater*, Paris 1928, pp 37 & 95

Watteau 1684–1721, Schloss Charlottenburg, Berlin 1985, pp 336–40, 419–21, 436–44 & 521–24

Molière (trans A R Walker), *The Plays of Molière in French with an English translation*, Edinburgh 1907, vol VI, pp 246–343

A pendant to the previous work, this painting is first recorded at Carlton House in 1816 with an attribution to Watteau. In 1843 it was transferred to Buckingham Palace. Although first documented in the collection of George IV, a drawing in the Royal Library of the central group by Princess Caroline (1713–57), a daughter of George II, suggests that it was in the Royal Collection by a much earlier date. Given his taste for contemporary French painting, Caroline's brother Frederick, Prince of Wales (1707–51), is a likely purchaser (cat nos 35 & 36).

The scene depicted is from a play by Molière (1622–73), the creator of French classical comedy. *Monsieur de Pourceaugnac* was first performed before Louis XIV at Chambord in 1669, and subsequently in Paris with Molière in the title role. A considerable success, it was published in 1670. The play revolves around the love of Julie, the daughter of Oronte, for Éraste. Julie's hand having been promised by her father to a lawyer from Limoges named Monsieur de Pourceaugnac, the lovers plot with the Neapolitan adventurer Sbrigani and his accomplices Nérine and Lucette to discredit her suitor. Pater's composition depicts a comic highlight of the play, from the end of Act II, scene 8. The central figure of Monsieur de Pourceaugnac, wearing a large tricorne hat, is accosted by Nérine on the right. Pretending to be from St-Quentin in Picardy, she presents him with a child and claims to be his deserted wife. Lucette on the left, speaking a macaronic of French and Spanish and pretending to come from Pezenas in Languedoc, has previously presented him with two children and also claimed to be his wife. The children cry out together 'Mon papa, mon papa, mon papa!', moving Pourceaugnac to exclaim that he cannot bear this any longer. Oronte, presumably the man with a cane at the right, replies that he deserves to be hanged. Accused of bigamy, Pouceaugnac flees and the lovers are married at the end of the play.

Pater has added a number of figures who are not mentioned in the text. Five children appear in the picture, although there are only three in Molière's play; Francon, Jeanet and Madelaine. The gesturing man in a feathered beret behind the main figures is probably Sbrigani. In the right background are the lovers Éraste and Julie. Accordingly, all the principal characters in the play appear in the composition and the central narrative is emphasised by the crowd of children.

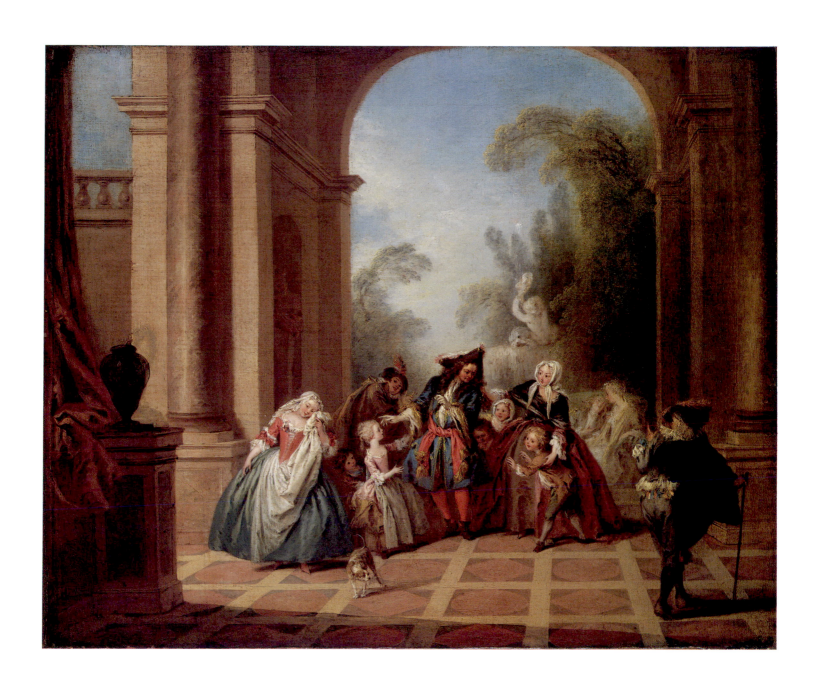

39
Sir Joshua Reynolds 1723-92
Maria, Duchess of Gloucester

Oil on canvas
187.3 × 136.5 cm (73¾ × 53¾ in)

OM 1015

OM 1016

DNB XXI, pp 348-49

E K Waterhouse, *Reynolds*, London 1941, pp 17, 25, 64 & pl 153-54

J Reynolds (ed R R Wark), *Discourses on Art*, New Haven & London 1975, p 108

J Brooke, *King George III*, London 1972, pp 277-81

The Duchess sat to Reynolds in 1771, but her portrait was not exhibited at the Royal Academy until 1774 and the artist did not receive payment for it until 1779, together with his fee for a portrait of the sitter's daughter Sophia Matilda, who had been born in 1773. His price, that usual for a full-length, was £150. In 1844 the painting was bequeathed by the Duchess's daughter to the Prince Consort, who hung it in his Drawing Room at Buckingham Palace.

1774 was the year in which Reynolds's rival, Gainsborough, moved from Bath to London. It has been pointed out that Reynolds made considerable display of his erudition – the very quality which Gainsborough lacked – in the paintings which he displayed at the Royal Academy in 1774. This is confirmed by the tone of his *Sixth Discourse on Art*, delivered to the students of the Royal Academy at the distribution of the prizes in December of the same year. The lecture is a detailed *apologia* for the study and the appropriation of ideas from the Old Masters, ranging across the principal Italian and northern schools of the sixteenth and seventeenth centuries. For this reason, the similarities between the bulky form, seated pose and melancholic attitude of the Duchess and Albrecht Dürer's famous engraving of *Melancholia I*, dated 1514, are unlikely to be accidental. Indeed, in the *Sixth Discourse* Reynolds specifically noted that 'The works of Albert Durer ... afford a rich mass of genuine materials, which wrought up and polished to elegance, will add copiousness to what, perhaps, without such aid, could have aspired only to justness and propriety'.

Maria, Duchess of Gloucester (1739-1807) was an illegitimate daughter of Sir Edward Walpole, the brother of the *dilettante* Horace Walpole. In 1766 she secretly married William, Duke of Gloucester (1743-1805), a younger brother of George III. Another of the King's brothers, Henry, Duke of Cumberland also married secretly – in 1771 (cat no 25). In 1772, after the Duchess of Gloucester became pregnant, her husband admitted to George III that he had married. The King banned the Duke and Duchess from the court and for many years refused to acknowledge their marriage. Notwithstanding this public ostracism and the passing of the 1772 Royal Marriage Act making it illegal for members of the Royal Family to marry without the previous consent of the Crown, the ban against associating with the Duke and Duchess was not strictly observed. A contemporary recalled 'The Duchess of Gloucester maintained a degree of state, approved of by the Duke, that gave some stiffness to her parties, which were commonly rather select'.

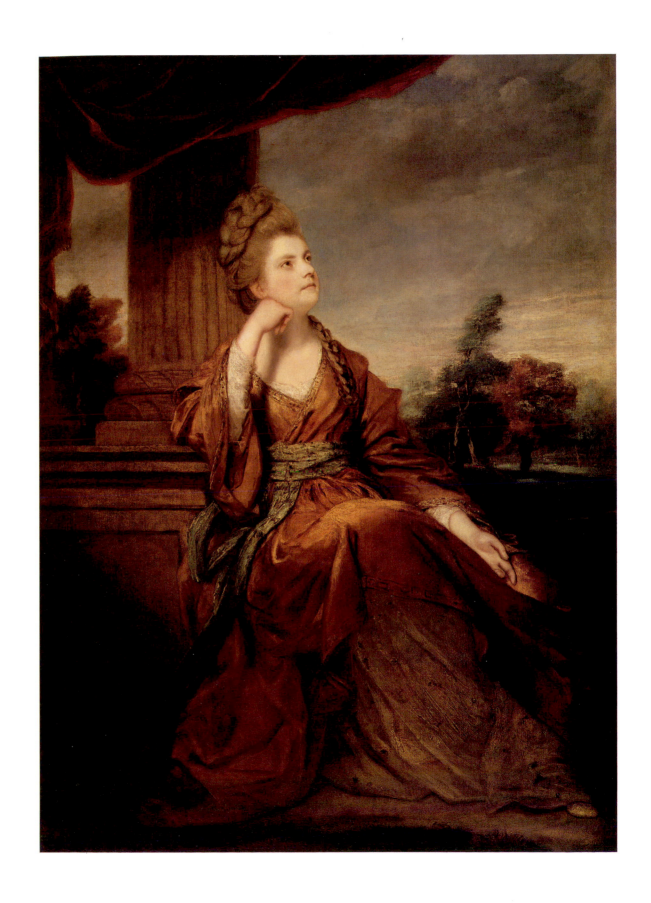

40

Sir Joshua Reynolds 1723-92
Thomas, Lord Erskine 1786

Oil on canvas
127 × 101 cm (50 × 39¾ in)

OM 1020

DNB VI, pp 853-61

R G Thorne, *The House of Commons 1790-1820*,
vol III, London 1986, pp 710-13

E K Waterhouse, *Reynolds*, London 1941,
pp 13-14, 77 & pl 264

C Hibbert, *George IV*, Harmondsworth 1976,
pp 275-82 & 586

R Walker, *Regency Portraits*, National Portrait
Gallery, London 1985, vol 1, pp 174-76

Despite failing health and the dislike of George III, Reynolds succeeded Allan Ramsay as Principal Painter to the King in 1784. At the time, he charged 100 guineas for a half-length, such as this. Erskine sat to Reynolds in January and February 1786 and his portrait was exhibited at the Royal Academy in the same year. The sitter gave it to the Prince of Wales in 1810 and it hung at Carlton House until 1828 when it was removed to Windsor.

A son of the 10th Earl of Buchan, Thomas Erskine (1750-1823) was brought up in straightened circumstances. After studies at the University of St Andrews, he served as a midshipman in the Royal Navy in 1764-68 and as an ensign and lieutenant in the 1st Foot in 1768-75. That year he sold his commission and entered as a student at Lincoln's Inn. He received his MA from Trinity College, Cambridge and was called to the Bar in 1778. Erskine made his reputation with his defence of Lord George Gordon in 1781. By 1786 he was, by his own account, 'as high as I can go at the bar' and in 1791 his annual income reached the enormous sum of £10,000. A favourite of the Prince of Wales, he was his attorney-general in 1783-92 and chancellor of the Duchy of Cornwall in 1802-07. In 1806 he was a member of the Commission of Enquiry which made the 'Delicate Investigation' into charges of adultery against the Princess of Wales and concluded that these were groundless (cat nos 30 & 32).

As MP for Portsmouth from 1790, he was a member of the Whig Club and a supporter of Charles James Fox against William Pitt (cat no 31). In 1802, during the Peace of Amiens, he was introduced to – and snubbed by – Napoleon. Four years later he was appointed Lord Chancellor and entered the Lords as Baron Erskine of Restormel. In 1820 he returned to the public eye with an impassioned defence of Queen Caroline against the Bill of Pains and Penalties brought against her by his old patron, by then George IV. A contemporary recalled 'He was a most brilliant, but sometimes a shooting star ... The very conflicting brilliance of his numerous superiorities led him into unsteadiness, and often into errors ... the meteors that danced before him often led him on too rapidly and too irregularly. He was apt to grasp at too much'. After painting his portrait, Reynolds remarked 'There is a wildness in his eye, approaching to madness, such as I scarcely ever met with in any other instance'.

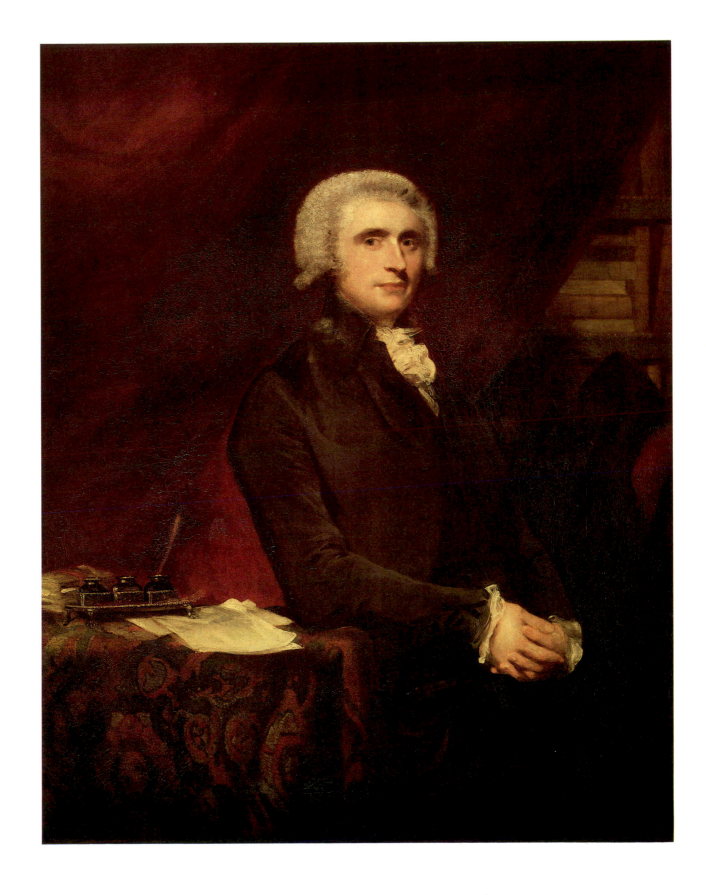

41
Sir Joshua Reynolds 1723-92
Portrait of the artist 1788

Oil on panel
75.2 × 63.2 cm (29 $\frac{5}{8}$ × 24 $\frac{7}{8}$ in)

OM 1008

OM 1032, 1210, xxv & pp 97-8

E K Waterhouse, *Reynolds*, London 1941,
pp 13-15, 38-39, 48-49, 57, 61, 64, 66 & 80 & pls
16, 17, 66, 150 & 160

N Penny (ed), *Reynolds*, Royal Academy of Arts,
London 1986, pp 320-22

S C Hutchinson, *The History of the Royal Academy
1768-1968*, London 1968, pp 45 & 49-51

Reynolds was profoundly impressed by Rembrandt, who inspired the distinguished series of self-portraits which punctuated the British painter's career. This picture, painted in 1788, belonged to Reynolds's niece, Mary Palmer, Marchioness of Thomond. In 1812 she presented it to the Prince of Wales, observing 'The deep sense I have of your Royal Highness's goodness to my uncle ... and your gracious condescension in accepting this portrait from my hand, will ever be a source of the most heartfelt satisfaction, since it must be accompany'd with the idea that it is his patron (and may I presume to say his friend) who thus honours his memory'. At Carlton House in 1816, it was in Buckingham Palace by 1841.

The artist is modestly but fashionably dressed, his wig loosely curled to resemble natural hair. This is the only one of the artist's self-portraits to show him wearing the spectacles which he adopted for painting, following the 'violent inflammation of the eyes' which he suffered in 1782. Reynolds deliberately alluded to his growing deafness, which necessitated the use of an ear-trumpet by 1772 (cat no 59), in an earlier self-portrait where he is shown with a hand cupped to one ear. It is therefore possible that the spectacles are a specific allusion to his failing sight. In 1789 he lost the use of one eye and by 1791 was almost completely blind. This likeness proved immensely popular and numerous copies of it exist, including some painted in the artist's studio. The cracking of the paint surface was caused by Reynolds's use of quick driers and bitumen. These caused the top paint layers to harden before the under-paint was properly dry, leading to swelling which subsequently fragmented the surface into knobbly lumps.

Sir Joshua Reynolds (1723-92) was historically the most important figure in eighteenth-century British art. Born in Devon, he studied in London under Thomas Hudson, before going to Rome in 1750. He spent two years in Italy before returning to immediate success. By 1755 he had over one hundred sitters in a single year and was charging as much as Hudson: 24 guineas for a half-length and 48 for a full-length portrait. Further price rises followed in 1758, 1759, 1764 and 1782 (cat nos 39 & 40). In 1764 his intellectual interests were stimulated by the foundation of 'The Club', whose other members included the poet and lexicographer Dr Johnson, the political writer Edmund Burke, the poet and dramatist Oliver Goldsmith, the historian Edward Gibbon, the economist Adam Smith and the actor David Garrick. Although Reynolds initially remained aloof from the founding of the Royal Academy, he was unanimously elected its first President – an office which he retained for the rest of his life (cat no 59). In 1769 he delivered before the Academy the first of fifteen *Discourses on Art* in which he expounded his aesthetics. Four years later his campaign to elevate painting to the status of a liberal art received official recognition when he was awarded an honorary doctorate in civil laws from the University of Oxford. Although appointed Principal Painter to the King in 1784, his work was never popular with George III. By contrast, the Prince of Wales always admired Reynolds and owed the painter £682 10s at the time of his death.

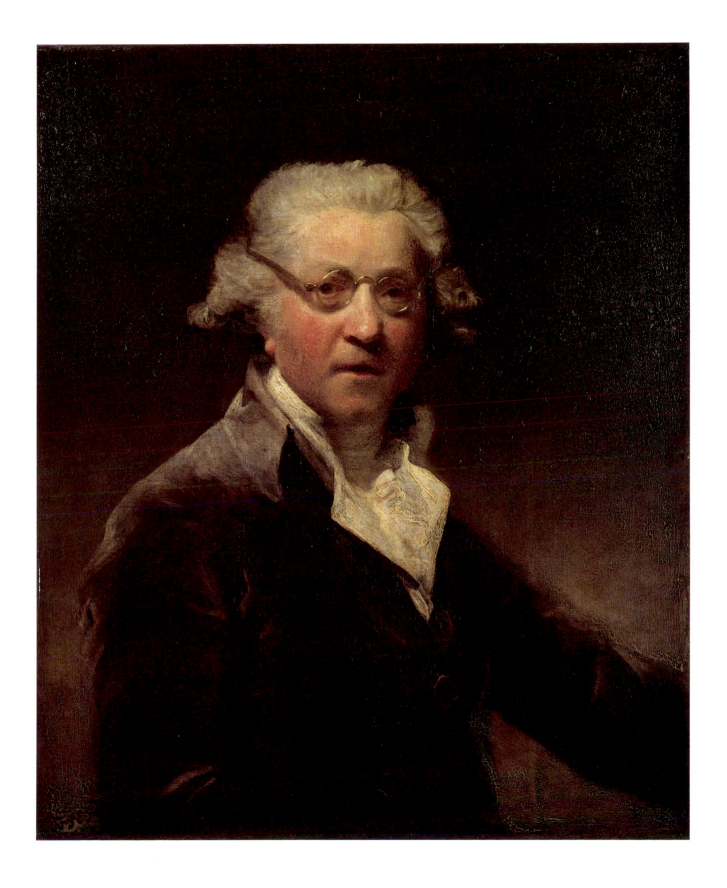

42
Marco Ricci 1676-1730
and Sebastiano Ricci 1659-1734
Landscape with cattle and a woman with a seated man

Oil on canvas
73.7 × 125.1 cm (29 × 49¼ in)

ML 625

ML 624, 626, 627, 637-40

J Daniels, *Sebastiano Ricci*, Hove 1976, pp xiii-xiv
& 54

J Daniels, 'Sebastiano Ricci in England', *Atti del
Congresso internazionale di studi su Sebastiano Ricci
e il suo tempo*, Milan 1976, pp 68-70 & 74-76

F Vivian, *The Consul Smith Collection*, Munich
1989, pp 18-20, 54-55, 60-61, 66-67, 70-74 &
76-77

Both Sebastiano Ricci and his nephew Marco were from the hill town of Belluno on the Venetian mainland. Thoroughly familiar with the styles of the principal Bolognese and Venetian artists of the later sixteenth and seventeenth centuries, Sebastiano became the leading painter of religious and mythological themes in early eighteenth-century Venice. Marco excelled as a landscape and architectural painter. He moved to London in 1708, where he received numerous commissions and designed scenery for the impresario Owen McSwinny, who was subsequently associated with Canaletto (cat nos 3 & 19). In 1711-12 Sebastiano joined his nephew in Britain, where he decorated Chiswick House and Burlington House for the gentleman architect and champion of Palladianism, Lord Burlington (cat nos 51 & 52). When Sebastiano and Marco returned to Venice in 1716, they soon became associated with Joseph Smith, the British diplomat and collector. His wife, the singer Catherine Tofts, whom Marco knew when she was appearing at the Haymarket in 1708-09, may have made the introductions. When Owen McSwinny fled to Venice to elude his creditors some years later, he lodged at Smith's residence, where he launched his project for a series of large allegorical paintings of tombs commemorating great figures in British history. Both Sebastiano and Marco Ricci, as well as the young Canaletto (cat no 3), were involved with this project. Smith acquired a magnificent collection of paintings and drawings by Sebastiano and Marco. Some were engraved and issued as a series of prints, as were many of the Canalettos in Smith's collection (cat nos 3, 11 & 15). Most later entered the collection of George III.

This painting is one of a set of four large landscapes, of which another is included in the exhibition (cat no 43). Acquired by George III in 1762, they were hung in the Queen's Drawing Room at Kew Palace and were moved to the Grand Corridor at Windsor in 1828. Consul Smith's own lists of his collection are lost, but one probably based upon them which was drawn up towards the end of George III's reign attributes these 'beautiful landscapes' to Marco and the figures in them to his uncle. While it is perhaps unrealistic to seek to distinguish absolutely between hands, it has recently been proposed that this picture is entirely by Marco.

43

Marco Ricci 1676–1730
and Sebastiano Ricci 1659–1734
Landscape with a woman and child in the foreground

Oil on canvas
73 × 123.8 cm (28¾ × 48¾ in)

ML 627

ML 591–622 & 624–26

J Daniels, *Sebastiano Ricci*, Hove 1976, pp xiii–xiv, 54 & 148–49

J Daniels, 'Sebastiano Ricci in England', *Atti del Congresso internazionale di studi su Sebastiano Ricci e il suo tempo*, Milan 1976, pp 68–70 & 74–76

F Vivian, *The Consul Smith Collection*, Munich 1989, pp 18–20, 54–55, 76–77, 80–81 & 86–91

One of a set of four large landscapes, of which another is included in the exhibition (cat no 42), this work is traditionally attributed to Marco Ricci, with figures added by his uncle Sebastiano. From the collection of Consul Smith, it was acquired by George III in 1762. Initially hung in the Queen's Drawing Room at Kew Palace, it was transferred to the Grand Corridor at Windsor in 1828.

Just as Sebastiano Ricci was profoundly influenced by Veronese, so Marco turned to the sixteenth-century pioneers of Venetian landscape painting. It has been pointed out that his early drawing style was reminiscent of the Renaissance painter and print maker Domenico Campagnola. The principal motifs in this composition: hills, fortified farmhouses, peasants and cattle, derive ultimately from the landscape backgrounds of Titian's religious paintings and mythologies, executed at the beginning of the sixteenth century. Ricci was a native of the mountainous Venetian mainland, to which he apparently returned annually for inspiration. His delicate handling of light and tone, schooled by the transitory atmospheric conditions of the hills, reflects a traditional fascination of Venetian artists.

George Stubbs 1724-1806
John Gascoigne with a bay horse 1791

Oil on canvas
101.6 × 127.6 cm (40 × 50¼ in)
signed and dated: *Geo: Stubbs pinxit/1791*

OM 1111

OM xxix

J Egerton, *George Stubbs 1724-1806*, Tate
Gallery, London 1984, pp 79 & 160

C Hibbert, *George IV*, Harmondsworth 1976,
pp 32-38, 46-49, 90, 173-74 & 334

Born in Liverpool, Stubbs trained as a painter and anatomist. By 1765 he was established as an animal painter, with numerous aristocratic patrons. From 1762 he exhibited at the Society of Artists and in 1781 was elected a Royal Academician, but did not receive its diploma as he refused to deposit a diploma picture. This is one of eight paintings by Stubbs in the Prince of Wales's collection which were provided with matching frames by Thomas Allwood for £110 16s 0d in 1793 (also cat nos 45, 47, 48, 50). Presumably commissioned by the Prince, it was at Carlton House in 1816 and was transferred to the King's Lodge in 1822 and, subsequently, to Cumberland Lodge.

The horse has been identified as Creeper, a colt bred by Lord Archibald Hamilton in 1786 by Tandem out of Harriet. In 1791, the year in which he was purchased by the Prince of Wales, he won a subscription purse of sixty guineas at Newmarket and the King's Plate at Lichfield. Creeper's portrait was presumably painted to commemorate this successful season. In 1792 the scandal over the Prince's horse Escape caused him to disperse his Newmarket stud and Creeper was sold, running his last race in 1794 (cat no 45).

Stubbs employed the motif of a groom approaching with a sieve of feed in a number of his paintings of horses. John Gascoigne (d.1812) was hunting groom and subsequently head groom to the Prince of Wales in 1785-1800 and in 1802-12 was Clerk of the Stables. In his younger days the Prince of Wales was notorious for his affairs (cat no 23) and had at least three illegitimate children. A contemporary claimed that he 'had a seraglio' in the Gascoigne family at his hunting seat in Hampshire, where Creeper seems to have been kept in 1791-92, 'the brother of the females being raised from groom to the head of the stud stables, and at his death buried with the honours of the Royal liveries'.

George Stubbs 1724–1806
George IV when Prince of Wales 1791

Oil on canvas
102.5 × 127.6 cm (40⅜ × 50¼ in)
signed and dated: *Geo: Stubbs pinx/ 1791*

OM 1109

OM 820-23, 818, 937-42, xxviii-xxix & pp 44-45

C Hibbert, *George IV*, Harmondsworth 1976, pp 40, 50, 66 & 142-53

R Walker, *Regency Portraits*, National Portrait Gallery, London 1985, vol 1, pp 200-13

George III had no interest in sporting art, but the Prince of Wales inherited several equestrian pictures which had belonged to his great-uncle William, Duke of Cumberland (1721-65) and during the 1790s commissioned a considerable group of paintings of horses from George Garrard and Benjamin Marshall, as well as Stubbs. This is one of eight paintings by Stubbs in the collection of the Prince provided with matching frames in 1793 (also cat nos 44, 47, 48, 50). At Carlton House in 1816, it was subsequently at the King's Lodge, Stud Lodge, Marlborough House and Buckingham Palace.

Probably identical with a work exhibited by Stubbs at the Royal Academy in 1791, it depicts the Prince wearing the star of the Garter, riding a chestnut horse accompanied by two terriers. The setting is probably Hyde Park with Westminster faintly visible across the Serpentine in the background. When the Prince of Wales was eighteen his father had encouraged him to go riding 'provided it is for exercise, not lounging about Hyde Park'. Two years later he infuriated George III by missing a Royal levee to hunt in Northamptonshire. He is also known to have ridden from London to Brighton and back in a day, a distance of 108 miles in ten hours.

At the time this picture was painted the Prince was politically isolated, his negotiations with the Whigs over the Regency Bill having come to nothing when George III recovered from the mental illness which had afflicted him in 1788-89. He was frequently under attack in the newspapers and the popular prints for overindulgence and gambling, as well as his friendship with 'creatures with whom a man of morality or even common decency' should not associate, such as Sir John and Lady Lade (cat no 47). Between 1788 and 1791 his horses won one hundred and eighty-five races at Newmarket. However in October 1791 there was a scandal when the Prince's horse Escape was beaten by two outsiders, only to win easily the following day at odds of 5 to 1 against. Although the Prince was not accused of impropriety, he was angered by the Jockey Club inquiry, vowed never to race at Newmarket again and sold his stud of horses.

George Stubbs 1724-1806
William Anderson with two saddle horses 1793

Oil on canvas
102.2 × 127.9 cm (40¼ × 50⅜ in)
signed and dated: *Geo: Stubbs p:/ 1793*

OM 1110

OM xxix

J Egerton, *George Stubbs 1724-1806*, Tate
Gallery, London 1984, p 176

C Hibbert, *George IV*, Harmondsworth 1976,
pp 89-92, 102-05, 148, 302-03 & 519-22

Presumably commissioned by George IV when Prince of Wales, this work was at Carlton House in 1816 and was transferred to the King's Lodge in 1822 and, subsequently, to Cumberland Lodge.

The Prince of Wales expressed his appreciation of chestnut horses in a letter to his friend Sir John Lade (cat no 47) from Brighton in 1792: 'I have driven every day of late the chestnut horses wh. go better than any horses I have belonging to me'. William Anderson appears here in the royal livery of scarlet with blue collar and cuffs. Helper and hack-groom to the Prince in 1788-1800, he was appointed head groom in 1804 and Groom to the Stables in 1812. The presence of his master is alluded to by the empty saddle of the horse he is leading. In Stubb's equestrian portrait of two years earlier, the Prince is also riding a chestnut horse (cat no 45).

The coastal landscape behind the groom and his charges is probably a view of the downs near Brighton. First visited by the Prince in 1783, he began to build a house there in 1787 and the town soon became the most fashionable resort in England. The Prince frequented the Brighton and Lewes races and in 1807-08 spent £55,000 adding to his Marine Pavilion a stable block for fifty-four horses. When William Anderson stayed at Brighton for twelve days during 1793 he was paid one shilling a day for board and lodging.

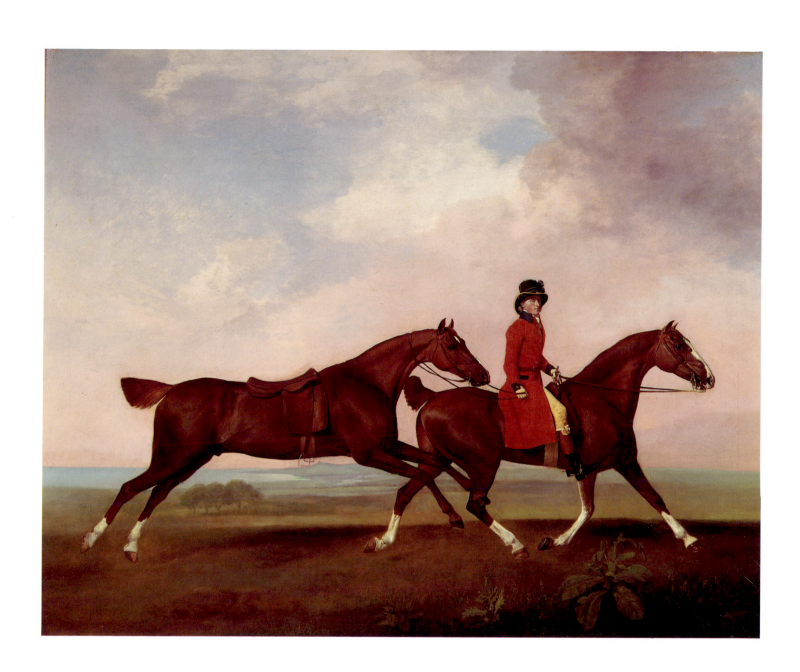

George Stubbs 1724–1806
Laetitia, Lady Lade 1793

Oil on canvas
102.2 × 127.9 cm (40¼ × 50⅜ in)
signed and dated: *Geo: Stubbs pinxit/ 1793*

OM 1112

OM xxviii–xxix & p 122

J Egerton, *George Stubbs 1724–1806*, Tate
Gallery, London 1984, pp 176–77

E K Waterhouse, *Reynolds*, London 1941, pp 76 &
pl 252

C Hibbert, *George IV*, Harmondsworth 1976,
pp 42–3, 145–47 & 310

Presumably commissioned by George IV when Prince of Wales, this is one of eight paintings by Stubbs provided with identical frames in 1793 (also cat nos 44, 45, 48, 50). At Carlton House in 1816, it was sent to the King's Lodge in 1822 and to Cumberland Lodge in 1844.

Set either in Kensington Gardens or St James's Park, this painting displays the considerable skills of the rider. Side-saddle, she controls her prancing horse with a whip and the additional rein running from bridle to saddle used to restrain spirited horses. Laetitia Darby, alias Smith, later Lady Lade (*d.*1825) had obscure origins. Reputedly the mistress of the highwayman John Rann, known as 'Sixteen-String Jack', she met the Prince of Wales at a masquerade in 1781 and confessed her love for his brother, Prince Frederick. The Prince of Wales recounted the meeting to the latter, concluding 'I believe no woman ever loved a man more passionately than she does you. She cried very much'. By 1785 she was the mistress of Sir John Lade (1757–1838), who was later reputed to have met her 'at a house in Broad Street, St Giles's, whose inhabitants were not endowed with every virtue'. Her portrait by Reynolds was exhibited at the Royal Academy in 1785 as 'Portrait of a Lady' and two years later she married Sir John. A member of the Jockey Club and the Four-in-Hand Club, he was a friend of the Prince of Wales, to whom he sold horses and gave advice on equestrian matters (cat no 49). Lord Thurlow (cat no 30) disapproved of him and in 1805, on discovering that he had been invited to dine on the same occasion, remarked to the Prince, 'I have, Sir, no objection, to Sir John Lade in his proper place, which I take to be your Royal Highness's coach-box, and not your table'.

At Brighton Pavilion in 1789 Lady Lade danced with the Prince, causing Lady Elizabeth Luttrell (cat no 25) and others to withdraw. *The Times* of 5 August 1789 criticised his public acknowledgment of 'a woman who lived in the style of a mistress to one-half of his acquaintance ... among those acquaintances, his own brother made one of that very woman's keepers'. Although moved by her notoriously bad language to coin the expression 'to swear like Lady Lade', the Prince of Wales was heedless of her critics, enclosing a ring 'with my very best compliments to my Lady' in a letter to her husband in 1791 and commissioning the present work two years later. He also granted the Lades an annual pension of £300, although Sir John was nevertheless imprisoned for debt in 1814.

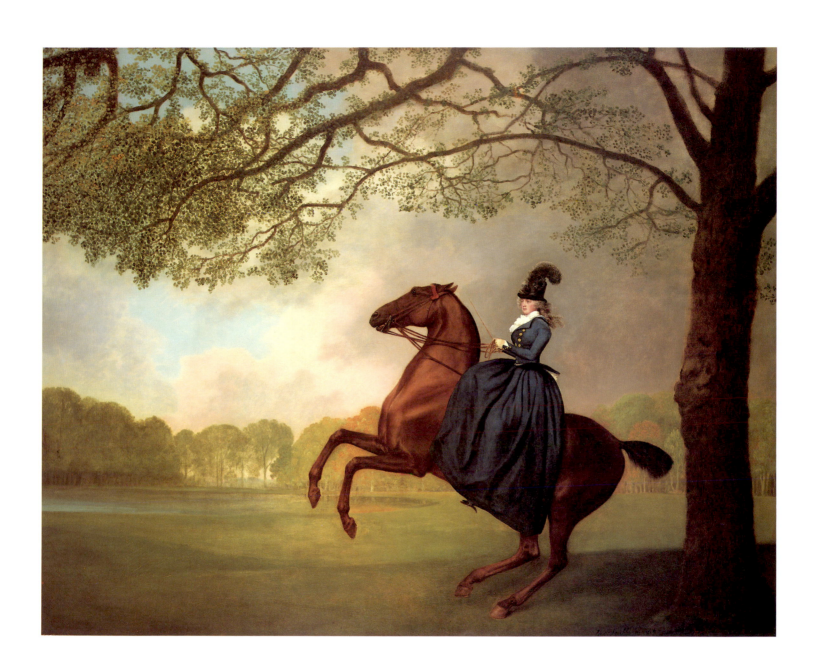

George Stubbs 1724-1806
Soldiers of the Tenth Light Dragoons 1793

Oil on canvas
102.2 × 127.9 cm ($40\frac{1}{4}$ × $50\frac{3}{8}$ in)
signed and dated: *Geo: Stubbs p:/1793*

OM 1115

OM xxix & p 122

J Egerton, *George Stubbs 1724-1806*, Tate
Gallery, London 1984, p 179

1776 The British Story of the American Revolution,
National Maritime Museum, London 1976,
pp 15, 17 & 193

C Hibbert, *George IV*, Harmondsworth 1976,
pp 163-165 & 220-23

The present work is one of eight paintings by Stubbs in the collection of the Prince of Wales which were provided with identical frames in 1793 (also cat nos 44, 45, 47, 50). In 1816 it was in the Armoury at Carlton House.

The soldiers portrayed are a mounted sergeant, a trumpeter, a sergeant shouldering arms and a trooper presenting arms. Both sergeants and the trooper are wearing the helmet known as the 'tarleton helmet' after the famous light cavalry officer of the American War of Independence, Col Sir Banastre Tarleton (cat no 23), who wears headgear of this type in his portrait by Reynolds of 1782. The strips of braid running across the soldiers' jackets were introduced in 1784 and probably derive from the decorative lacing of continental hussar costume. The trumpeter wears a jacket with 'reversed colours' – that of the facings rather than the uniform of the regiment – usual with military musicians during the period. Instead of a helmet, he wears a hussar busby of the sort adopted by the 10th Light Dragoons after they converted to hussar dress in 1805 (cat no 2). These distinctive variations of uniform served the practical function of making trumpeters more conspicuous to their officers in battle – a major consideration in an era when orders were conveyed by trumpet calls. While the mounted sergeant wears riding boots and spurs, the others wear short boots as part of their dismounted dress order.

Just before the French declaration of war on Britain in 1793 the Prince of Wales had been appointed Colonel Commandant of the 10th Light Dragoons, thereafter known as 'The Prince of Wales's Own' (cat no 2). Accordingly, the mounted sergeant's saddle cloth and holster flaps bear the device of the Prince of Wales's feathers. Although immensely proud of his regiment, after the Duke of York was dispatched to command the British forces in the Netherlands he fretted against his 'inglorious life, while his brother and all the Princes of Europe are acting personally in their common cause', wishing 'to serve abroad and to have his share of the glory that is going'. George III refused his request, later adding 'The command I have given you of the 10th Regiment of Light Dragoons, should the enemy succeed in their intentions of invading this island, will enable you at the head of that brave Corps to show the valour which has ever been a striking feature in the character of the House of Brunswick'. On 12 August 1793 the Prince of Wales spent his thirty-first birthday with the regiment, then encamped at Brighton; an event which the present work may have been commissioned to commemorate. Subsequently, the 10th Light Dragoons served with Sir John Moore on the Corunna campaign in 1808-09 and with the Duke of Wellington at the battles of Vitoria, Orthez, Toulouse and Waterloo in 1813-15.

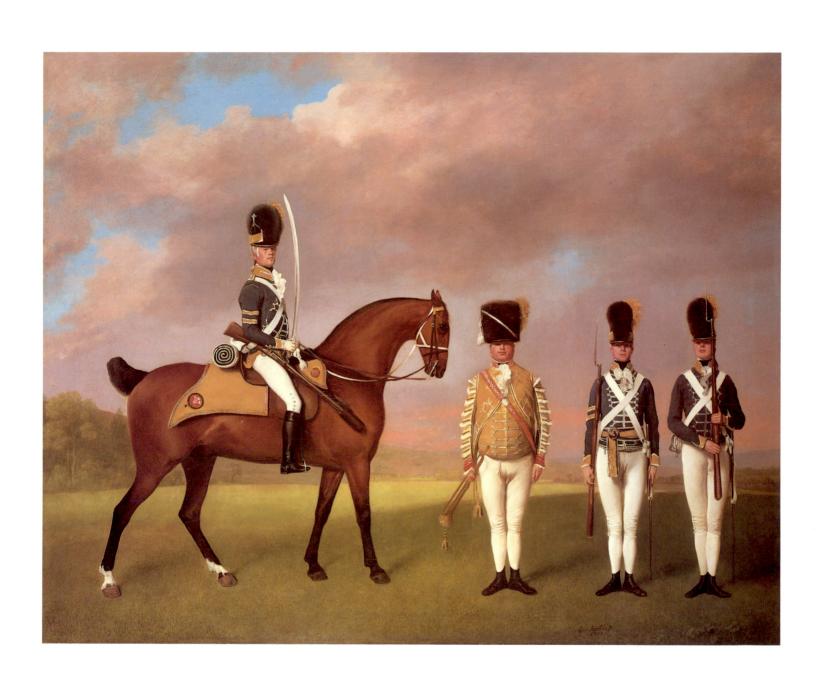

49

George Stubbs 1724-1806
The Prince of Wales's Phaeton 1793

Oil on canvas
102.2 × 128.3 cm (40¼ × 50½ in)
signed and dated: *Geo: Stubbs pinxit/ 1793*

OM 1117

OM 1110, 1124, xxix

J Egerton, *George Stubbs 1724-1806*, Tate
Gallery, London 1984, p 178

C Hibbert, *George IV*, Harmondsworth 1976,
pp 66-67 & 702-03

Presumably commissioned by George IV when Prince of Wales, this painting was at
Carlton House in 1816 and was transferred to the King's Lodge in 1822 and,
subsequently, to Cumberland Lodge.

A phaeton was a light carriage, on account of its speed named after the legendary son of
Helios killed by Zeus for failing to control the chariot of the sun. Here, a groom raises the
carriage's shaft to which the two dark bay horses will be harnessed. Their blinkers bear
the device of the Prince of Wales's feathers. One horse is held by the Prince's State
Coachman, Samuel Thomas, who is wearing the full livery of a scarlet coat with gold
collar and cuffs and a black cocked hat with gold tassles. Appointed Post-Chaise Man in
Ordinary to George III in 1767, he became Body Coachman to the young Prince of Wales
in 1771 and seems to have retained this post until 1800. The Prince's black and white
Spitz dog named Fino, itself the subject of an earlier painting by Stubbs, jumps at the feet
of the second coach horse. The expanse of water in the background may be Virginia
Water, the artificial lake in Windsor Great Park made by William, Duke of Cumberland,
the godfather of George IV.

In 1792 and 1793 the Prince of Wales wrote to his friend Sir John Lade (cat no 47)
about several new carriages under construction, requesting 'If you think there is anything
to be done to make them easier, better or safer, I hope you will be so good as to give such
directions as may be necessary'. One of these is presumably the phaeton in the present
work, which may have been painted to commemorate its inauguration. It is of the type
known as a 'Highflyer' on account of its height, which would have made it comparatively
dangerous to drive. The Prince prided himself on his coach driving, boasting to his
brother Prince Frederick of his 'pretty good driving' in covering 22 miles in two hours at
a trot in a phaeton-and-four. As in Stubbs's portrait of *William Anderson with two saddle
horses* (cat no 46), painted by Stubbs the same year, the Prince's presence is alluded to by
the preparations for a journey which he is shortly to make.

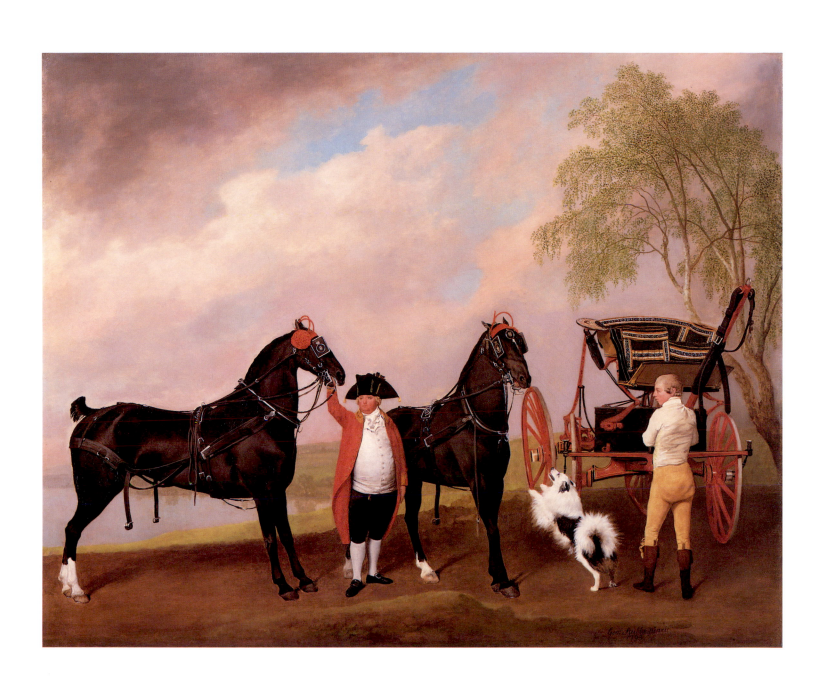

50

George Stubbs 1724-1806
A Grey Horse 1793

Oil on canvas
102.2 × 127.3 cm ($40\frac{3}{4}$ × $50\frac{1}{8}$ in)
signed and dated: *Geo: Stubbs./pinxit 1793*

OM 1123

OM 819, 820, 1119 & 1122, xxviii-xxix & p 122

J Egerton, *George Stubbs 1724-1806*, Tate
Gallery, London 1984, pp 59-61, 70, 126 & 133

The present work is one of eight pictures by Stubbs provided with matching frames in 1793 (also cat nos 44, 45, 47, 48). Presumably commissioned by George IV when Prince of Wales, this is one of a pair of paintings in the Royal Collection of identical size and date of what appears to be the same horse. In the other, it is walking to the left without a bridle. Both were at Carlton House in 1816 and were transferred to the King's Lodge in 1822 and, subsequently, to Cumberland Lodge.

The horse has been identified as Grey Trentham, a colt bred by the 3rd Earl of Egremont, in 1788 by Trentham out of a mare by King Herod. Paintings by Sawrey Gilpin of Herod and his dam, Cypron, were painted for the Duke of Cumberland and inherited by the Prince Regent. Grey Trentham raced in 1791-94, winning the King's Plate at Burford and Lichfield in 1793 and the King's Plate at Guildford in 1794.

Stubbs generally finished his horses before beginning their landscape settings, which were subsequently painted up to the edge of the figure. Technical analysis of the present work indicates that the painter initially intended to portray Grey Trentham with a saddle and girth and had also left a blank area of ground for a figure of a rider. This is also true of Stubbs's other painting of the horse in the Royal Collection, in which the outline of a rider is visible under infra-red light. The Prince of Wales was passionate about horse racing, but sold his stud in 1792 following a Newmarket scandal (cat no 45).

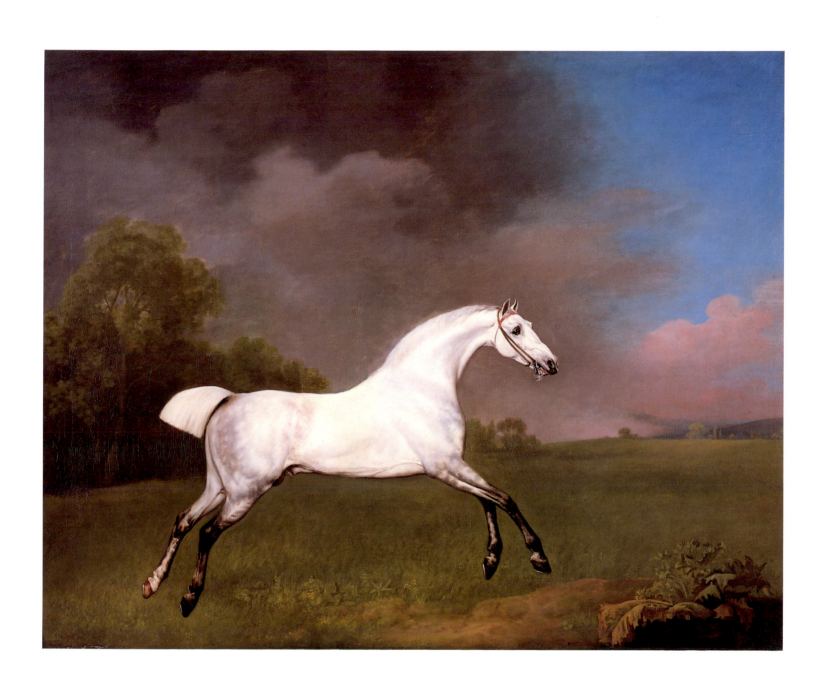

51

Antonio Visentini 1688–1782
and Francesco Zuccarelli 1702–88
Burlington House, London 1746

Oil on canvas
80 × 130.8 cm ($31\frac{1}{2}$ × $51\frac{1}{2}$ in)
signed and dated: *Visentini et Zuccarelli/*
Fecerunt Venetiis 1746

ML 671

ML 386–91, 396, 397, 669–70 & 672–76,
pp 28–35

F Vivian, *The Consul Smith Collection*, Munich
1989, pp 14–15, 21–22 & 108–23

D Succi, *Canaletto & Visentini Venezia & Londra*,
Gorizia 1986, pp 216–73

A Blunt, 'A neo-Palladian programme executed
by Visentini and Zuccarelli for Consul Smith',
Burlington Magazine, no 665, vol 100, August
1958, pp 283–84

C Campbell, *Vitruvius Britannicus*, London
1715–25 (reissued in 1 vol, New York 1967), vol
3, pp 7–8 & pl 23–24

J Summerson, *Architecture in Britain 1530 to
1830*, Harmondsworth 1970, pp 257–58, 319–20,
332–38 & 347

Trained as a painter, Visentini became associated with Joseph Smith in around 1717. In
1735 his series of prints after Canaletto's views of the Grand Canal in Smith's collection
was published (cat nos 3–10). He remained closely associated with Smith, as an illustrator
and architect, until the latter's death in 1770. In 1743–44 Smith commissioned from
Canaletto a series of pictures, most of which are now in the Royal Collection, depicting
Venetian monuments, including the principal buildings of Palladio, in imaginary settings.
This inspired Smith to commission a series of British architectural subjects, mainly
Palladian in style. Eight of these remain in the Royal Collection, of which the present
work and one other (cat no 52) are included in the exhibition. Visentini painted the
buildings, using volumes of British architectural engravings for reference, and the Tuscan
painter Zuccarelli executed the figures and landscape settings. Painted in 1746 and
acquired in Venice by George III in 1762, the series was hanging in the Hall at
Buckingham House by 1819 and was moved to the Grand Corridor at Windsor in 1828.

In the present work, the view of Burlington House is based upon pl 23–24 in the third
volume of Colen Campbell's *Vitruvius Britannicus* published in 1725. Campbell describes it
thus: 'In the double Plate you have the principal Front, where a bold rustick Basement
supports a regular *Ionick* Collonade of $\frac{3}{4}$ Columns 2 Feet Diameter. The Line is closed with
Two Towers, adorned with Two *Venetian* Windows in Front, and Two Niches in Flank,
fronting each other, where the noble Patron has prepar'd the Statues of *Palladio* and *Jones*,
in Honour to an Art of which he is the Support and Ornament'. Visentini had evidently
not read this caption to the engraving, for when he transformed the regular elevation of
the façade in *Vitruvius Britannicus* into a composition receding in perspective, he omitted
the niche in the flank of the right tower, which should be visible from the changed
viewpoint.

Campbell's singling out of the sixteenth-century Vicenzan architect Andrea Palladio
and the court architect of Charles I, Inigo Jones, is significant. They were the two
authorities revered above all others by eighteenth-century British Palladian architects, for
whom *Vitruvius Britannicus* was an essential source of inspiration. When Campbell rebuilt
the façade of Burlington House in 1717 he based its design upon Palladio's Palazzo Porto-
Colleoni at Vicenza, but took its architectural details from Inigo Jones. His patron,
Richard Boyle, 3rd Earl of Burlington and 4th Earl of Cork, also contributed to the design
and himself became a leading Palladian architect. During the nineteenth century the
Royal Academy moved to Burlington House (cat no 59) which was drastically remodelled.
Zuccarelli's landscape background is entirely an invention, bearing no relationship to the
house's actual setting and omitting the forecourt linking it with Piccadilly.

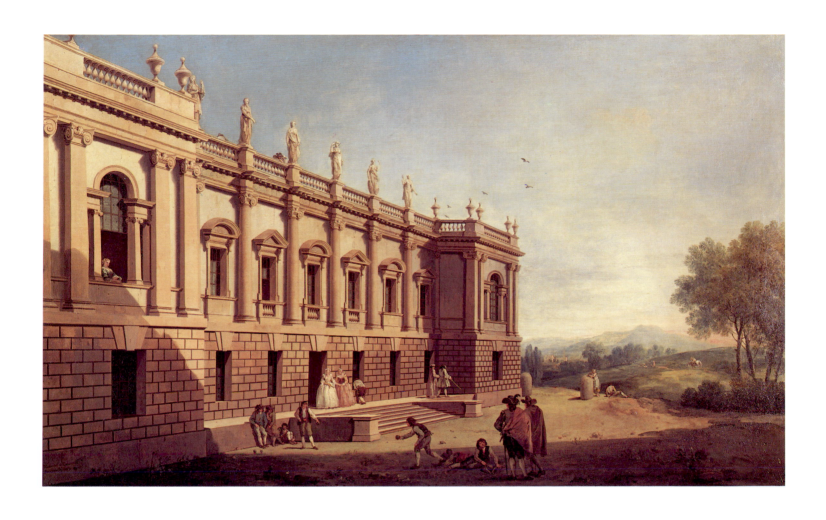

Antonio Visentini 1688-1782
and Francesco Zuccarelli 1702-88
Triumphal Arch to George II 1746

Oil on canvas
81 × 131.4 cm (31⅞ × 51¾ in)
signed and dated: *Visentini et Zuccarelli/
Fecerunt Venetiis 1746*

ML 672

ML 669-71 & 673-706, pp 28-35

F Vivian, *The Consul Smith Collection*, Munich
1989, pp 14-15, 21-22 & 108-23

D Succi, *Canaletto & Visentini Venezia & Londra*,
Gorizia 1986, pp 216-73

A Blunt, 'A neo-Palladian programme executed
by Visentini and Zuccarelli for Consul Smith',
The Burlington Magazine, no 665, vol 100,
August 1958, pp 283-84

J Summerson, *Inigo Jones*, Harmondsworth 1966,
pp 122-24

J Summerson, *Architecture in Britain 1530 to
1830*, Harmondsworth 1970, pp 338-46

Like the previous work, this is part of a series commissioned by Consul Smith in 1746, with architecture painted by Visentini and figures and landscape by Zuccarelli. Acquired by George III in 1762, it hung in the Hall at Buckingham House by 1819 and was moved to the Grand Corridor at Windsor in 1828.

The series comprised views of five buildings by Inigo Jones and five by leading British Palladian architects of the early eighteenth century, including Campbell and Lord Burlington. Only one depicts the work of an English Baroque architect, and this is a view of an uncharacteristically Palladian design by Sir John Vanbrugh. Unlike the other views, which are based upon engravings in Campbell's *Vitruvius Britannicus* published between 1715 and 1725, the present work derives from an illustration in *Designs of Inigo Jones*, published by the architect William Kent with the encouragement of Lord Burlington in 1727. The engraving in question was based upon Inigo Jones's unexecuted design of 1638 for a structure at Temple Bar between the Strand and Fleet Street, where the jurisdiction of Westminster meets that of the City of London.

Jones's design was based upon that of ancient Roman triumphal arches, such as that of Septimus Severus (cat no 14), and would have been surmounted by an equestrian statue of Charles I between figures of Hercules and Neptune. Visentini closely followed the engraving down to the sculptural reliefs on the arch. However, the Latin inscription in the painting differs from that in the print. The former, presumably written by Consul Smith, identifies the mounted figure as George II, praising him for his achievements concerning the recognition of Francis I as Emperor in 1745, the Peace of Breslau in 1742 and the defeat of the Jacobite rebellion in 1745. Smith may have been given the idea of including the triumphal arch in the series by the architect Roger Morris, who had sent him a drawing for an arch commemorating George II, intended for Eastbury in Dorset. George II was a logical dedicatee for a series of paintings depicting the glories of English Palladian architecture – especially as the third volume of *Vitruvius Britannicus* had been dedicated to him in 1725. In Zuccarelli's landscape, the mounted figures are wearing seventeenth-century costume, which may be a reference to Inigo Jones. Probably through Consul Smith, Zuccarelli made English contacts which facilitated his move to Britain in 1752. He remained there ten years, returning again in 1765-71, enjoying the patronage of George III and becoming a founder member of the Royal Academy (cat no 59).

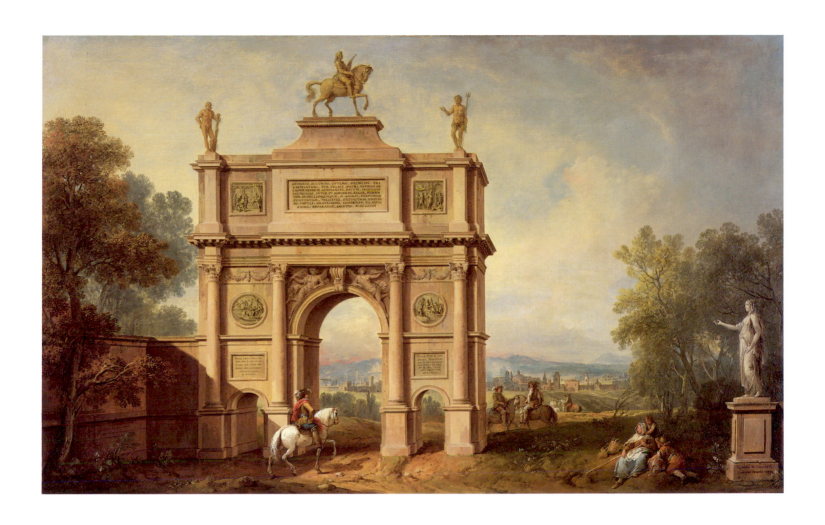

John Wootton 1682-1764
A distant view of Henley-on-Thames

Oil on canvas
101 × 153 cm (39¾ × 60¼ in)

OM 550

OM 548 & 549, pp 28-30 & 179-83

DNB VII, pp 675-78

A Meyer, *John Wootton 1682-1764*, Iveagh
Bequest, London 1984, pp 56-58

J Harris, *The Artist and the Country House*,
London 1985, p 229

J Walters, *The Royal Griffin Frederick Prince of
Wales 1707-51*, London 1972, pp 99-100, 124-25,
155-59 & 183-84

Trained by the Dutch immigrant artist John Wyck, Wootton was the leading British painter of sporting and landscape subjects during the first half of the eighteenth century. He enjoyed the patronage of leading members of the aristocracy and the Royal Family, being visited in his studio by Queen Caroline (1683-1737) and Frederick, Prince of Wales (1707-51). This is one of a set of three landscapes in the Royal Collection which Horace Walpole understood to have been painted for Lady Archibald Hamilton (d.1752), daughter-in-law of the 3rd Duke of Hamilton and from 1736 Keeper of the Privy Purse, Lady of the Bedchamber and Mistress of the Robes to Augusta, Princess of Wales (1719-72). They are usually dated to about 1742-43. At Buckingham House in around 1763, they were at Kensington Palace in 1818, were transferred to the Grand Corridor at Windsor in 1829 and were subsequently at Buckingham Palace.

The present work depicts Henley-on-Thames as viewed from the grounds of Park Place, a country house on a hill overlooking the town. Another picture, of almost the same size and included in the exhibition (cat no 54), depicts Henley from a closer viewpoint. The third in the set shows the view in the opposite direction, of Park Place itself and its surroundings seen from a point on the other side of the Thames in the fields near Henley. The estate was bought by Lord Archibald Hamilton (1673-1754), who built the country house painted by Wootton in 1719. In 1737 the Prince of Wales quarrelled with his father George II and was banished from court until 1742. Denied the use of the royal palaces, he rented Norfolk House in London, and, as a country residence, Cliveden on the Thames near Maidenhead. At about the same time he seems to have acquired Park Place, not far up river from Cliveden. Lord Archibald Hamilton and his wife, who was sometimes reputed to have been the Prince's mistress, continued to live there, probably in another house on the estate.

This picture depicts an early morning scene with, on the left, the Prince and Princess, Lady Archibald Hamilton and others and four children playing with dogs. The children are probably Princess Augusta (1737-1813), Prince George, later George III (1738-1820), Prince Edward, later Duke of York (1739-67) and Princess Elizabeth (1740-59). Wootton altered the figures of the children, leaving under-drawing which shows through in places. At the right is a group of horsemen, presumably waiting to be joined by Prince Frederick to go hunting. This narrative is concluded in the matching *View of Henley-on-Thames* (cat no 54). Although the landscape is depicted with considerable exactitude, reminiscent of the Dutch tradition, the tree framing the composition at the right alludes to the classical landscapes of Claude Lorrain, so popular with eighteenth-century British collectors.

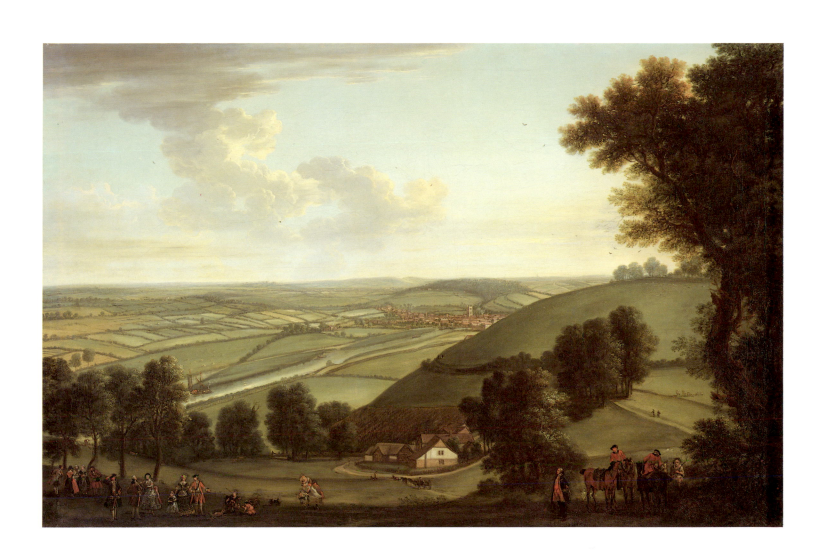

54
John Wootton 1682-1764
A view of Henley-on-Thames

Oil on canvas
101 × 156.2 cm (39¾ × 61½ in)

OM 549

OM 548 & 550, pp 28-30 & 179-83

DNB VII, pp 675-78

A Meyer, *John Wootton 1682-1764*, Iveagh
Bequest, London 1984, pp 56-58, 66 & 68-69

J Harris, *The Artist and the Country House*,
London 1985, p 229

Like the previous work, this is one of three landscapes apparently painted for Lady Archibald Hamilton. At Buckingham House in around 1763, they were at Kensington Palace in 1818, were transferred to the Grand Corridor at Windsor in 1829 and were subsequently at Buckingham Palace.

The paintings were presumably intended to be hung in a row or on adjacent walls in Park Place, the country house acquired by Frederick, Prince of Wales from Lord Archibald Hamilton in about 1738. Given the assumed date of the set of about 1742-43, it was probably painted as a gift for the Prince of Wales. This view depicts Henley from substantially further away from Park Place than the previous picture. Moreover, it portrays late afternoon, with long shadows stretching to the right, rather than early morning. At the left several horsemen are grouped around the Prince, who is wearing the ribbon of the Garter, and to the right is a group of falconers and grooms with dogs. In the centre a coach drawn by six horses greets the returning hunters. It bears the Royal Arms and the Prince of Wales's feathers, so its passengers are presumably the Princess of Wales with Princes George and Edward and Princesses Augusta and Elizabeth.

A day's hunting separates the time and place of this scene from those of the previous work. This concept of a pair of landscapes depicting different times of day derives from Claude Lorrain, whose work inspired Wootton to paint his own classical landscapes contrasting morning and evening light. However, his application of this formula to these identifiably English landscapes is a new development. After the death of Frederick, Prince of Wales, a subsequent owner of Park Place made Picturesque embellishments to the estate, moving Horace Walpole to describe it as 'one of the most charming places in England' where 'Pan & the Sylvan Deities seem to have made it their favourite residence, & Father Thames enobles it by his fair stream'.

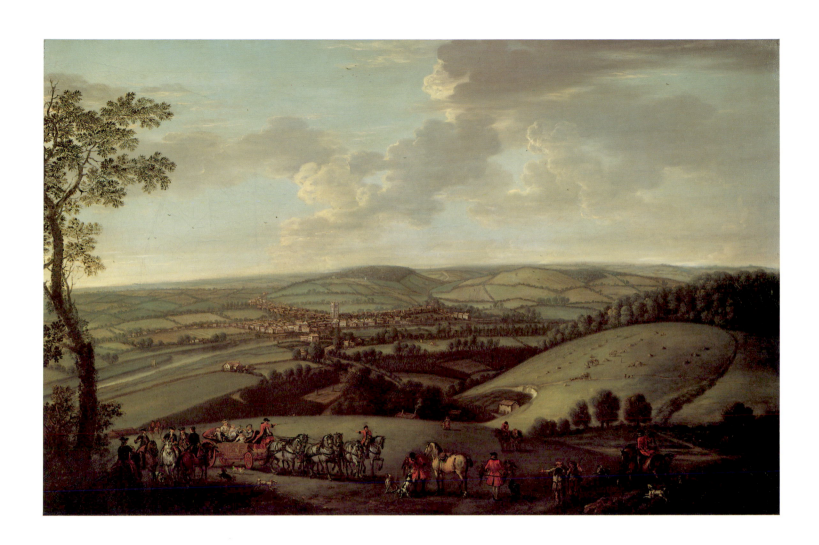

Johann Zoffany 1733/4–1810
Queen Charlotte with her two eldest sons

Oil on canvas
112.4 × 129.2 cm ($44\frac{1}{4}$ × $50\frac{7}{8}$ in)

OM 1199

OM 1200

DNB IV, p 123

M Webster, *Johan Zoffany*, National Portrait Gallery, London 1976, pp 33–34

J Brooke, *King George III*, London 1972, pp 80–85, 242 & 283

C Hibbert, *George IV*, Harmondsworth 1976, pp 17–20

O Hedley, *Queen Charlotte*, London 1975, pp 1–41 & 93

Born near Frankfurt, Zoffany studied at Regensburg and visited Rome in 1750. In about 1757 he became a court artist to the Prince-Archbishop and Elector of Trier. Zoffany came to England in 1760, a year before the marriage of George III to Charlotte Sophia of Mecklenburg-Strelitz. A diary entry by the royal governess Lady Charlotte Finch recording the order and arrival in September 1764 of 'a Telemachus Dress for the Prince of Wales and a Turk's for Prince Frederick', evidently the costumes worn by the princes in the present work, dates it to late 1764. By 1794 it was in the possession of the Prince of Wales. In 1816 it was at Carlton House, from where it was transferred first to Kew and by 1878 to Buckingham Palace.

The scene is set in the Queen's Dressing Room at Buckingham House, which seems to have been altered and rearranged somewhat in the painting. Formerly a country house of the Duke of Buckingham, this residence was purchased by George III on his marriage. It was renamed Buckingham Palace after rebuilding on a grander scale during the nineteenth century. Queen Charlotte is surrounded by some of her finest possessions. The rich lace toilet-table cover is that supplied at the cost of £1,079 14s in 1762 and the French long-case clock is still in the Royal Collection. On the table is a German silver-gilt toilet service, probably brought by the Queen to England.

Queen Charlotte Sophia (1744–1818) was the daughter of Karl Ludwig, brother of Adolf Friedrich III of Mecklenburg-Strelitz, a small protestant state north of Berlin which, towards the end of the eighteenth century, had a population of only 56,000. On 7 September 1761 she arrived in England, met George III for the first time the following day and was married that evening. At this time Horace Walpole described her thus: 'She is not tall nor a beauty. Pale and very thin; but looks sensible and genteel. Her hair is darkish and fine; her forehead low, her nose very well, except the nostrils spreading too wide. The mouth has the same fault, but her teeth are good. She talks a great deal, and French tolerably'. Although Charlotte Sophia had learned to play 'God save the King' on the harpsichord during the sea crossing from Cuxhaven to Harwich, she spoke no English at the time of her arrival. That Zoffany was himself German probably commended him towards the Queen during her early years in England. George, Prince of Wales (1762–1830) appears in the costume of Odysseus's son Telemachus with the addition of the Prince of Wales's feathers on his helmet. He was almost exactly a year older than Prince Frederick (1763–1827). The brothers would have been a month over two and a month over one year old, respectively, when they received their fancy dress costumes in September 1764 (cat no 56).

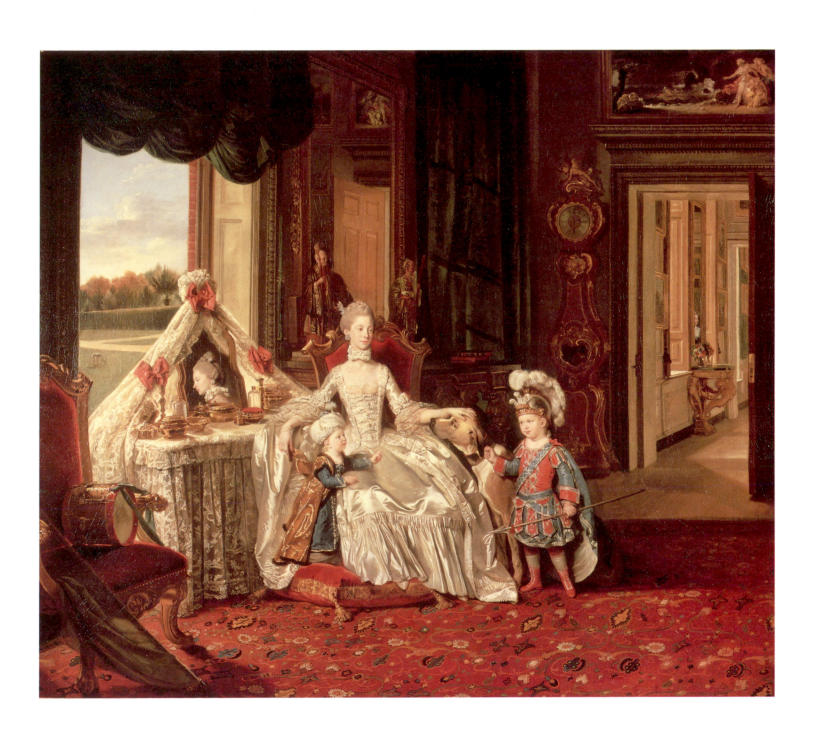

56
Johann Zoffany 1733/4-1810
George, Prince of Wales and Frederick, later Duke of York

Oil on canvas
111.8 × 127.9 cm (44 × 50⅜ in)

OM 1200

OM 151, 153 & 1199

ML 545

DNB VII, pp 673-75

M Webster, *Johan Zoffany*, National Portrait
Gallery, London 1976, pp 33-34

F Russell, 'King George III's picture hang at
Buckingham House', *Burlington Magazine*, no
1012, vol 129, August 1987, pp 526-27 & 530-31

O Hedley, *Queen Charlotte*, London 1975, p 93

J Brooke, *King George III*, London 1972, p 283

This picture is close in date to the previous work and definitely predates 31 March 1765 when Prince George was breeched. It was probably delivered to Carlton House in 1809 and was variously there, at Kew and at Buckingham House later in the nineteenth century.

The scene is set in the Second Drawing Room or Warm Room in the Queen's apartments at Buckingham House. With the exception of the Prince of Wales, all the children of George III were born at this residence, which was transferred to the Queen in 1775 after her original dower house, Somerset House, was given to the newly-founded Royal Academy. At the right is a tapestry firescreen supplied in 1763 before a marble fireplace which is now in Windsor Castle. Over the fireplace is Van Dyck's *The Three Eldest Children of Charles I* and on the left wall is the same artist's *George Villiers, Second Duke of Buckingham and Lord Francis Villiers*, both of which were painted in 1635. These are still in the Royal Collection and are recorded as hanging in the Second Drawing Room at the time. *The Infant Christ Child Holding a Cross* by a follower of Carlo Maratta between the two Van Dycks hung elsewhere in Buckingham House and is now at Windsor. Beneath it are portraits of Queen Charlotte and George III. These are probably inventions of Zoffany, the likeness of the Queen derived from his own portrait of *Queen Charlotte with her two eldest sons* (cat no 55).

George, Prince of Wales (1762-1830) stands holding his hat beside Prince Frederick (1763-1827), seated on a chair. Both are wearing infants' 'coats'. Prince George was born on 12 August 1762 and his brother Prince Frederick on 16 August 1763. In 1764 the latter was elected to the sinecure of Bishop of Osnabrück (cat no 1), by which title he was generally known until he was created Duke of York in 1784. According to the diary of the royal governess Lady Charlotte Finch, Prince Frederick walked unaided for the first time on 11 September 1764. The present work may have been painted slightly earlier than this date. It seems likely Zoffany sought to draw a direct analogy between the royal princes and Van Dyck's earlier portraits of children. This is confirmed by the inclusion of the small spaniel with which Prince George and Prince Frederick are playing, reminiscent of the two King Charles spaniels prominent in the foreground of Van Dyck's *The Three Eldest Children of Charles I*. Zoffany later developed the analogy further (cat nos 57 & 58).

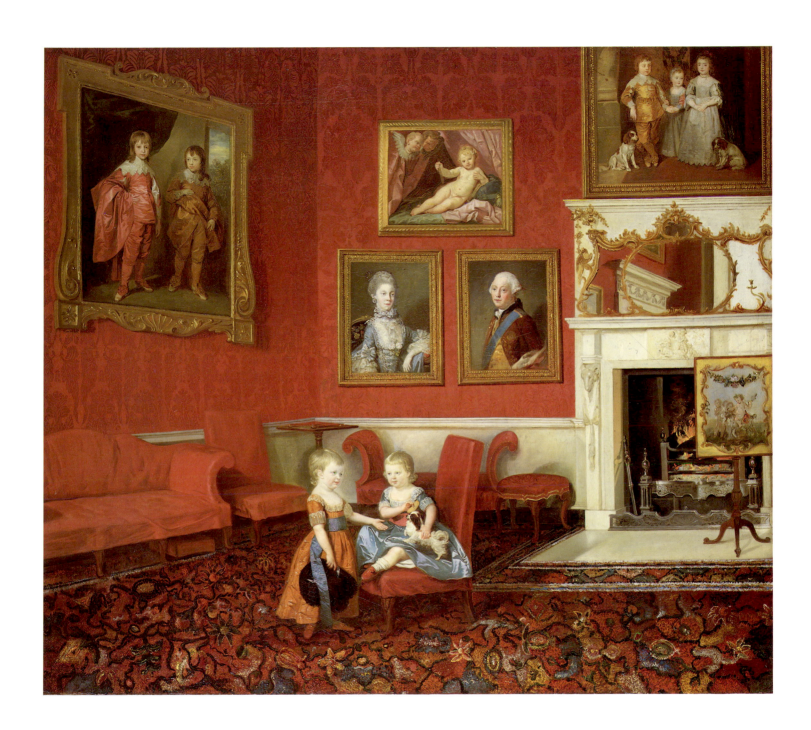

57

Johann Zoffany 1733/4–1810
George III, Queen Charlotte and their six eldest children 1770

Oil on canvas
27.6 × 41.3 cm (10⅞ × 16¼ in)

OM 1202

OM 151, 152, 153, 1200, 1201 & pp xiv–xv

J L Nevinson, 'Vandyke dress', *The Connoisseur*,
vol 157, November 1964, pp 166–71

J Reynolds (ed R R Wark), *Discourses on Art*,
New Haven & London 1975, pp 138–39

J Hayes, *Thomas Gainsborough*, Tate Gallery,
London 1980, p 129

J Brooke, *King George III*, London 1972,
pp 57–58

Having been nominated a member by George III, Zoffany exhibited at the Royal Academy for the first time in 1770. The present work is a small sketch for the large composition of the Royal Family (cat no 58) submitted on this occasion. It was purchased from a Paris collection by Her Majesty The Queen in 1957.

In most essentials the final version follows the sketch, which is more spontaneous. The features of the sitters are much more generalised, suggesting that the detailed studies necessary to ensure proper likenesses followed. The family is wearing seventeenth-century costume. From the 1740s fancy dress, including hussar uniform (cat no 2), became increasingly popular. At the Duchess of Norfolk's Masquerade in 1742 Horace Walpole saw 'quantities of pretty Vandykes, and all kinds of old pictures walked out of their frames'.

By the middle of the century the fashion of having one's portrait painted in seventeenth-century dress was firmly established. Gainsborough's most famous painting, the so-called *Blue Boy* exhibited at the Royal Academy in 1770, portrays its subject in a Van Dyck suit which seems to have been one of the painter's studio properties. In his *Seventh Discourse on Art* delivered at the Royal Academy in 1776, Reynolds observed: 'The great variety of excellent portraits with which Vandyck has enriched this nation, we are not content to admire for their real excellence, but extend our approbation even to the dress which happened to be the fashion of that age. We all very well remember how common it was a few years ago for portraits to be drawn in this fantastick dress; and this custom is not yet entirely laid aside. By this means it must be acknowledged very ordinary pictures acquired something of the air and effect of the works of Vandyck, and appeared therefore at first sight to be better pictures than they really were'.

What made the Royal Family's adherence to this fashion rather different to that of their contemporaries was the quantity of Van Dyck portraits in the Royal Collection and the House of Hanover's relationship with the Stuarts. Zoffany's *George, Prince of Wales and Frederick, later Duke of York* (cat no 56) sit beneath Van Dyck portraits of Stuart princes and the children of Charles I's favourite, the Duke of Buckingham. The latter portrait also suggested the pose of the two eldest boys in the present work. Moreover, in 1765 George III spent £525 on the purchase of Van Dyck's *The Five Eldest Children of Charles I*. George III's schoolbooks reveal that he was brought up to be deeply critical of Charles I for holding 'too high a notion of the regal power'. Nevertheless, the Hanoverian dynasty's claim to the throne of England stemmed from the marriage in 1658 of Sophia, a niece of Charles I, to Ernst Augustus, Elector of Hanover. Stressing his own Stuart ancestry confirmed the right of George III's family to the Crown.

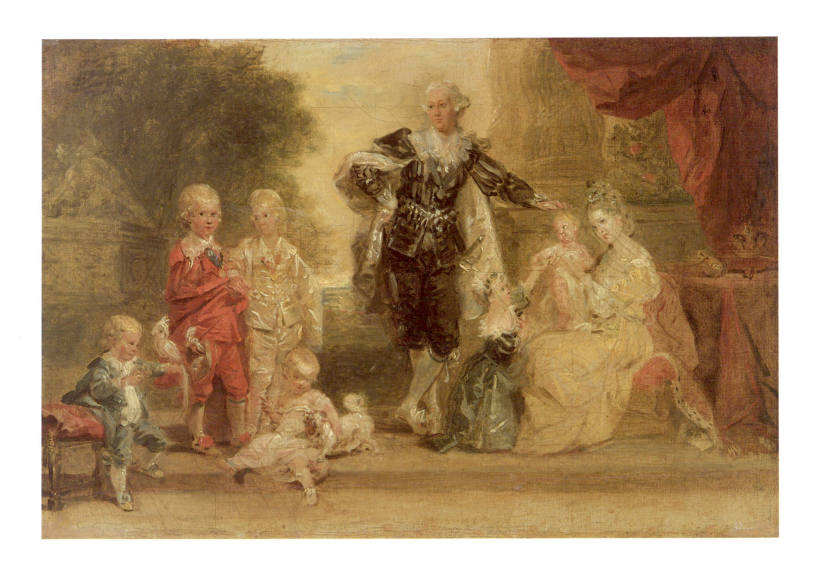

58
Johann Zoffany 1733/4–1810
George III, Queen Charlotte and their six eldest children 1770

Oil on canvas
104.8 × 127.6 cm (41¼ × 50¼ in)

OM 1201

OM 43, 150, 1200, 1202, 1203, 1204 & pp xiv–xv

M Webster, *Johan Zoffany*, National Portrait
Gallery, London 1976, pp 10–11 & 52–53

F Haskell & N Penny, *Taste and the Antique*, New
Haven & London 1988, pp 337–39

This painting is based upon a small oil sketch (cat no 57), also in the Royal Collection. Presumably painted for George III or Queen Charlotte, the large version caused Horace Walpole to remark 'In Vandyke dresses, ridiculous' when he saw it at the Royal Academy in 1770. Subsequently at Kew, it was at Windsor by 1862.

From left to right, the sitters are: Prince William, later William IV (1765–1837); George, Prince of Wales, later George IV (1762–1830); Prince Frederick, later Duke of York (1763–1827); Prince Edward, later Duke of Kent (1767–1820); George III (1738–1820); Charlotte, Princess Royal (1766–1828); Princess Augusta (1768–1840) and Queen Charlotte (1744–1818). The King and Queen had nine further children, all but two of whom survived to adulthood. George III and the Prince of Wales are both wearing the ribbon of the Garter, Prince Frederick wears the ribbon of the Bath and Prince William wears the ribbon of the Thistle. A crown, orb and sceptre lie on the table at the right. The Queen wears a miniature portrait, presumably of the King, over her heart and Princess Augusta is holding a teething coral. Prince William is holding a cockatoo and Prince Edward is playing with a small spaniel. The garden sculpture in the background is probably based upon the *Wrestlers* in the Uffizi, one of the most famous classical marbles in Florence, which was much copied during the eighteenth century.

The spaniel is quite different to the dog in the preparatory oil study (cat no 57), but is identical in appearance and pose to that in Zoffany's portrait of George III's two eldest sons (cat no 56), painted about five years earlier, suggesting that the artist had recourse to old sketches. This painting was presumably finished after Prince William was made a Knight of the Thistle on 5 April 1770 but before Princess Elizabeth, who does not appear in the composition, was born on 22 May 1770. At about the same time Zoffany painted two larger double portraits, one of the Prince of Wales and Prince Frederick and the other of the Princess Royal and Prince William, also in 'Vandyke' dress. In the present work, not only the costume and poses of the sitters, but also their setting, is profoundly reminiscent of Van Dyck. His *Charles I and Henrietta Maria with their two eldest children*, also in the Royal Collection, depicts the sitters beside a table with a crown, orb and sceptre and seated before a column partly obscured by drapery beyond which is a landscape vista. Zoffany's portrait is both an exercise in the eighteenth-century 'conversation' or 'family piece' and a self-conscious contribution to a distinguished tradition of British royal family portraits which may be traced back, before the seventeenth century, to *The Family of Henry VIII* painted in about 1545 by an anonymous follower of Holbein.

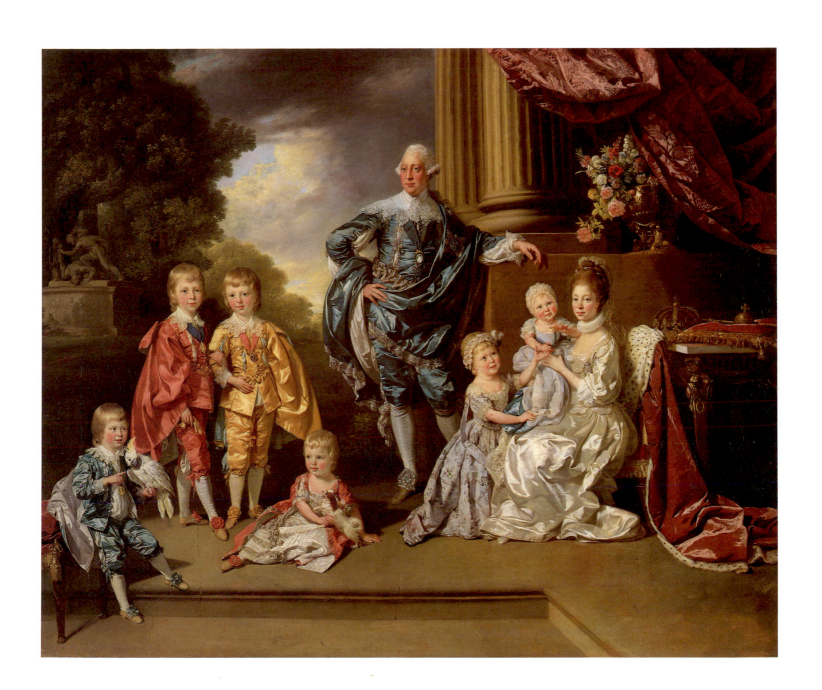

59
Johann Zoffany 1733/4–1810
The Academicians of the Royal Academy

Oil on canvas
100.7 × 147.3 cm (39¾ × 58 in)

OM 1210

M Webster, *Johan Zoffany*, National Portrait Gallery, London 1976, pp 57-8

N Penny (ed), *Reynolds*, Royal Academy of Arts, London 1986, p 341

S C Hutchison, *The History of the Royal Academy 1768-1968*, London 1968, pp 42-62

O Hedley, *Queen Charlotte*, London 1975, pp 69, 73, 86, 94 & 114

Following a petition from twenty-two of the leading artists in Britain, George III approved the Instrument of Foundation of the Royal Academy in December 1768. This decreed that there should be forty academicians who would be painters, sculptors or architects of high reputation, aged at least twenty-five and resident in Great Britain. An elected President and eight members were to manage the society, the principal aims of which were to run an academy of design for students and to mount an annual exhibition 'open to all artists of distinguished merit'. Unusually, Zoffany was not elected to the Royal Academy, but nominated a member by George III in 1769. Presumably commissioned by the King, the present work was exhibited at the Royal Academy in 1772 where it apparently drew 'the densest crowd about it'. By 1819 it was in the Upper Library at Buckingham House. It subsequently alternated between Carlton House and Buckingham Palace before being transferred to the Grand Corridor at Windsor by 1859.

This painting commemorates the gift in 1771 from George III of rooms in Old Somerset House on the Strand, formerly Queen Charlotte's dower house (cat nos 19, 20 & 56), to house the schools of the Academy. The artist has combined the two principal teaching methods employed – casts of famous statues from the plaster academy and living models from the life room, both of which were drawn by lamplight to accentuate shade and relief. Instead of the students who normally attended, Zoffany has filled the room with the academicians. Absent are Gainsborough (cat nos 21-25) and George and Nathaniel Dance, who had apparently argued with Sir Joshua Reynolds (cat nos 39-41), and the only female academicians Angelica Kauffmann and Mary Moser. The latter were excluded when nude models were present and are represented here in effigy as the two portraits on the wall at the right.

George Moser, Keeper of the Academy, is adjusting the pose of the model, using a line suspended from the ceiling to keep his upright hand still. He is assisted by Francesco Zuccarelli (cat nos 51 & 52), who leans round with hand on knee to check the model's pose. As one of the Visitors of the schools, it was his duty to set the figures. Each of the two models posed for a session of two hours – timed by the hour-glass at the feet of the one seated at the right, who strikes a pose reminiscent of the *Spinario* statue in Rome as he pulls on his stocking. Beneath the oil lamp the landscape painter Richard Wilson leans against the wall between a shelf of plasters and a life-size dummy of a flayed man used to study musculature. In the centre of the composition, hand on chin and contemplating the model, stands Dr William Hunter, obstetrician to Queen Charlotte and Professor of Anatomy at the Royal Academy. Beside him the President, Sir Joshua Reynolds, listens through an ear-trumpet to the Secretary, Francis Milner Newton. Between them stands the architect Sir William Chambers, Treasurer of the Academy. To their left, seated with legs apart, is Francis Hayman, appointed Librarian 'that he might enjoy its emoluments, small as they were, in consequence of his bodily infirmities which in the evening of his life pressed heavily upon him'. Behind him, in conversation, are the watercolourist Paul Sandby and his brother Thomas, Professor of Architecture. At the left, half seated with one leg bent, is Benjamin West, Reynolds's successor as President. To his right is Tan-che-qua, a Chinese modeller who came to Britain. Although never an academician, he visited the Academy schools in 1771. Zoffany included a self-portrait, seated with palette in hand, at the extreme left foreground. The Royal Academy was transferred to Burlington House in 1867 when Sir Francis Grant negotiated it a 999-year lease at a rent of one pound a year (cat nos 26 & 51).

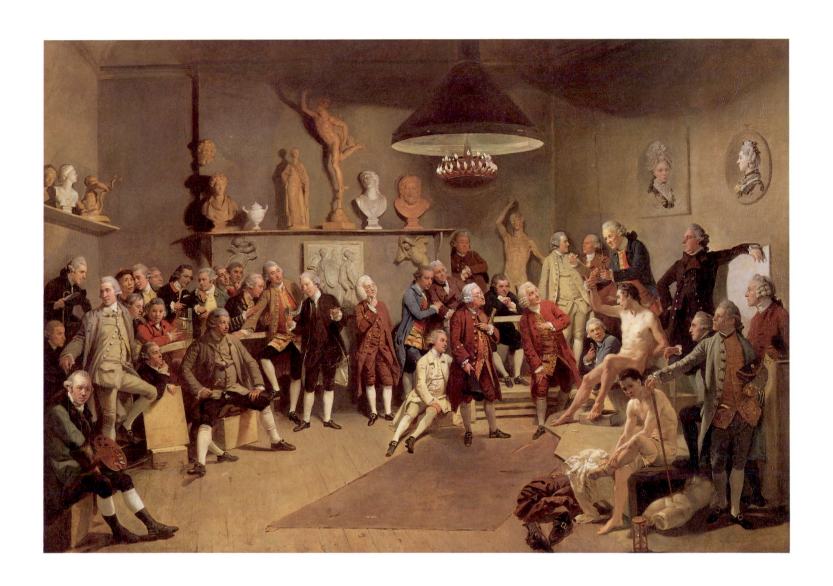

Johann Zoffany 1733/4-1810
Queen Charlotte with members of her family

Oil on canvas
105.1 × 127 in (41⅜ × 50 in)

OM 1207

OM 1201 & 1208

O Hedley, *Queen Charlotte*, London 1975, pp 26,
109-10, 189, 263 & 282 & ill facing p 73

In 1772 Zoffany went to Florence to paint for Queen Charlotte the Tribuna of the Uffizi. He remained in Italy until 1779. Presumably painted for the Queen, this picture was exhibited at the Royal Academy in 1773. By 1862 it was at Windsor.

In a park, perhaps at Kew, the Queen is seated on a bench with Princess Charlotte (1766-1828), holding a doll, at her feet. Standing on the bench is Prince William (1765-1837), wearing the star of the Order of the Thistle. Behind the bench the royal governess, Lady Charlotte Finch (1725-1813) holds a baby. At the left of the group stands the Queen's older brother Prince Karl of Mecklenburg-Strelitz (1741-1816), wearing the Order of St Andrew of Prussia. At the right stands her brother Prince Ernst (1742-1814), wearing the Order of the White Eagle of Poland. The children look no older than in *George III, Queen Charlotte and their six eldest children* (cat no 58), which was complete in 1770. Their portraits may be based on studies made in connection with the earlier family group. Prince Ernst was in England for some time prior to his departure for Hanover in the Spring of 1772 and sat to Zoffany for a half length, also in the Royal Collection. On 1 July he stood godfather to Queen Charlotte's eighth child Prince Ernest (1771-1851), later Duke of Cumberland and King of Hanover. Prince Karl was in England more briefly, in August 1771, when he stayed with the King and Queen at Richmond. He presumably sat to Zoffany for the present work on this occasion. Accordingly, it is probable that the baby portrayed here is Prince Ernst's godson Ernest, rather than Princess Augusta (1768-1840), the baby in Zoffany's royal conversation piece of 1770 (cat no 58).

Lady Charlotte Finch, daughter of the 1st Earl of Pomfret, was an intimate friend of the Queen. Appointed Governess in Ordinary to the Prince of Wales in 1762, she retained this post with a series of royal children for twenty years. Prince Karl succeeded his elder brother Adolf Friedrich IV as Duke of Mecklenburg-Strelitz in 1794. After the dissolution of the Holy Roman Empire in 1806 he was forced to join the Confederation of the Rhine, but defected to the alliance against Napoleon in 1813 and took his diminutive duchy into the Germanic Confederation in 1815, assuming the title of Grand Duke. His younger brother Ernst served in the Hanoverian army and was made a British general in 1788.

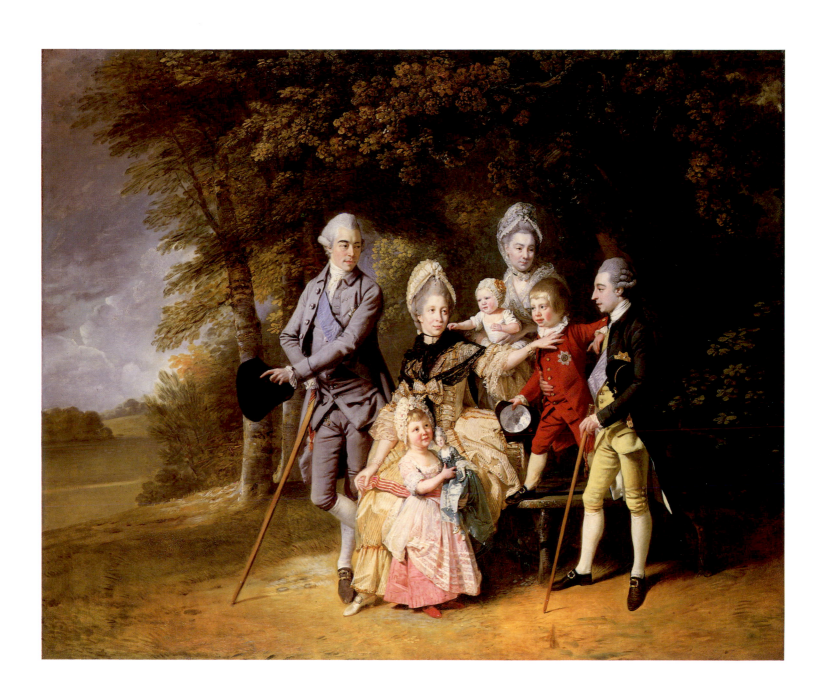

Acknowledgements

The principal debt of any student of the paintings in the Royal Collection must be to
the authors of the exemplary volumes in the *Catalogue Raisonné* of The Queen's pictures;
in this case the Surveyor Emeritus Sir Oliver Millar GCVO and Sir Michael Levey LVO. I
am also grateful to the present Surveyor of The Queen's Pictures, Christopher Lloyd, for
numerous ideas, support and encouragement. His colleagues have been prodigal with their
time and I would like to thank the Honourable Caroline Neville, Viola Pemberton-Pigott,
Rupert Featherstone, Karen Ashworth, Elizabeth Dennes and Marcus Bishop MVO. At the
Department of Art of the National Museum my colleagues have been unstinting in their
practical assistance and have cheerfully accepted the increased workload which my
absences writing this catalogue have entailed. Kate Lowry has handled the practical
arrangements of transport, storage and display with the assistance of Mike Jones and
Keith Bowen. Timothy Stevens and Oliver Fairclough have read the catalogue text,
drawn my attention to publications I had missed and provided numerous helpful
suggestions. Sylvia Richards typed the text swiftly and accurately. Sarah Herring was a
most valuable assistant. I am also grateful to Rachel Duberley, Tim Egan, Rosa Freeman,
Avril Haynes, Christine Mackay, Judi Pinkham and Paul Rees. Elsewhere in the National
Museum, considerable assistance with the exhibition has been provided by Deborah Cole,
John Kenyon, Frank Neal, Hywel Rees, John Rowlands, Basil Thomas and Kevin Thomas.
I am most appreciative of the advice of Giulia Bartrum, Frank Evans, Nigel Meager,
Roger Pinkham and Reinhild Weiss. I have received every courtesy from the library staff
of the British Library, Cardiff Central Library, the Courtauld Institute, the National Art
Library, the University of Wales College of Cardiff and the Warburg Institute.

MARK L EVANS